Color Observed

To Terence Verity, in gratitude

Color Observed

Enid Verity

VNR VAN NOSTRAND REINHOLD COMPANY
NEW YORK CINCINNATI TORONTO LONDON MELBOURNE

First published 1980 by The Macmillan Press Ltd., London and Basingstoke

Library of Congress Catalog Card Number 79–20730

ISBN 0–442–21906–7

Printed in Hong Kong

Published in 1980 by Van Nostrand Reinhold Company
A division of Litton Educational Publishing, Inc.
135 West 50th Street, New York, NY 10020, U.S.A.

Van Nostrand Reinhold Limited
1410 Birchmount Road, Scarborough, Ont. M1P E27, Canada

16 15 14 13 12 11 10 9 8 7 6 5 4 3 2 1

Library of Congress Cataloging in Publication Data

Verity, Enid.
 Color observed.

 Bibliography: p.
 Includes indexes.
 1. Color. I. Title.
QC495.V47 535.6 79–20730
ISBN 0–442–21906–7

Contents

Foreword

by Professor W. D. Wright

In searching for a word or a phrase to describe *Colour Observed*, I found myself caught up in the meshes of colour terminology. For Enid Verity wields her pen as an artist wields his brush, painting a fascinating picture of almost every aspect of colour. And I think it is no exaggeration to describe this picture as 'brilliant'. She is clearly in love with her subject and takes delight in reminding us about the many and varied uses to which colour has been put—from primitive man using colour to symbolise his tribal relationships, to modern man exploring space and planting his flags on the moon. What a relief, too, to read a book that does not set out to prove anything, still less to advocate some new theory of colour perception.

Is this a book for the general reader or the colour specialist? Surely for both. Certainly the specialist, whether artist, scientist or technologist, ought to read it if he wishes to become a 'whole' colour man. At the same time, there is nothing to scare the general reader away. Quite the contrary, in fact, for wherever he opens the book, he will find the subject-matter of the chapter being presented in an easy style which immediately holds his attention.

This is a very enjoyable as well as a very rewarding book to read and it is a privilege to have been invited to write the Foreword.

David Wright

Acknowledgements

The Art Institute of Chicago for figure 8.10.

The British Museum, London, for figure 8.7.

Carl Zeiss, Oberkochen, West Germany, and Science Photo Library, London, for the colour photograph of a flame.

Courtauld Institute Galleries, London, for the colour photograph of Final Study for 'Le Chahut' by Georges Seurat.

Eric de Maré, for the colour photographs of natural and painted wood, natural and dyed wool, medieval heraldry, ochre landscape in Provence.

Gerald Duckworth and Co Ltd for figures 5.3 and 5.4 and for extracts from *Illusion in Nature and Art* (1973) edited by R. L. Gregory and J. Gombrich.

Fogg Art Museum, Harvard University, for figure 2.17.

Gallerie dell'Accademia, Venice, for the colour photograph of Madonna and Child by Paolo Veneziano. Photograph by Eric de Maré.

Margaret B. Halstead for extracts from her paper 'Colour Rendering Past, Present and Future' published by Adam Hilger Ltd in *Colour: Proceedings of the Congress of the International Colour Association, 1977.*

Adam Hilger Ltd for figures 2.13–2.15, 4.5, 6.3 and 6.4 from *The Measurement of Colour* by W. D. Wright.

Macmillan Education for figure 5.5 from *Common Reef Fishes* by K. R. Bock.

John Mattock of Oxford for the colour photograph of a rose.

Munsell Color, Baltimore, USA, and Tintometer Ltd, Salisbury, UK, for figure 2.9.

Museum of Modern Art, New York, for figure 8.9.

The Trustees, The National Gallery, London, for the colour photograph of Michelangelo's Madonna and Child with the Infant Baptist and Angels.

Otto Maier Verlag, Ravensburg, and B. T. Batsford Ltd, London, for diagrams 2.1–2.8 and 2.10 from *Colour Matching and Mixing* (1970) by A. Hickethier, published in the USA by Van Nostrand Reinhold Co under the title *Color Mixing by Numbers.*

Oxford University Press for figures 4.4, 4.6 and 7.4 from *Colour Technology* by F. A. Taylor.

Penguin Books Ltd for extracts from *Colour Photography* by Eric de Maré.

Mr Ronald Sheridan for the colour photograph of the Dome of the Rock.

Miss Bridget Riley for permission to reproduce her painting *Fall* (figure 7.3).

Studio Vista for extracts from *Colour for Architecture* edited by T. Porter and B. Mikellides.

The Tate Gallery, London, for figures 7.3, 8.8 and the colour photograph of Turner's *Light and Colour* (Goethe's Theory) – *The Morning after the Deluge* (Photograph by John Webb).

Van Nostrand Reinhold Co for figures 2.11, 7.1, 8.1 and 8.3–8.6 from *History of Color in Painting* by Faber Birren (1965).

The Victoria and Albert Museum for the colour photograph of a garden design on a Persian carpet.

George Weidenfeld and Nicolson Ltd for figures 4.1, 6.1, 6.2 and 7.2 from *Eye and Brain* by Richard Gregory.

Mr Robert Wilson for figure 9.1 from *Roses and Castles*, published by the Waterways Museum.

Winsor and Newton Ltd for figure 2.12 from *Colour Science* by W. Ostwald, translated by the late J. Scott Taylor, and figure 3.2 from *Brief History of Winsor and Newton*.

Figures 3.1, 5.1, 5.6, 9.2 and 9.3 were drawn by the author.

The author would like to thank the following for commenting on different parts of the book: Frank Hill, for the chapter on colour and light; Allan Jones, for the chapter on biological colour; Keith Maclaren, for the chapter on colorants; Pamela Tudor-Craig, for the chapter on colour-science and art; and Eric de Maré, for encouragement and proof-reading.

Understanding Colour

In one way or another, everyone is interested in colour. It often arouses emotional reactions—sometimes powerful ones—yet information about colour remains mostly specialised, and is very rarely comprehensive. I have tried here to provide widely based information on a subject which, although it is of such universal importance, is seriously neglected in general education.

There are signs that the present attitude to colour is changing. After all, almost no technique is more important to science than colour measurement, which has so enormously extended the range of scientific enquiry and application that it is changing the lives of this generation with extraordinary rapidity. Colour television is only one of such transforming influences, the technology for which is wholly dependent upon the science of colour that has been built up gradually over the last three or four centuries.

Apart from abstract hypotheses on the structure of the universe based on spectrographic examination of the stars, and the analysis of atomic matter in which colour science also plays a role, the results of colour technology are directly affecting the man-made environment in ways that intelligent observers cannot ignore. Colour technology governs, for instance, the world of fashion, from the computation of colour trends to the production of dyes and pigments and the chemical research it involves. The complex world of communications and entertainment is also dependent on the technical and aesthetic control of colour and light. Psychologists and anthropologists are aware of some of the psychological implications of colour symbolism in fashion and the arts.

The production of food is very much assisted by colour measurement in stock farming, fishing, agriculture, horticulture and forestry, which all need colour technology both for quality control and biochemical investigation. More colorants are used in food production than in the textile industry! Commerce and industry are using the technical application of colour science at many levels of research, production and marketing. The building industry, one barometer of technical achievement in society, is, in a competitive market, increasingly using colour technology in the specification, production, maintenance and marketing of building materials.

Researchers in chemistry, physics and medicine are using instruments that, by

the control and measurement of the wavelengths of light, provide them with an inexhaustible source of information by means of which the scientists can analyse and calculate the properties of matter vital to their research.

Techniques that are sometimes the by-product of such research are applied in printing processes. An enormous number of colours can be distinguished and recorded by the camera, and a colour film or print provides a lasting record of a visual image that is only ephemeral in human memory, the memory being notoriously weak in recollecting colour accurately. As a refinement of visual discrimination, the classification of colours, attempted over centuries, has advanced steadily in the twentieth century, aided by the camera to record colour, and by the spectroscope and colorimeter to specify and measure colour.

But what is colour? Goethe observed about 200 years ago: 'All nature manifests itself by means of colour to the sense of sight.' This is still true. The interaction of light with the physical and chemical properties of surfaces accounts for the manifold variety of colours in the natural world: the marvellous economy of the spectral palette, a few natural pigments, the play of light on textured surfaces, together constitute all the wealth of colour provided by nature. Colour experience is now enormously expanded by the production of synthetic colorants and artificial lighting.

Colour is mysterious, eluding definition; it is a subjective experience, a cerebral sensation depending on three related and essential factors: *light,* an *object* and an *observer.* It is a psycho-physical reaction to light seen by the eye and interpreted by the brain. What does this mean? Is it a sensation, a quality, an experience? A tool for survival, for discovery, for imagination? What *are* these factors, light, object and observer which, appropriately combined, produce the awareness of colour?

Where, in fact, does light come from? Out of the total spectrum of electromagnetic energy radiated by the sun, the *visible spectrum,* from which we derive the faculty of sight, is a relatively narrow band of wavelengths combining to give white light. What then of the object, its molecular and atomic structure providing the surface necessary to reflect light to the observer? 'The fingerprint of the atom', wrote Professor Bronowski in *The Ascent of Man* (1973) 'is the spectrum, in which its behaviour becomes visible to us looking at it from the outside.' He continued, 'When we step through the gateway of the atom, we are in a world which our senses cannot experience.'

The visual sense, linked as it is with the visible spectrum and with atomic structure, is an infinitely subtle and complex computer-type process with a coded colour information input in the form of electrical impulses and biochemical exchanges, and an output of image symbols identifying the world around us. The eye perceives many thousands of colours, sometimes simultaneously. The mind seeks visual order: it automatically organises colour and discriminates coloured and textured surfaces. We 'feel' with our eyes, just as we 'see' with our fingertips.

The more the study of light, the object and the observer reveals of colour and human perception, the more fascinating and mysterious does the subject become. It is therefore difficult to understand the resistance—even with a crowded curriculum—of much of today's education to colour information, whether historical, theoretical, practical or aesthetic, when they affect so many aspects of modern

life. This is particularly true of art education, including architecture. The problem is not a new one. As long ago as the middle of the nineteenth century, Eugène Delacroix, deploring the neglect of colour science in French schools of art, wrote: 'Secrets of colour theory? Why call those principles secret which all artists must know and all should have been taught?'

For artists and scientists alike, knowledge of colour, its theory and technology, can be enormously rewarding. More general reasons exist for colour education. Dr Nicholas Humphrey in a contribution to *Color for Architecture* (1976), entitled 'The Colour Currency of Nature' remarks: 'Today almost every object that rolls off the production line, from motor cars to pencils, is given a distinctive colour—and for the most part these colours are *meaningless*. As I look around the room I am working in, man-made colour shouts back at me from every surface: books, cushions, a rug on the floor, a coffee cup, a box of staples—bright blues, reds, yellows, greens. There is as much colour here as in any tropical forest. Yet whilst almost every colour in the forest would be meaningful, here in my study almost nothing is.' Dr Humphrey makes the point that though indiscriminate use has no doubt dulled man's biological response to colour, his response to it continues to show traces of his evolutionary heritage. 'So men persist in seeking meaning from colour even where no meaning is intended: they find colour attention-catching, they expect colour to carry information, and, to some extent at least, they tend to be emotionally aroused.'

This book attempts a comprehensive survey of colour information in the hope of stimulating greater interest in both the science and aesthetic appreciation of colour, and of building a bridge between the two, in the belief that beauty lies in the educated eye of the beholder.

2
Classifying Colour

The classification of colour in terms of dimensions is comparatively recent: that is to say, it has evolved gradually since Newton's great discoveries relating to colour and light in the seventeenth century.

Three related aspects of colour, *hue, value* and *intensity,* can be described as the dimensions of colour. Any colour can be defined in terms of these dimensions—it is simply a way of grouping together particular attributes of colour.

A dimension in a spatial context implies length, breadth and thickness. The three dimensions of colour representing these hypothetical attributes can be built up as a solid body.

The first of these dimensions is hue. Pure spectral hues are produced when sunlight is refracted by a prism. Physically a spectrum consists of light of different wavelengths, so that each hue can be identified by its corresponding wavelength, or band of wavelengths, in the spectrum. The visible solar spectrum spans between red, at about wavelength 750 nanometres (nm), and violet at wavelength 380 nm (1 nm = 10^{-9} metres). Beyond these wavelengths are infra-red on the long end and ultra-violet on the short end of the spectrum, and these are invisible to the human eye.

When the colours of the solar spectrum are sharply in focus, they are perceived as brilliant, saturated and free from the sensations of white and black. Characteristic colours representing bands of wavelengths in the spectrum are visually distinguished by their hue. The colours of the solar spectrum are composed of monochromatic or single wavelength colours, though very little coloured light is technically monochromatic. The exception occurs when a direct vision prism splits the initial white beams of a multicolour krypton-argon laser into its monochromatic components. Laser beams are intense, sharply defined sources of totally saturated colours, capable of being deflected and projected by small mirrors, so that colours seen on the projection screen are the purest, most intense that it has so far been possible to obtain.

No purple light is visible in the solar spectrum. A mixture of red and blue light produces visible purple light. Purple hues are included in a diagrammatic circle composed of discrete, surface colour hues, where the perceptible difference is constant and continuous.

Surface colours reflect back to the observer light from which certain spectral components have been selectively absorbed or subtracted by substances contained in the surface. Spectral colours are components of white light refracted directly back to the observer from a white or colourless surface, and since the majority of colours normally perceived are surface colours, in this book, as in general conversation, 'colours' are assumed to be surface colours unless specified as spectral colours. Any brilliant colour at full saturation is called a hue. All pigment mixtures obey chemical laws that are different in certain ways from the laws governing light mixtures, though any colour that can be obtained by a mixture of pigments can to some degree be simulated by light mixtures.

When refracted colours of the spectrum are sharply focused at full strength on a white reflective surface, each colour has the single dimension identified as hue. They vary from each other only in wavelength or quality of hue. Apart from this variation, any hue can be modified in another dimension of colour determining its degree of lightness or darkness according to the amount of light reflected from a surface or radiated from a source.

The usual term for this second dimension is *value*, though physicists distinguish between *lightness* for coloured light, and *reflectance value* for surface colours. Pure hues in any surface colour can be modified by the addition of blackness or whiteness in such a way that the differences in value are constant and continuous, to form a two-dimensional monochromatic scale of value.

A *monochrome* describes the relationship of colours selectively deriving from a single hue. Using pure pigments in paints, inks or dyes, a monochromatic system of colours can be built up based on any selected hue—for example red—plus black and white. The dimension value varies from very pale, or high value, colours, to very dark, or low value, colours, and changes in value make the red increasingly pale or increasingly dark. A monochromatic scale based on red shows a progression from clear pale pinks (which are light reds of very high value), deepening to the fully saturated red hue, and deepening to clear dark reds of very low value.

This is one type of monochromatic value scale, where all the colours contain only one hue, red, plus white or black, but not grey. A second type is non-chromatic or achromatic: a grey scale from near white to near black, through a midway neutral grey. It includes the colours familiar in a so-called 'black and white' photograph. (In surface colours, black and white and pure greys are usually called 'colours', but these are non-chromatic, and contain no hue or pure colour.) Both these scales, the one chromatic and the other non-chromatic, demonstrate the second dimension of colour: value.

The third dimension of colour is *intensity* (variously referred to as saturation, chroma, greyness or intensity of colour). In this book it is, for convenience, generally referred to simply as intensity. This dimension relates to the ratio of pure hue to greyness in the appearance of a colour. The more saturated a colour, whatever its hue or value, the more intense, pure, or strong it appears. Conversely, the less saturated the colour, the less intense or more grey it appears.

Three progressions of saturation, or intensity, can be demonstrated, in a red monochrome, by a horizontal scale between:

Development of Colour Systems

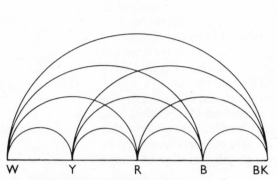

Figure 2.1 Two-dimensional colour chart by Athanasius Kircher (1671)

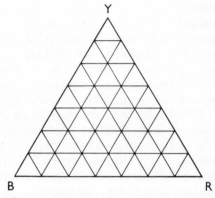

Figure 2.2 Two-dimensional colour triangle by Tobias Mayer (1745)

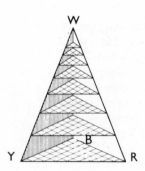

Figure 2.3 Colour pyramid by Johann Heinrich Lambert (1772)

Figure 2.4 Colour sphere by P. Otto Runge (1810)

Figure 2.5 Colour hemisphere by Michel Eugène Chevreul (1861)

Figure 2.6 Colour cube by Charpentier (1885)

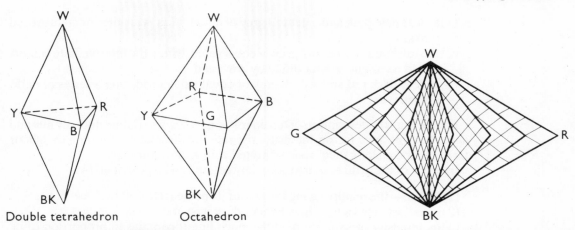

Figure 2.7 Colour solids by A. Höfler (1905)

Figure 2.8 Colour body by Wilhelm Ostwald (1916)

Figure 2.9 Section through Ostwald solid

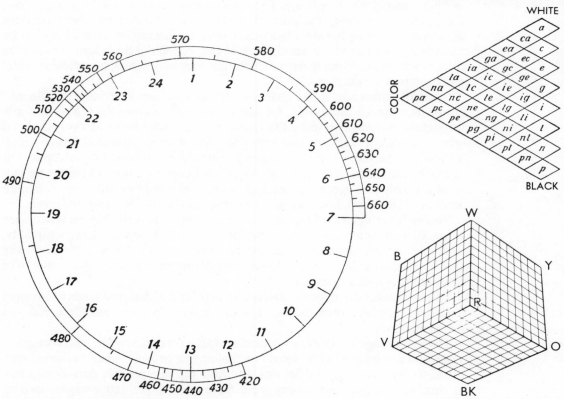

Figure 2.10 Ostwald hue circle and approximate wavelengths

Figure 2.11 1000 colour cube by Alfred Hickethier (1940)

(1) a clear pale pink and a neutral grey of equal value, with intermediate greyed pinks;
(2) the full hue and a neutral grey of equal value, where the intermediate colours would be bright reds modified by grey; and
(3) a clear dark red and a dark grey of equal value producing a series of dark, greyed reds.

For a complete description of a colour it is necessary to define not only hue and value, but this third factor, intensity: the ratio of chromatic saturation to light or dark colours, making them vivid or muted with grey accordingly.

In terms of these three dimensions, any colour can be described by:

(1) its hue—the quality giving the colour its name (red, yellow, blue, etc.);
(2) its reflectance value—how light or dark it is; and
(3) its intensity or saturation—how much hue it contains in proportion to its greyness.

Six elementary colour sensations are now distinguished: red, yellow, green, blue, white and black. Any hue (which by definition contains no whiteness or blackness) can therefore be specified according to the ratio of red, yellow, green or blue it contains perceptually. The hues themselves vary in value from yellow, the lightest, to violet, the darkest of the hues. Apart from these inherent differences in value between individual hues, the other two dimensions can be identified according to the white, black or grey content of the colour. Most of the colours we see are three dimensional in that they have a hue, a particular value, and contain some greyness.

Inherent differences in the quality of the various hues determine their monochromatic characteristics. Red, for instance, retains its character fairly uniformly throughout its monochromatic extension, and it is recognisable as a very dark red when it is almost black, or as a very pale red, or pink, when it is almost white. Yellow, on the other hand, is of such luminosity that it is acutely susceptible to changes in lightness and intensity. As yellow becomes paler, it loses its characteristic yellowness, retaining, when it is very pale, only its radiance. A minute amount of blackness, however, alters its character, inclining it towards green.

Yellow is the lightest of the hues, with correspondingly the highest reflectance value. Blue, its complementary, is the darkest hue. All the hues change in quality, or character, with changes in value or intensity. Pure blue has so little luminosity that it darkens quickly to black. Conversely, it can absorb an immense amount of white without losing its identity.

Purple changes dramatically as it becomes paler, but darkness tends to augment its character, while green, darker or paler, changes character as little as red—its complementary.

The hue orange is capable of enormous variation in character, with changes in value and intensity, ranging from hot challenging browns, when darkened with black, to mysterious greyed browns, and from the very positive pure-orange hue to clear apricot pinks and tawny greys. Such a list of qualitative adjectives is an indication of the poverty of real colour names in language and of the need for some more universal and explicit colour terminology and classification.

The terminology used by people engaged in practical or design work connected with the appearance of surface colours—architects, industrial designers, painters and those concerned with fashion and consumer marketing—differs considerably from strictly scientific terminology used for colour measurement, where the terms of reference are dictated by the physics of light.

Though extremely precise for the use of scientists, scientific colour terminology is often incomprehensible to other people. To some extent these differences are bridged by terms used in colour systems and applications.

Verbal description, the classification of colour appearance by chemical formulae, physical equation, or psycho-physical notation in colour systems, all help in the understanding and evaluation of colour as a science, or as a visual phenomenon. But the actual sensuous experience of the rich colour quality provided by variations on a theme of so many hues, ranging from the brilliance of the pure hues to the subtle changes of light, dark and greyed colours, is difficult to communicate by any of these means.

An understanding of the three dimensions of colour and of the notation and classification of colours in established systems promotes visual observation and the evaluation of colour in visual images, so that the mental analysis of colour in works of art and in nature becomes a specialised aesthetic experience. Once the observer is familiar with the technique, all visual experience becomes more or less organised into the colour dimensions.

For anyone engaged in the scrutiny, measurement and specification of colour in science or industry, a working knowledge of colour systems and classifications is essential. It is also extremely useful in commercial and industrial art, in fashion, and in the teaching of art.

Modern technology has produced synthetic dyes and pigments on such a scale that an enormous and expanding variety of coloured products has become available for industry, commerce, and the arts. A corresponding need has arisen to define and organise colours.

The many thousands of colours that we can discriminate can all be accurately measured and defined in scientific terms such as a chemical formula, a graph or a mathematical equation, but material surface colour samples are often necessary to supplement the theoretical information. In the field of pure and applied science colour measurement has become an indispensable tool, but even here the scientific information has frequently to be correlated with one of the visual colour systems based on the concept of the three dimensions of colour.

Many methods have been devised for arranging surface colours in a systematic way. In nearly all of these systems, colours are arranged according to the three colour dimensions—hue, value and intensity—but the interpretation of these dimensions varies. Each system has its own presentation of colour scales intended to present visually uniform steps in spacing.

To present a three-dimensional concept in two-dimensional terms is difficult. This problem is met by colour atlases that produce a two-dimensional expansion of each hue in a spectral sequence of hues varying in number according to the system. A comprehensive range of colours is made available in this way. The same range of colours can be built up into a three-dimensional model showing the

relationship of all the colours simultaneously—useful for demonstration purposes and as an aid in the teaching of colour.

Standards have been agreed internationally for the exact specification of individual colours, but circumstances arise when the quantitative measurement of colour is essential or when a visual or qualitative reference is more appropriate. Sometimes both are necessary. All the colour charts, atlases and dictionaries that have been compiled are concerned with the visual appearance of surface colours. They may be used independently for colour matching and design purposes and, when colour measurement co-ordinates are provided, they can also be used as visual supplements to colour measurements.

Four principal colour systems in current use meet the complex demands for colour information from science, commerce and industry.

Ostwald, a distinguished German physiscist and chemist, interested in aesthetics, devised a theory of colour harmony based on his own colour system. Using psycho-physical observation and chemical calculation, Wilhelm Ostwald produced a colour atlas (later developed commercially in Germany and the USA), in which eight principal hues are distinguished by names: yellow, orange, red, purple, blue, turquoise, sea-green and leaf-green. These are arranged in a colour circle and subdivided into a 24-hue circle capable of further expansion. All other colours in the Ostwald system are obtained by mixing hues with white, black or grey. These mixtures of white, black and full colour result in Ostwald's equation: white + black + hue = 1.

In Ostwald's colour atlas, colours relating to each hue are proportionally arranged as formal triangles. Complementary hues are diametrically opposed to each other in the atlas. Colours are limited to hues of pigments technically available at the time the atlas was developed, and the notation is rather complicated. Since the system is confined within a symmetrical framework, it is less flexible than others which allow for the irregular development of more saturated hues than were available when Ostwald was developing his system at the beginning of the twentieth century. The Ostwald system is mostly in demand by designers for colour matching and design inspiration.

Based on the Ostwald system the Container Corporation of America in 1942 produced their very beautiful *Colour Harmony Manual*, with colour chips glossy on one side and matt on the other. This publication has been carefully described and illustrated by Egbert Jacobson in his *Basic Color* (1948).

At about the same time as Ostwald was working on his atlas in Germany, *Albert Munsell*, an American teacher of art, produced his own system. Based on hue, value and chroma (Munsell's equivalent of Ostwald's intensity), and a hue circle that can be expanded from 10 to 100, the system allows for a wider specification of colours than the 800 or so colours incorporated in the 40 charts of the Munsell colour atlas. Ten principal hues are distinguished by name, abbreviated to initials: red (R), yellow-red (YR), yellow (Y), green-yellow (GY), green (G), blue-green (BG), blue (B), purple-blue (PB), purple (P) and red-purple (RP). When these are arranged in a circle, each named hue is usually divided into four as 2.5, 5.0, 7.5, and 10.0, but each may be divided into 10, resulting in hue circles of 10, 40 or 100 easily identified hues.

The second dimension, value, is represented by a grey scale with equal visual

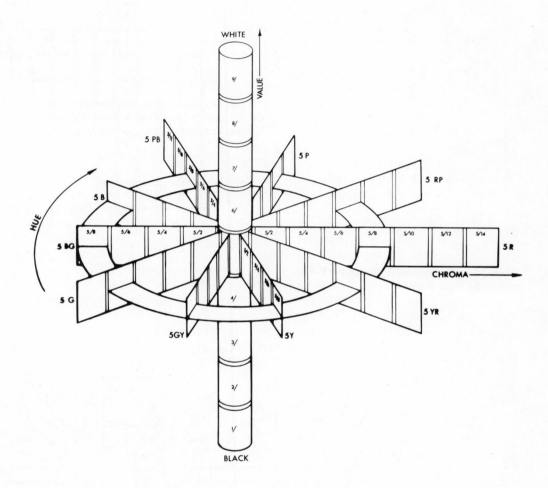

Figure 2.12 Detail of colour solid by Albert H. Munsell (1936)

spacing between 9 (near white) and 1 (near black). The system is illustrated by a series of charts with colours deriving from individual hues and uniformly disposed according to the inherent lightness (which Munsell calls value) and intensity of colour (which he calls chroma) of the particular hue. Provision is made for computed extensions of more brilliant hues as these become technically available. The system has been widely developed and brought up to date.

Comprehensive, flexible and scientifically graded for association with colour

Figure 2.13 Vertical section through the Y-PB plane of the Munsell solid

Figure 2.14 Horizontal section through the value-5 plane of the Munsell solid

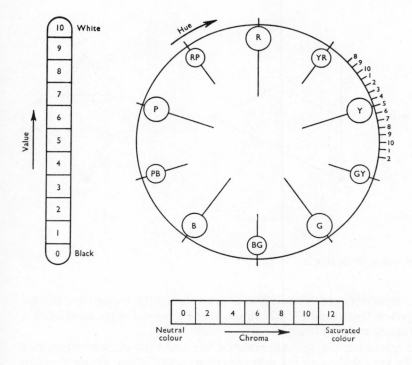

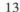

Figure 2.15 Hue, value and chroma co-ordinates of the Munsell system

measurement standards, the Munsell system is the most widely used in the technical context at the present time.

The Swedish Natural Colour System is called a 'natural' colour system because it is based on Hering's psycho-physical classification of colour according to his six elementary colour sensations: red, yellow, green, blue, white and black. The colour circle is divided into four sections accordingly, and notation relates to percentages of hue, white and black as perceived visually. One of the latest to be developed, this system is somewhat similar in concept to Ostwald, but has the flexibility of Munsell and is similarly provided with standard colour measurement co-ordinates.

The notation is simple, deriving from the four hues plus whiteness and blackness. It has a hue circle of 24, and the system has been carefully devised to conform with modern requirements.

The I.C.I. Colour Atlas, an atlas of pure hues, recently produced in England, is arranged in finely graded scales of saturation. Five basic hues can be distinguished in bands of closely associated hues, all the hues desaturating almost imperceptibly to near white. Each of the 1 379 pure colours so obtained can be multiplied 20 times by the application of a scale of values in greys, ranging from colourless to

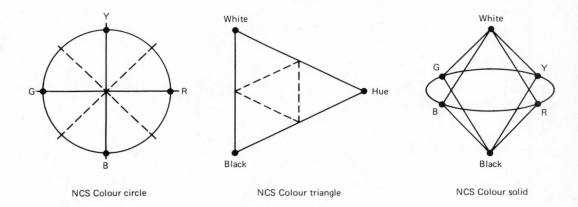

NCS Colour circle NCS Colour triangle NCS Colour solid

Figure 2.16 Swedish Natural Colour System (NCS) (1953)

almost black, separately provided. It is in effect a scale of 20 transparent graded blacks. Altogether, more than 27 500 colours can be achieved by the combination of saturation scales and grey filters.

To match a colour sample, select the nearest hue at the correct saturation, then manoeuvre the grey scale over the selected colour until finding the appropriate grey to give the colour match. The colour is then easily specified by means of a very practical and simple notation. Where the brilliance of the colour sample to be matched exceeds the brilliance of the pigmented colours of the atlas, the procedure is put into reverse and a grey film applied over the sample until a match can be found in the atlas. Notation is then given as an *x* or minus quantity. This provision is extremely useful for new developments in dyes and pigments.

The I.C.I. atlas differs from conventional colour atlases in providing an ingenious solution to the difficulty of representing several thousand colours in a two-dimensional format. It was designed by Keith MacLaren.

Many other colour atlases have been prepared during this century, including the *Nu-Hue System* developed by the Martin-Senour Company; the *Colorizer* developed by Colorizer Associates; and the *Plochère Colour System*. Other atlases have been prepared for the classification of naturally occurring colour found, for instance, in birds and flowers. La Société Française des Chrysanthémistes issued in 1905 its *Répertoire des Couleurs*; in 1912 R. Ridgeway prepared *Color Standards and Color Nomenclature*, primarily for identifying the colours of birds; and Robert Wilson produced his *Horticultural Charts* in 1938 and 1941.

Colour charts for more general use were prepared by P. Baumann (*Baumanns neue Farbentonkarte*); E. Séguy (*Code Universel des Couleurs*, 1936); A. Maerz and M. Rea Paul (*Dictionary of Colour*, 1930); and by S. Hesselgren (*Colour Manual*, 1953). One of the most extensive ever produced is the *Villalobos Colour Atlas* developed in Argentina and containing more than 7 000 colour samples.

In 1934 the British Colour Council produced a *Dictionary of Colour Standards*, which included 220 patterns on both smooth and ribbed pure silk. Each pattern

was named according to generally accepted nomenclature, and the historical origin and meaning of each colour was given. Each colour was also specified in terms of its C.I.E. co-ordinates, and in terms of Lovibond Tintometer measurements. This dictionary has been adopted by the British Standards Institution as a method of specifying colours. The British Colour Council has altogether produced three definitive dictionaries of standard colours: for silk, wool and interior decoration. The *Dictionary for Interior Decoration* is produced in two volumes: one of clear, intense colours; the other of greyed colours. Three of the 64 hues are shown on each page, each hue in six values, with each colour produced on three surfaces: matt and glossy paint, and velour fabric. The dictionary is supplied with a glossary of names for all the 375 colours, now international standards, with a historical synopsis. This unique and fascinating collection of colours, beautifully presented, has been a source of reference and inspiration to designers all over the world.

All colour-producing industries need to promote their products commercially. The programming of the product follows a pattern that demands colour information at various levels. The initial marketing research concerns consumer colour preferences. Specialised fashion charts are produced periodically by various interested organisations, generally for the promotion of particular fabrics, such as wool, cotton, silk, linen and leather, or any of the man-made fibres, and also paints, building and decorating materials and so on, and these are promoted by manufacturers and fashion houses.

Commercial fashion charts are also available specifically for the use of interior designers and buyers in that field. One is produced by the International Colour Authority (I.C.A.) and published in London, New York, and Amsterdam as a guide to subscribers to the fashion colours of the current period. The I.C.A. charts forecast the fashion colours for textiles, floor and wall coverings and paints used in interior decoration, and presents them in co-ordinated arrangements.

A well-known series of seasonal fashion colours is promoted by the American publishing group, Condé Nast, and organised by *House and Garden* magazine, which specialises in the prediction of fashion colours, and colour co-ordination and presentation. Fashion trends in colour can be predicted by trained observers of the fashion scene, but are seldom directly influenced by individual colour charts or predictions.

The initial marketing research in the promotion of coloured products is concerned with consumer colour preferences. Fashion colour is highly emotive, and in commerce a visual presentation at retail level is essential. The colour systems—Ostwald, Munsell, the Swedish Natural Colour System—the colour dictionaries and fashion colour charts are all relevant here.

The production programme requires control of colour production, technical control, and specification of colour tolerances. For this aspect the C.I.E. (Commission Internationale d'Éclairage) system of colour measurement is needed, backed by full and accurate visual colour charts, notably the I.C.I. colour atlas, and Munsell.

Distribution and merchandising is again concerned with consumer preference. Here colour information must be not only attractive but must also include emotive colour names. For this the British Colour Council's *Dictionaries of Colour*, with

their evocative and historical colour names, are ideal and may help with the names of the products.

Early attempts to systematise colour date effectively from the seventeenth century with the first colour circle, introduced by Newton in his experiments on colour, and the first two-dimensional colour chart by Athanasius Kircher. The first attempt to put Newton's colour circle to practical use was made by a copperplate engraver, Le Blon, of Frankfurt, who in 1730 prepared colour prints employing Newton's seven colours. He then discovered that he could obtain approximately the same results with only three colours, red, yellow and blue. This discovery was applied by Johann Tobias Mayer, a German mathematician, who in 1745, with these three primaries produced a diagrammatic triangle containing the three pure colours in its angles, binary mixtures along the sides, and tertiary mixtures in the interior of the triangle.

J. H. Lambert, an English physician and mathematician, experimented with three pigments yielding the purest colour mixtures, and, correctly mixed, a pure black, and with these colours designed triangles which could be assembled into the first three-dimensional colour body.

The first recorded example of a colour circle illustrated in full colour, was contained in Moses Harris's paper *The Natural System of Colours*, published in 1776. The system which Harris devised features 660 colours presented in sequence on two plates. It was the first attempt at wide-scale colour organisation. Harris put his system to practical use in the production of a book on English insects, which included a further colour circle with a system for the codification of colours valuable to the naturalist.

This was followed in 1810 by the colour sphere of a German painter, Philipp Otto Runge, who arranged white at one pole of his sphere and black at the other, with greys in the axis between them and chromatic colours around the circumference. The sphere, published in Runge's *Farbenkugel* (1810), was as complete a solution of the problem of representing a complete body of colours in three dimensions as could be achieved without a more sophisticated means of colour measurement but since continuous transitions, rather than discrete colour steps, were used, it did not advance the standardisation of colour.

Somewhat later, the French chemist Chevreul produced a theory of colour mixture which included a three-dimensional intersected colour hemisphere, which gained a great deal of public support, notably of the Paris Academy of Sciences, and influenced the teaching of colour in art schools for more than a century, regressive though it later proved to be.

A variation in colour solids was introduced by Charpentier in 1885, in the form of a colour cube, the eight corners of which were coloured red, yellow, blue, orange, green and purple, and white and black respectively, with greyed colours contained in the interior of the cube. In 1905 the psychologist Höfler introduced two further colour bodies, a tetrahedron and an octahedron. These were hypothetical colour bodies and were intended to explain visual and psychological colour relationships, rather than colour organisation or specification, and used the subtractive primaries in the tetrahedron, and yellow-red, green and blue in the octahedron, corresponding to the four primary hue sensations.

Ogden Rood's conception of a double cone (1915) provided a practical

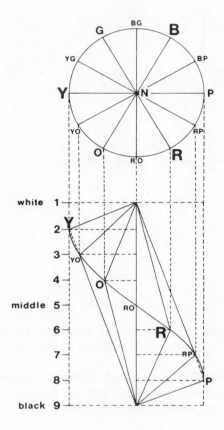

Figure 2.17 Pope's colour solid based on the 12 constant-hue triangles (1929). Above, the colour circle of 100% intensity; below, section through the warm side

variation on Höfler's colour solids and Runge's sphere. Rood, an American scientist and painter, wrote in *Modern Chromatics* (1879): 'In this double cone, then, we are at last able to include all the colours which under any circumstances we are able to perceive.' The statement is endorsed by Ostwald.

However, this was not to be the final statement on colour solids. Munsell was still to produce his asymmetric colour body, its form governed by the varying values of the hues. In 1940, Alfred Hickethier produced his 1 000 colour cube in which the three primary colours, yellow, red and blue, were so arranged on the edges of a cube that each edge was divided into ten graduated steps.

A rational and lucidly explained colour solid—a spiral based on constant hue triangles—was produced by Arthur Pope, who taught in the Fine Arts Department at Harvard University between 1906 and 1949. More recently Harald Küppers has published a logical system based on the three additive light primaries—red, green and violet-blue—and the three subtractive pigment

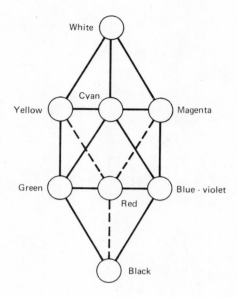

**Figure 2.18 Colour solid based on six light
primaries by Harald Küppers (1976)**

primaries—cyan-blue, magenta-red and yellow—together with white and black.
The colour solid, a rhomboid, can be divided into saturation, chromatic and
achromatic levels.

The organisation of surface colours into colour systems, and their demonstra-
tion by means of colour solids is probably incapable of a single finite solution.
Collectively, the various systems are very useful in the classification of colour.

3
Colorants

Surface colours derive from the action of light on colourless molecular structures—a physical process—or on chemical colorants contained in the surface of the object. Chemical components which selectively reflect coloured light to the observer, called colorants, are either dyes or pigments, depending on whether they have, or do not have, affinity for the materials to which they are applied, but, conventionally, they are classified as dyes or pigments according to their usage. The main use of pigments is to make paints, which provide a new surface, whereas dyes combine with the substrate. The main difference between the two is that pigments are insoluble and most dyes are soluble.

The colorant primaries are magenta, cyan and yellow—the three subtractive or chemical primaries. No colour substances are yet in existence that correspond to the theoretical requirements of optimum subtractive primaries, but in practice pigments and dyes of highly saturated hues in the spectral region of magenta, cyan and yellow, when mixed one with another, will produce bright, clear intermediate hues and, correctly combined, approximations to the three primaries will produce most surface colours. Different colouring processes require varying combinations of colorants: colour photography requires only three subtractive primaries; colour printing on paper only four colours; paints a limited number; and the modern dyeing industry, for technical reasons, mixtures of a very large range of dyes, in order to obtain all the colours demanded for all the different types of fabric now available.

Pigments and dyes are either natural or synthetic. The particular colour of a dye or pigment is caused by the absorption of light of specific wavelengths, and involves the displacement of an electron into a higher orbit. Visible colours result from reaction with certain configurations of atoms called chromaphores. Organic chemistry can synthetically construct a wide variety of chromaphores by determining the arrangement and grouping of basic molecules, the chief source of such synthetic dyes being coal tar or petroleum distillates, from which derive benzene, toluene and anthracene, and other primary dye materials. A tremendous number of dye products are synthesised from distillation of such chemical primaries.

The main division of colorant manufacture is into dyes and pigments—the latter being augmented by lakes and toners. The lakes are coloured dyes respond-

chromophores

ing to chemical treatment to give a product which is insoluble in water and is precipitated on to a base, such as alumina hydrate, which becomes an integral part of the pigment. Toners require no such precipitation process, and these have more powerful tinting properties.

Paint consists of a finely ground organic or inorganic material suspended in a liquid vehicle before application to a surface, where the pigment is embedded in a dried film. It is the chemical and physical properties of both pigment and vehicle which determines the permanence or impermanence of the paint film and contributes to its colour. The vehicle type includes water, gums, oils and polymers. There are two main groupings of pigment sources: organic and inorganic (organic means containing carbon). Today, colorants are alternatively classified as being natural or synthetic (man-made). Natural colorants include those derived from vegetable or animal sources, native earths, calcined natural earths and other variously prepared minerals.

Natural pigments are now mostly superseded by artificially prepared pigments, including a wide range of complex dyestuffs. Several pigments which were at one time popular are now seldom used, because chemists are able to produce better alternatives in terms of permanence, toxicity, or intermiscibility (the ability to mix without chemical or hue deterioration). Madder lake, for instance, traditionally made from the root of the madder plant, and one of the first natural dyestuffs to be synthesised, is now artificially prepared from alizarin, because of superior light-reactive qualities. Similarly, ferric ferrocyanide, popularly known as Prussian blue, has been largely superseded by monastral blue—the organic dyestuff phthalocyanine blue, which is more permanent and more saturated in hue, and king's yellow, originally made from the highly poisonous natural mineral orpiment, has now been superseded by non-toxic synthetics.

Both traditional and synthetic pigments are available, though for private use it is sometimes easier to obtain small quantities of traditional products, as the synthetics are so widely used on a huge industrial scale.

Tempera, oil, gouache, water colour and, recently, the polymer group of acryllic or plastic paints, have all now been commercially developed. Large-scale production of paint began with the Industrial Revolution, which produced a great deal of machinery requiring paint for protection against corrosion. Handcraft techniques gradually gave way to high-speed equipment capable of turning out thousands of

Figure 3.1 Some natural colorants. (a) Saffron (flower): YELLOW. (b) Madder (root): RED. (c) Indigo (leaf): BLUE. (d) Onion (bulb): ORANGE. (e) Black Walnut (fruit): BROWN/BLACK. (f) Cochineal (insect): RED. (g) Malachite (mineral): GREEN/Azurite (mineral): BLUE. (h) Murex (shellfish): PURPLE

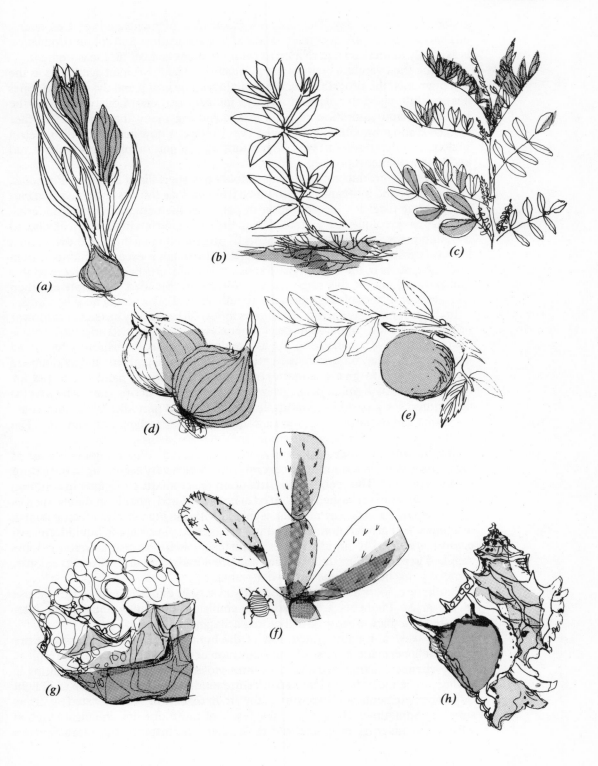

gallons of paint per day. The basic raw materials—pigments and vehicles, resins, oils and solvents—are now manufactured to specification, and colour production is carefully monitored and related to colour systems and colour measurement.

During the twentieth century the production of such brilliant synthetics as the azo pigments, the procian dyes, the phthalocyanine group and the quinacridones has revolutionised the pigment and dye industry and enormously extended the hue range and saturation of colorants, achieving many thousands of surface colours distinguishable to the trained eye. Colorants now include all the spectral regions and the purples at very high saturation. In natural pigments, yellow, red and brown pigments predominate.

Small-scale production of artist's colours is a specialised industry. Pigments, both organic and inorganic, are obtained from various sources and converted into dry powder form for incorporation in paints as the actual colouring material. Some organic colours are extracted from the raw materials in the form of a liquid dye, and made into 'lakes' by a process of precipitation of the liquid dye upon a base or substrate, and pressed, or strained, to remove excess liquid, and then dried. Pigments in the form of dry lumps are washed, crushed and pulverised to a fine powder, and at this stage certain colours are blended. Pigments are then allocated for further processing in the manufacture of oil, water or acryllic paints.

In the preparation of artists' oil colours today, oil (generally linseed or safflower oil) is added to the pigments in exact proportions by weight; extenders to improve the consistency of some colours are also added, and the colours thoroughly mixed in paste form. The colours are then ground in mills until pigment and medium are fully dispersed, to give a smooth consistency. Samples of paint are tested for colour standard, pigment particle size, consistency and drying time. The paint is next stored for a period of maturation and inspected periodically for the separation that can occur because of variations in the oil-absorbency of pigments. The paint is then ready for filling into tubes for the use of artists.

The making of water colours is more complicated. Water colours consist of pigments ground in a solution of several gums, which vary according to the nature of the pigments. The medium consists of an exact mixture of gums in solution, usually gum arabic, crushed and mixed in hot water, and other ingredients, such as glycerine and ox gall. The medium is mixed with the pigments in electric mixing machines, and ground in mills. At this stage, some colours are in liquid form. All colours are dried to an ideal paint consistency, some for use as water colours supplied in pans, others dry-moulded and pressurised into discs as poster colours, some as gouache, and some as powder paints.

Synthetic colours are incorporated with an acryllic emulsion evolved for the use of the artist. Pigments are mixed with emulsion in a milky liquid form, later adjusted to a thick creamy paste before packaging in tubes.

When used in a paint system few of the hundreds of pigments available are completely permanent. Loss of hue saturation or character is mainly the result of photo-chemical action, the effects of ultra-violet light, or oxidation, resulting in fading or change of hue. Heat and moisture tend to accelerate the effects of light on various pigments, and exposure to the air, or oxidation, is accelerated by strong sunlight. Sometimes changes are the result of more obvious chemical reaction when pigments come in contact with each other—for instance, the interaction of a

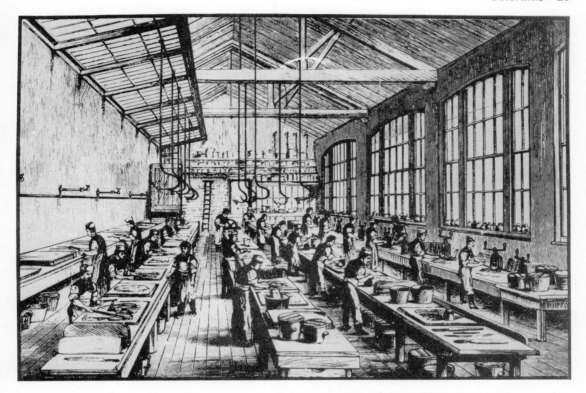

Figure 3.2 Water colour room at Winsor and Newton Ltd in 1889. Colours being ground by hand and spread out on stone slabs for drying

lead with a sulphide pigment, which results in darkening. This kind of chemical interaction occurs only when pigment granules are in actual contact, so that the type of vehicle, which promotes or prevents such contact is another critical permanence factor. In artists' colours, the permanence rating is (1) polymer, (2) oils, and (3) gum media.

The pigment vehicle also affects intermiscibility. The oil absorption rate of pigments affecting the drying qualities of oil-based paints is a variable and critical factor when underpainting is involved. Coloured pigments can be diffused, diluted or given additional 'body' by the use of extenders, certain inert, colourless or white pigments. The proportion in which extenders may be added to pigments varies with the individual pigment, but many of the organic dye pigments are so strongly saturated that a small addition of an extender enhances their colour. A large addition of the extender barium sulphate to white titanium dioxide produces no colour loss, but certain coloured pigments, such as phthalocyanine blue, are extremely sensitive to the amount of extender added. For the decoration of buildings paints are often obtained from the retailer using modern mixing apparatus to obtain a specified colour. These mixing devices contain a few pure colours called stainers plus white and black bases. Paint is automatically measured and mixed to provide a quantity of paint relating to a paint colour preselected

from the paint manufacturer's pattern card. The achievement and maintenance of the accurate control of the required scattering power and absorptivity of the paint components—pigments and media—demands technology of a very high order, which is reflected in the price of the paint.

The range of available colours in paint is very much increased by the use of mixer appliances but, as always in architecture, the correct interpretation of small-scale samples for large-scale application requires visual imagination based on practical experience.

The sheer number of colours produced by manufacturers today may be bewildering to the artist, whose palette is no longer limited by the availability of colours. The artist has to acquire his own discipline in the selection of his palette. The control of colour relationships, both technical and aesthetic, is much easier with a strictly limited palette than with a large palette of colours. The number of colours it is possible to produce from a very few basic pigments is, as the colour systems demonstrate, almost unbelievable. The painter Titian is quoted by his pupil, Giacomo Palma, as saying that a great painter needed only three colours (Boschini, *Le Ricche minere della pittura Veneziano*, 1674) and, in theory at least, all colours can indeed be mixed with three appropriate hues only, though not with maximum intensity of colour.

A palette restricted to, say, six colours, such as lemon cadmium and yellow ochre, rose madder and red ochre, cerulean blue and monastral blue, plus titanium white and ivory black, provides tremendous scope for the artist, is easy to use and keeps colour relationships simple.

The commercial manufacture of artists' colours, however, is a comparatively new development. The workshop or studio tradition, in which the painter purchased pigments and other raw materials from an apothecary and supervised apprentices in making his paints, persisted from the Renaissance as a craft which was an integral part of the painter's skill. The tradition survived among great painters, including Turner, who was an inspired technician, right up to the late nineteenth century, when the French Impressionists were still experimenting with pigments and media. But, as early as the first quarter of the seventeenth century, painting was already beginning to be regarded as an art rather than a trade, and the workshop tradition declined as the number of amateurs grew. Water colours were obtainable from print shops and oil colours from hardware and oil shops.

Historically the use of pigments in painting and staining precedes the use of dyes. Paints and daubs have been used for functional and decorative purposes since time immemorial. Prehistoric paintings such as those found in southern France or northern Spain, are believed to be 20 000 or more years old. The various animal and hunting scenes they depict are painted in red, yellow and black, derived from minerals in the earth, and sometimes applied with the fingers of the painter. The paintings are remarkable for their vitality and realism, as are the rock paintings of certain primitive tribesmen, including those of the Bushmen of the Kalahari, whose beautiful art, mostly extinguished by brutal persecution, was created by artists equipped with miniature brushes and a palette of eight colours. Palaeolithic painters used natural pigments such as chalk, clay, charcoal, naturally occurring red and yellow ochres, and green minerals. These colours were augmented in ancient paintings by other inorganic pigments. Some of the oldest

paintings extant are found in ancient Egyptian temples, palaces and tombs, decorated in seven traditional colours: black, white, blue, yellow, green, cinnabar red and a brownish red.

Black was obtained from carbon. Gypsum was used for white, to which the red extract of the madder root was sometimes added to obtain a pale red. Blues were derived from lapis lazuli, or compounded copper salts dissolved in molten glass in fluxes and applied in a resin medium. Greens were obtained from powdered malachite and copper verdigris. The brownish red, resembling Pompeian red, in chemical composition was a mixture, or precipitate, of iron oxide and clay. Combined with various coloured clays and lime, iron oxide also yielded yellow, to which red was added to give orange, and heat was applied to give brown.

Since all colour in painting was used symbolically, no more colours were required. Permanence was an essential feature to the Egyptian painter. An Egyptian inscription, 5000 years old, reads: 'Colour decoration for temples must be as eternal as the gods themselves.' The ancient Greeks added new colours to the Egyptian palette, and by 2000 B.C. these included colours containing manganese and mercury and, by the sixth century B.C., cinnabar.

The technical exploitation of minerals—copper, iron, silicon dioxide, carbonic acid and mercury, combined with argilaceous earths—provided a rich variety of blues. Black was obtained from manganese and iron salts, and there was available, as in Egypt, a rich variety of reds, violets and greens, and of gold and other metallic foils for yellow, orange and bronze effects.

The Romans brought increased sophistication to the production of pigments. Besides natural white pigments such as chalk, white lead was produced artificially. Ochres were mainly used for yellows, browns and reds, and orpiment was also used for yellows. Extracted madder, red orpiment, and red ochres provided red pigments. Other reds included red lead from the heating of white lead, and cinnabar (mercuric sulphide) extracted from Spanish mines, and both, being extremely poisonous, cost the lives of many slaves labouring in the mines. 'Egyptian blue' was made by heating a mixture of copper, sand, lime and soda to produce a vivid crystalline substance. Ultramarine was made from powdered lapis lazuli, green from malachite deposits in Macedonia and Cyprus, and from verdigris and green earths. Scraps of metal were pulverised to make gold, silver and bronze leaf, applied with resins for enrichment.

Apart from conventional painting, both Greeks and Romans coloured their sculptures, stone or wood. Polychrome in Roman sculpture became very realistic, but in the golden age of classical Greece, colour on sculpture was conventionalised to conform with the prescribed colour symbolism used in their architectural setting. Praxiteles, the most famous of Greek sculptors, is said greatly to have appreciated the sympathetic colouring of his sculpture by the painter Nicias.

The most usual media for pigments used in ancient paintings were gum arabic, gelatine, casein and beeswax. The Egyptians used gouache (opaque water colour), and transparent tempera colours mixed with resin or honey, applied to slow-drying plaster. In Pompeii, frescoes were painted in mineral colours on a wet surface of powdered marble and chalk, often polished with a hot iron. Encaustic processes were also employed with a wax base. The Romans were great technical innovators, and no doubt any number of variations on these techniques were used

in frescoes—a fresco being any wall painting in which colours are applied to wet plaster to form an impervious surface. Fresco secco involves lime plaster saturated with lime water before painting.

All these painting processes filtered through to medieval Europe, and were further developed in the Renaissance. The most revolutionary innovation in painting techniques was the introduction of oil painting, refined in the early fifteenth century by the van Eyck brothers, who mixed their pigments into linseed or nut oil, adding amber or copal resins. The techniques and materials of the Renaissance painters were fully described by such writers as Giorgio Vasari, a great Italian architect, painter and art historian, and Benvenuto Cellini, famous as a sculptor and goldsmith. Modern scientific investigations have confirmed the truth of many of their lively observations.

The practice of painting, though it developed and changed, and in some respects, undoubtedly deteriorated, did not in essentials alter radically until the introduction in the nineteenth century of synthetic pigments, and the commercially scaled production of artists' colours. The twentieth century introduced polymer or plastic paints, which are still being rapidly developed, together with another modern innovation: luminous paints, inks and dyes, containing fluorescent or phosphorescent powders; fluorescent colours are more brilliant under daylight than inert pigments, while phosphorescent colours continue to glow in darkness for a limited period of time. The usual phosphorescent powders are calcium sulphide and zinc sulphide, while fluorescent powders contain either zinc sulphide or zinc orthosilicate. Fluorescent dyes include rhodamine and eosin. The technical and aesthetic exploitation of these innovations in the field of the applied arts are changing decorative concepts, particularly in their architectural context.

Parallel to technical advances in the second half of the twentieth century, and as an increasing paradox of our time, all kinds of vanishing arts and crafts are being revived and preserved in the field of painting and the applied arts. This social phenomenon is clearly manifest in the area of dyes and dyeing processes.

Dyeing fabrics involves a series of processes, the two traditional ones being mordanting and dyeing. A dye is a soluble colouring matter that combines with a substrate; a mordant, from the Latin *mordere* to bite, is any substance applied to the fabric for the purpose of fixing the colour, and must be capable of combining chemically with the colouring matter. Properly used, the mordant enriched the colour and was generally essential if the dye was to 'take' and remain permanent, but since about 1900 the use of mordants for these purposes has been discontinued in industry and today is confined to loose wool and slubbing for woollen and worsted manufacture.

Dyeing is a prehistoric craft, though the prehistoric dyes were often only fugitive stains from plant substances. It is certainly one of the oldest of technical arts. Dyed fabrics have been found in the most ancient Egyptian graves—one of the earliest known yellow dyes from the Egyptian safflower (*Carthamus tinctorius*) was used to dye the bindings of mummies as early as 2 500 B.C. in the twelfth dynasty. References were made in the Old Testament (*Genesis, Exodus* and *Esther*), and three dyes, purple (from the Tyrian dyeworks), kermes, a scarlet dye, and madder, a red dye, are specifically mentioned. The dyes used in antiquity were probably exclusively organic, deriving from either plants or animals. Mineral substances were used later.

The history of ancient dyes and dyeing processes owes much to the historian Herodotus, who wrote around 450 B.C., and to two first-century writers, the Greek physician Dioscorides, whose work survives in the Latin translation *De Materia Medica*, and the Roman naturalist, Pliny the Elder. From these historians a wealth of information exists on the ancient dyeing crafts and their sources of materials. All three historians describe the use of the indigo plant. The other principal dye plants mentioned are madder (*Rubia tinctorum*) for an enduring red, anchusa, a red dye obtained from the root of the bugloss (alkanet) and litmus (orchil) for a dye varying from a deep rose-red to purple and blue, according to the process used. There were several yellow dyes, including saffron (*Crocus sativus*), and the saffron (genista) used in Rome, weld (*Reseda luteola*), woad (*Lutum*), and the root of the lotus tree which also yielded a yellow dye. Blues too were plentiful, from the leaves of the indigo plant, from woad, and violet-blue from the pomegranate (*Punica granatum*). Oak bark and walnut shells contributed black and brown, and the bilberry (*Vaccinium*) was used for dyeing slaves' dresses a dull dark red. Names of colours were often allusive, as they are today, especially in commercial use, and such terms as the blue of the cloudless sky, the green of myrtle, oak or almond, the grey of the crane, hyacinth blue, or amethyst were used poetically. Dyeing from animal sources was widespread in the Mediterranean region, where the shellfish *Purpura lapillus*, and several species of the genus *Murex* were marketed and processed in vast quantities by the Phoenicians, who were famed for their dyeing, and were the original extractors of the purple dye which this type of shellfish yielded; the Phoenicians, master shipbuilders and seamen, established trading centres and dyeworks wherever the shellfish were found in abundance. The dye was extracted from the mucous gland adjacent to the respiratory cavity, and it was so expensive that it became the prerogative of the wealthy and powerful. The Phoenicians succeeded in hiding the secret of their very lucrative trade for hundreds of years. In antiquity purple was the symbol of aristocracy. In Rome, senators wore the broad purple stripe around the opening of the tunic, knights a narrower stripe, and state officials a toga edged with purple. Only the emperor himself was privileged to wear a purple robe.

Pliny described the complicated preparation of the various shellfish which yielded red, blue and violet as well as the famous imperial purple. The woollen fabric was treated first with the mordants soapwort (*Sapnaria officinalis*), ox-gall or alum. Lighter colours were obtained by diluting the dyebath with water or urine, as well as by adding other red colouring matters such as orchil and kermes, giving a range of colours from violet to red. Other animal dyes included a rich red dye derived from the scale insect, kermes, used for dyeing wool, silk and leather, with alum or urine as mordants.

Evidence shows that commerce between China and the Mediterranean region existed before the era of recorded history. Dyeing was a widespread industry in Egypt, India and Mesopotamia by 3 000 B.C., and by then wool was being dyed blue, red and green in Babylonia. The use of the vat dye, Tyrian purple, survived the fall of the Roman Empire, and was found to be current in South America at the time of the Spanish invasion. A later substitute was made from infusions of lichen. Woad, the blue dye of the Ancient Britons, was probably imported from Palestine, where it grew wild.

Vat and mordant processes were familiar in ancient dyeing processes, but resist

processes, such as batik, came from the East, with patterns produced by local protection of fabrics by means of wax. Baghdad, Damascus, Cairo and Byzantium were all closely connected with the trade of dyestuffs and dyed fabrics. Venice became the principal city for imports from the East because of its strategic position for both sea and overland trade. Marco Polo, the famous Venetian merchant explorer, brought back from China, amongst many wonders, information on indigo, on sapan, and red dyewood.

Trade routes over the Alps spread the use of dyes and mordants to the rest of Europe: Geneva, Genoa, Florence, Basle, Frankfurt, Antwerp and London grew into trade centres where medieval guilds were developed for the promotion and protection of the dyeing industry, associated with trade in wool, linen, silks and cotton, and with the weaving industry.

The colours depicted in medieval manuscripts illustrate not only the range and brilliance of available pigments and their masterly use by the artists, but testify to the skill of contemporary dyers and weavers in the production of tapestries, banners, hangings, costumes and embroideries for Chaucer's England, and for the courtiers attending the Field of the Cloth of Gold, and other magnificent state functions.

After Vasco da Gama's discovery of the sea route to the Orient, and Columbus's voyage of discovery to the American continent, overland trading was reduced and intercontinental trade by sea was established. The Spanish invasion of Aztec territory in Mexico revealed great new sources of dyestuffs and dyeing processes. Two documents written in the sixteenth century, when Aztec names and usages were still in memory, indicate some of the wealth of natural resources and the skill and ingenuity of the ancient empire. In 1552, Juan Badianus compiled a herbal known as the *Badianus Manuscript*, listing native plants and their medical usages, with 184 aquarelles beautifully illustrating the text, using orange, yellow, ochre, gamboge, magenta, scarlet, lavender, black and white pigments of very fine quality. Badianus was himself an Aztec Indian and his text was translated into Latin by another Indian scholar, Martin de la Cruz. The second document was by the court physician of Philip II of Spain, sent to Mexico by the king to record the plant, animal and mineral resources of his newly acquired empire. The much larger herbal that this Spanish naturalist compiled described some 1 200 native plants and their medical properties, listing local names which modern ethnobotanists are gradually identifying. The two most famous of the imported Mexican dyes were logwood and cochineal, which replaced the use of kermes because they were more powerful. It is clear from surviving fragments of dyed material that the ancient Mexican dyeing industry produced dyes of quality outstanding in their range of colour and durability.

A tradition survives in North America, from the wives of settlers who crossed the Atlantic in the seventeenth century in the *Mayflower* and later sailing vessels and who took with them little bags of seeds for the cultivation of dye herbs. They also cultivated native vegetation—barks, leaves and roots—to produce several home dyes. Since these early dyes were often fixed with primitive mordants such as rusty nails or urine, the colours that resulted were usually the dull ones often associated with their religious convictions, but such difficulties were gradually overcome and here, as in other parts of the world where home dyeing persists,

beautiful, subtle colours were achieved. The Plymouth Antiquarian Society has investigated the resources the seventeenth-century settlers possessed for dyeing homespun yarn and cloth. Many early mordants were household staples such as salt, vinegar, soda and lye made from wood ashes or urine. Alum, blue vitriol, and iron, brass and tin were also used. Wood-chips, bark, roots, leaves, nuts and flowers were used as dyes. The most successful dyes were in the yellow range of hues. Blues and reds had to be imported, mostly madder and indigo. Green was made by top-dyeing indigo or logwood with a native yellow dye.

Although the dyeing industry is now a sophisticated part of huge chemical industries with an enormous output and world-wide distribution, a cottage industry still survives in many parts of the world, partly as an economic necessity in poorer areas and partly, in sophisticated societies, in reaction to commercial technology on a vast scale, and the growing need for leisure activities. In such circumstances commercial dyes may be bought and used on homespun yarns and fabrics, or the dyes themselves may be home manufactured; so a flourishing home industry is becoming established and old traditions researched and re-introduced. In the British Isles, for instance, local dyeing is successfully practised in western Ireland, the Scottish Highlands, and in various parts of England. Native dyeing crafts all over the world have been supplemented, enriched, supplanted or destroyed, according to various opinions, by modern synthetic dyes. Those supporting the use of natural dyes claim that these, when they fade with age, or exposure to light or water, maintain their natural colour relationships, and may even be enhanced. This is certainly true of indigo, and is well illustrated by the pre-synthetic colours of older Oriental rugs and carpets.

As a result of technological advances, which included improved machinery, detergents and bleaches, textile industries expanded rapidly in the nineteenth century, but until the second half only natural dyestuffs were available to meet a huge increase in demand, and indigo, logwood, cochineal and other natural colorants were still imported in large quantities by the manufacturing countries.

Yet already in the eighteenth century a contribution to the future production of synthetic dyestuffs had been made by Woulfe, who in 1771, by treating indigo with nitric acid, had obtained a substance that dyed both wool and silk yellow. In 1779 Welter nitrated the silk to obtain the same colour, and both had prepared picric acid, which was applied to dyeing by Guinon in 1845. In the eighteenth century, too, Karl Scheele not only discovered chlorine, which revolutionised the bleaching of fabrics, but in 1776 prepared purpuric acid, from which in 1818 Proust obtained the ammonium derivative. This discovery was followed by that of Runge, who in 1834 oxidised crude phenol to produce rosolic acid, and by that of Laurent, who in 1885 succeeded in preparing picric acid from tar.

The enormous potential significance to the chemical industry of these and other early discoveries by individual enthusiasts, using, for the most part, empirical methods along the lines of the alchemists, passed practically unnoticed as a source of dyestuffs, because of the almost universal acceptance of the belief that colorants were natural products derived from various plants, animals and minerals. According to Franco Brunelli (*The Art of Dyeing*, 1968), there existed, in the first quarter of the nineteenth century, an *a priori* belief that only living

organisms were capable of producing organic substances. The synthesis of dye-stuffs was not yet conceptualised, and, in any case, the dye chemists of that period possessed no theoretical lead through an understanding of the structure of the organic molecule. The foundations of the molecular architecture of organic compounds, using the structure formula to represent the number of atoms present in the molecules of a given compound, was laid by Friedrich Wöhler and the methods of analytical chemistry were advanced by Justus von Liebig and other nineteenth-century chemists.

The actual leap into the commercial production of synthetic dyestuffs was promoted by an eighteen-year-old English student of chemistry, Henry Perkin, who accidentally discovered the first artificial dyestuff when attempting in 1856 the synthesis of quinine by oxydising aniline with a mixture of sulphuric acid and potassium bichromate. The substance Perkin obtained, when treated with hot water, produced a solution which, to his surprise and delight, dyed silk a splendid purple. Quick to exploit his discovery, Perkin, acting on the advice of dyers at Pullar's Dyeworks in Perth, patented his dye, which he called mauve, and subsequently in 1857 set up his own factory to produce synthetic dyestuffs. The very talented and astute young chemist not only made himself a fortune, but continued his chemical researches successfully, and found time to travel round giving a technical service to manufacturers, thus establishing another precedent.

Once the success of Perkin's mauve was established, other chemists reacted to the potential of coal tar as a source of synthetic dyestuffs. Because he was the first to recognise the importance of the extraction and analysis of fossil coal-tar products, Wilhelm von Hofmann, Perkin's mentor at the Royal College of Chemistry in London, is acknowledged as the father of the chemistry of dyestuffs. Following the production from aniline of a brilliant dyestuff called fuchsine by the French chemist Verguin, Hofmann, by 1862, had succeeded in obtaining violet, blue and green derivatives from the salt of a colourless base which he called rosaniline. From then on the proliferating discoveries of pioneering chemists in England, France, Switzerland and Germany accelerated the international estab-lishment of manufacturing centres. Germany was to dominate the production of colorants for many years.

The incredibly rapid evolution of the chemical industry in the second half of the nineteenth century was paralleled by advances in the field of pure science. Inspired by the work of two great teachers and innovators in analytical chemistry, Hofmann and Kekulé, talented students were attracted to German universities, where a scientific education in chemistry could be obtained based on the theory of the structural formula, which Kekulé, in particular, had done so much to promote in his classic analysis of the composition of benzene and the hexagonal representa-tion of its molecular structure.

In the twentieth century, technological achievement in the chemical production of new and more dangerous explosives was eventually switched to the production of new dyes and dyeing techniques.

Many more types of dyes are used on textiles than on any other materials, but leather, paper, anodised aluminium, and many foods and drinks are dyed. In 1856 only a few hundred or so natural dyes were available. By the middle of the twentieth century, several thousand chemically distinct dyes had become avail-

able and the use of natural dyes was very much diminished and locally confined. Intensive investigations by dyestuffs chemists have now synthesised over 3 000 000 dyes. Of these, over 4 000 dyes and pigments are marketed in quantity—not because so many different colours are required, but because certain fibres have no affinity for particular dyes. One dye will dye only a few fibres for reasons connected with standards of light, washing or perspirant fastness, and cost. If such technical factors did not exist, 95 per cent of all known colours could still be matched by the appropriate mixture of just three dyes—a red, a yellow, and a blue, and the remaining 5 per cent would not need more than another five.

Quality control in the large-scale production of dyes and pigments has been advanced by the introduction of modern colorimetric techniques, since conformity to a colour requirement can now be determined with greatly increased accuracy by spectroscopic processes.

The use of colour measurement techniques in the production of dyes and pigments is a reminder of the constant interaction between chemical substances and physical processes, of light and matter, that together constitute our visual world.

(a) Chain compound

(b) Ring compound

(c) Benzene molecule

Figure 3.3 Modern colours produced synthetically. (a) Chain compounds: six atoms of carbon may combine with 14 atoms of hydrogen in 'chain' formation; normal hexane, C_6H_{14}, one of the components of gasoline, is represented here. (b) and (c) Ring compounds: six atoms of carbon may, however, combine with only six atoms of hydrogen in 'ring' formation, e.g. as in benzene, C_6H_6, shown here; this structural representation was first proposed by Kekulé, but is usually abbreviated to the form shown in (c)

4
Colour and Light

The function of a paint, printing ink, dye or other colorant is to absorb or subtract some parts of the spectrum, and to transmit or reflect other parts. The colour is determined by which parts of the visible spectrum are reflected when absorption takes place. The process is a subtractive one. The subtractive primaries known as cyan, magenta and yellow, subtract respectively the three primary regions of the spectrum known as red, green and blue, which are the additive light primaries. Additive and subtractive primaries are complementary aspects of the visible manifestation of the electromagnetic spectrum.

A comprehensive understanding of colour requires some knowledge of the nature and constitution of the visible spectrum, and of the harmony and inter-action between the principles of additive and subtractive colour mixture. A study of light is the essential factor. All colour perception depends on light, which can be measured and quantified numerically. Colorimetry—the measurement of colour expressed numerically— comes under the general heading of *spectroscopy*, the study of the emission and absorption of light and other radiations, and the science connected with the sources, measurement, analyses and uses of spectra. Two kinds of spectra can be distinguished: emission spectra, which show bright lines or bands of colour on a dark ground, and absorption spectra, on which dark absorption lines or bands are seen in an otherwise continuous spectrum.

Spectroscopy is used in chemistry and physics as a tool for studying the structures of atoms and molecules. It provides a precise analytical method for finding the constituents in materials having unknown chemical composition. Sophisticated spectroscopic methods can provide analysis of the composition of small amounts of material with an accuracy and speed that cannot be achieved by chemical processes.

Spectroscopic data on the properties of atoms, ions and molecules is used in the design of lasers, with their wide scientific, industrial and military applications. The use of the laser beam and the computer have revolutionised the science of spectroscopy, which is now a key factor in research and application in ever-increasing fields of scientific enquiry, both macroscopic and microscopic.

In astronomy and the exploration of outer space, the chemical constitution of stars and other bodies in space can be analysed by the spectroscopic study of

atomic and molecular structures, providing data which opens up vistas of scientific speculation and hypotheses undreamed of before the introduction of the more advanced spectroscopic techniques. The micrographic study of the physical and chemical structure of matter on earth by spectroscopic methods is similarly expanding research in chemistry and biochemistry, for medical, ecological and industrial application.

The measurement of colour is proving to be one of the most effective tools ever devised for the compilation of data providing a clearer understanding of man and his environment, far and near.

The production and analysis of a spectrum usually requires four components: a light source; a disperser to differentiate wavelengths; a detector to sense the presence of light where it appears after the dispersion; and a recorder to make a spectrogram—a temporary or permanent copy of the selected spectrum.

In the evolution of the science of spectroscopy, many instruments have been invented and constructed. These include:

a *spectrometer*, which receives light, separates it into its component wavelengths, and determines the characteristic spectrum;

a *spectrograph*, which additionally records the spectrum;

a *spectroscope*, which is a combination of disperser and associated optics for the visual observation of spectra;

a *monochromator*, which uses a disperser and associated optical components to receive light and selectively transmit a small range of wavelengths;

a *spectrogram*, which records the results when the detection of spectra is done photographically;

a *photo-electric colorimeter*, which is a tri-stimulus instrument in which a photo-electric cell and colour filters give measurements corresponding to the sensitivities of the three receptor processes in the eye;

a *photo-electric radiometer*, which is capable of measuring the spectral energy distribution of any light beam; and

a *spectro-photometer*, which is a spectrometer using monochromatic light or a narrow band of radiation to measure the percentages of light transmitted or reflected by a colour filter or coloured surface.

Spectro-photometry is fundamental to colour standardisation, and modern colorimetry is based on spectro-photometry, interpreted according to the standardised properties of the light source and the observer, and it depends on the experimental fact that colours can be matched by the additive mixture of red, green and blue stimuli contained in the visible spectrum. The colour-matching characteristics of a standard observer have been defined, and a reference framework for the specification of colours has been established by the C.I.E. (Commission Internationale d'Éclairage), based on the tri-chromatic system of colour measurement. With the recognition of the C.I.E. standards, the whole of colorimetry can in principle be carried through with purely physical measurements by the photo-electric recording spectro-photometer.

In the past, glass prisms were first used to break up or disperse light into component colours. Now, diffraction gratings, composed of closely spaced trans-

mitting slits on a flat surface, are more frequently used.

There are many applications of colour measurements in which the assessment of colour requires no visual comparison and the mathematical specification is appropriate. This applies, for example, to the spectro-photometer of tri-stimulus colorimeters already mentioned. With visual instruments, a colour can be measured by matching the colour by a mixture of the primaries red, green and blue. Alternatively, a six-primaries instrument, acting on the same principle but incorporating six filters—red, orange, yellow-green, green, blue-green and blue—has been used for industrial purposes.

Colorimeters acting on the subtractive principle operate by the absorption or subtraction of light from an initially white beam of light. They provide a visual colour match more appropriate to certain colour measurement requirements. The most frequently used of subtractive colorimeters is the Lovibond Tintometer range of instruments, in which the subtractive primaries are provided by glass slides in sets of magenta, yellow and cyan. These slides are produced in a graduated series of standardised glass filters varying from extremely pale, to those of maximum saturation. Where required, the instrument is modified to give a reading which can be calibrated to a C.I.E. specification. In this way additive and subtractive methods of colour measurement can be linked in the standard system.

Lovibond Tintometers were first marketed in the nineteenth century and, before 1926, most colour comparisons and measurements were made by visual methods.

The theory of colour has attracted the minds of great scientific investigators since the time of the ancient Greeks. In general Aristotle's ideas of colour phenomena dominated the Renaissance revival of classical scientific investigation, with the exception of that extraordinary enquirer Leonardo da Vinci, who adopted six colour sensations: white, black, red, yellow, green and blue, along the lines of those developed by the nineteenth-century scientist, Ewald Hering. Galileo was the first to attempt to measure the velocity of light.

The seventeenth century produced the first scientific studies of colour in relation to light, notably by the French philosopher Descartes, who hypothesised that light was essentially a pressure transmitted through a dense mass of invisible particles, and by the Englishman Robert Boyle, perhaps the first to differentiate between colour as physical energy and colour as sensation.

In the development of such concepts, Sir Isaac Newton brought precision and organisation and a phenomenal scientific imagination into the field of the investigation of colour theory. Based on his observation that a beam of white light passing through a prism was converted into a continuous band of coloured lights, and that these coloured lights might be reconstituted by the reverse process, he proved that all colours, in the physical sense, are contained in white light. He assumed that light was generated by the emission of particles and wrote: 'Light is neither aether nor its vibrating motion, but something of a different kind propagated from lucid bodies. . . . it is to be supposed that light and aether mutually act upon one another.' This indicates that he was aware of both corpuscular and wave theory of light. He also noted the visual resemblance of the two ends of the spectral band—red and violet—and that their mixture would produce a purple not

Figure 4.1 Freehand sketch by Newton of one of his experiments on colour and light

contained in the visible spectrum, and on this observation he based his colour circle—the first ever devised. Although Newton's insights into the nature of colour were so advanced and so far-reaching (and only a selection has been mentioned here), they were only a part of his enormous scientific output, and they proved so highly controversial that he was at times driven to regret their publication.

Based on these seventeenth-century discoveries a mass of data and hypotheses has been accumulated by a long and impressive list of colour scientists. One of the most remarkable minds of all time, that of Sir Thomas Young, was attracted to the study of colour and colour perception. In publishing his *Tri-chromatic Theory of Colour Vision* in 1801, he became the founder of physiological optics. His undulatory theory of light established the principle of interference, and this work, together with that of the French scientist A. J. Fresnel, contributed to the wave theory of light phenomena. As with Newton, Young's scientific investigations into the nature of colour was only a fraction of his outstanding intellectual achievements.

Young's *Tri-chromatic Theory of Colour Vision* was recognised as a work of genius by the eminent German mathematician, physicist and biologist Hermann von Helmholtz, who greatly developed Young's theory and worked out its application to colour-defective vision. Helmholtz, besides making great new strides in optics and ophthalmology, was also a pioneer in the field of the conservation of energy, electro-dynamics, and the abstract principles of dynamics. One of the intellectual giants of the nineteenth century, Helmholtz, too, was incredibly versatile in his activities, and held a chair of physiology at Bonn and at Heidelberg, and of physics at Berlin.

Another contributor to the evolution of the theory of colour vision was Gustav Fechner, a German scientist who established in his *Elements of Psycho-physics*

Fechner's law: 'Sensitivity is Proportional to the Stimulation' and 'If a given stimulus is allowed continually to decrease, the sensation does not diminish in the same way, but completely vanishes at a certain finite value of the stimulus, known as the Threshold.' Were it not for this threshold of perception, any sort of minute stimulus would keep the senses active, and we should never be able to rest.

The development of the theory of colour vision proceeded, and still proceeds side by side with that of the physics of colour. Ewald Hering, the great German physiologist, is perhaps best known for his work on physiological optics, and particularly for his theory of six primary colour sensations: red, yellow, green, blue, white, and black, the same that, four centuries earlier, Leonardo had discovered. Hering pointed out that all colour derivatives the eye can experience may be produced by graded mixtures of pure colours with black and white, and that these can be comprehensively arranged in a triangle containing white, black and pure colours in its angles. He also introduced the concept of psycho-physical perception.

Hering's work was taken a stage further by the work of the German scientist Wilhelm Ostwald, who, in producing his authoritative colour system, used his understanding of existing colour science and his competence as a successful chemist and physicist. Ostwald also developed the unexplored field of colour harmony, based on mathematical calculation and notation monitored by his own considerable aesthetic sensibility.

Contemporary with Ostwald, Munsell in America was designing his own colour system, which was destined to be linked so widely with colour measurement. These two prepared the way for the systematic documentation of surface colours providing a visual key, or check, to colour measurement when this is required, apart from their use as organised arrangements of colour for non-scientific purposes. The scientific co-ordination of the Munsell Colour Atlas has been a major contribution to colour science by two eminent colour scientists in U.S.A., Deane Judd and Dorothy Nickerson.

But in the nineteenth century, the greatest advance in the *physics* of colour and light, were made by the Scottish physicist, James Clerk Maxwell, whose work on the electromagnetic wave spectrum was to have such dramatic consequences. Maxwell studied the known phenomena of electricity and magnetism and their interaction, and formed them into mathematical equations. His principal work was concerned with the mathematical approach to the problems of electro-magnetism, and with the electromagnetic theory of light. Maxwell's practical researches into colour and colour mixtures produced the Maxwell discs, and he designed the colour box for obtaining specified combinations of spectral light—a fore-runner of the modern colorimeter.

Because of Maxwell's discoveries, light became recognised as an electromagnetic phenomenon, and on his work, and on the earlier discoveries on the properties of electricity by the English scientist Michael Faraday, a whole new field of development based on the concept of matter as an electrical phenomenon has been expanded by Planck, Bohr, Kelvin and Einstein. This formidable body of experience and data has been exploited for the scientific development of colorimetry in the twentieth century by the famous colour scientists of today, including Wright, Evans, Judd, Nickerson and others, to whom so much is due for

the acceptance of colour measurement as an essential tool for scientific research and application.

Yet of all the intellectual giants who have shaped our awareness of the nature of colour, Newton is still the outstanding genius. With the limited scientific data at his command, it is remarkable that his own imaginative insight, so far ahead of his time, should have considered the change and interchange of known forms of energy, conceptualised in one of his musings: 'And among such various and such strange transmutations, why may not Nature change bodies into light, and light into bodies?' How far from Einstein's classical equation is this?

Light travels at an estimated 186 000 miles (299 780 km) per second—a speed hardly to be comprehended in human terms. The velocity is regarded as one of nature's constants, represented by c, a common symbol in physics. It was Albert Einstein who, in answer to the question: 'What relationship, if any, exists between mass (m) and the energy (E) associated with that matter?', arrived at the historic conclusion: 'The amount of energy is equal to the amount of mass, times the square of the velocity of light', expressed as the simple equation $E = mc^2$. Einstein's work enormously stimulated research in the field of nuclear physics reflected in certain spectacular advances in colour science.

The latest advance in colour physics is the discovery of the laser, based on original research by Niels Bohr, the Danish physicist, who in 1913 discovered that electrons could be raised to a higher energy level by exposure to outside sources of energy. He found, however, that the energy source would only suffice if it equalled the energy difference between the 'ground state' of the electron when circling closely round the nucleus, and its 'excited state', when circling at a much greater circumference.

The aesthetic and emotional potential of this property of the laser beam has also been only fractionally explored. Together, the laser beam and the hologram could, in yet unpredictable ways, transform the human environment.

Light is a form of energy radiated as a transverse harmonic vibration in the form of an extremely large number of elementary units of energy known as quanta. The vibrations are electromagnetic disturbances of these units.

In colorimetry, light is regarded as various amounts of energy being radiated per second, at various frequencies, within the visible spectrum, and propagated as transverse vibrations at a very high velocity. The different regions of the spectrum may be identified either by the appropriate frequency or by the corresponding wavelength. The radiations are transmitted at a velocity of about 300 000 km per second. Wavelengths are now usually measured in nanometres (1 nm $= 10^{-9}$ metres).

The total gamut of electromagnetic radiations extends from the shortest wavelength gamma rays to the longest radio waves, and only a small range of these radiations is capable of stimulating the human eye. This very narrow band in the electromagnetic spectrum, covering a wavelength range of about 380 to 750 nm, is regarded as the visible spectrum, since this comprises those radiations to which the human eye is sensitive. The measurement of light relates to radiations that stimulate the eye, and for this reason, ultra-violet and infra-red regions of the

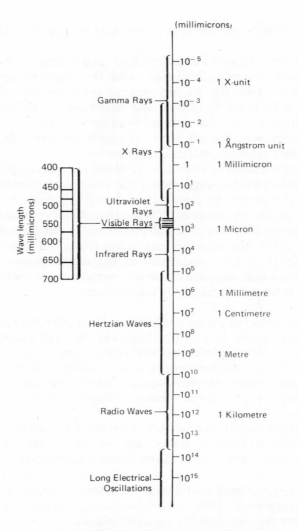

Figure 4.2 The electromagnetic scale

electromagnetic spectrum, invisible to the eye, lie just outside the visible spectrum.

The band of radiations in the 380 to 750 nm range of wavelengths is therefore supremely important to the human race, since it is the source of all visual perception.

The limits to this waveband are not sharply defined. At the long-wave, red end of the spectrum, the limit is set by the gradual loss of sensitivity of the light-sensitive photo-chemical substances in the retina of the eye as the wavelength is increased. At the short-wave, violet, end of the spectrum, the limit is set by absorption in the crystalline lens in the eye, which cuts down, and eventually stops altogether, the ultra-violet radiation, which might otherwise reach and harm the retina.

Although light is radiated in the form of a wave motion, the actual energy is emitted in the form of elementary units of energy known as photons or light quanta, the energy in a photon being proportional to the frequency of the radiation. Considerable conceptual difficulties arise in understanding how light can possess both wave and particle properties, but the particle aspects are particularly important in connection with the way light sources emit light, and in understanding how light interacts with matter.

The simplest way of making a body emit light is to heat it. As the temperature rises, the impacts between the atoms and molecules in the substance become of sufficient intensity to cause the emission of electromagnetic radiation from its surfaces. These radiations increase in strength and spread to shorter and shorter wavelengths the hotter the body becomes.

When an electric current is passed through a metal wire, the metal becomes slightly warm, and at that stage is emitting infra-red rays but no light waves, and the wire remains dark, but as the electric current increases and the metal gets warmer, it begins to glow a dull red, because it is emitting light from the long-wave, or red, end of the spectrum. With increasing current the wire becomes hotter and quite a bright red, as in an electric fire. The wire is now radiating light of all wavelengths through the visible spectrum, but most of the energy is still concentrated at the red end. With even higher temperatures, the wire becomes not only very much brighter, but also very much whiter, as more of the blue end of the spectrum is included, as in the electric tungsten filament lamp.

The whiteness and brightness of a heated body is an indication of its temperature. A candle, for example, emits a yellow light because it is not very hot, whereas the sun is very much whiter and brighter because of its tremendous heat.

Colour temperatures of light sources are measured in degrees Kelvin. The Kelvin scale starts at absolute zero, which is thought to be minus 273°, the lowest possible temperature in the universe, where absolute cold and darkness prevail. Degrees Kelvin are therefore given in degrees centigrade plus 273°. At about 800°K, a radiator would glow a dark red; at about 1 200° it would be orange; at 1 300°, yellow, and then it would begin to turn blue. Candle-light would be around 2 000°, and direct sunlight as high as 5 000°K.

A quite different method of producing light is to pass an electric current through a gas. Under the right conditions, the atoms of the gas are excited by the electric discharge, and produce an emission of light of frequencies or wavelengths which are characteristic of the gases being excited. The yellow sodium lamps now so widely used for street lighting emit light which is confined almost entirely to a very narrow region in the yellow part of the spectrum. This corresponds to a particular resonant frequency in the sodium vapour atom. Similarly, in the mercury discharge lamp, the radiations occur at isolated lines in the spectrum, principally in the yellow, green, blue and violet areas. With high-pressure sodium or mercury lamps the radiation spreads out over broader areas of the spectrum.

The fluorescent lamp, now much used in public lighting and in factories, uses another method of generating light. This type is a mercury discharge lamp with the inner glass walls lined with a mixture of phosphors which are excited under the strong ultra-violet radiation that forms part of the mercury spectrum. This is luminescent lighting, in which the atoms of the luminescent material are excited in

various ways to emit light. In the fluorescent lamp the excitation is by the absorption of ultra-violet light; in the television receiver, the phosphors in the cathode-ray tube are excited by the bombardment of electrons. In the firefly and glow-worm, the light emission is generated by a chemical action known as chemi-luminescence.

Historically, the development of alternative sources of illumination to daylight has extended over thousands of years. M. B. Halstead, in a paper entitled 'Colour Rendering, Past, Present and Future' (1977), observed:

> For many centuries the only artificial illuminants were those based on burning vegetable matter and, later on vegetable and animal oils and waxes. Thus some form of incandescence was the type of spectral power distribution alternative to that of natural daylight, and these sources all produced similar distortions in colour rendering. In the middle of the eighteenth century coal gas was discovered, but it was 50 years before it came into general use for lighting purposes, and another century passed before the Welsbach mantle was invented.
>
> In 1802 Davy produced the electric arc between carbon rods, but it was not until 1878–9, that the first carbon-filament lamps were invented by Swan and Edison, working independently in G.B. and the U.S.A. These new light sources were basically a form of incandescence, but their colour temperatures were much higher than those of the earlier oil and wax lamps and candles.

At the end of the nineteenth century Paterson made 'an extensive examination of a comprehensive range of colouring matters, both artificial and natural, under the nine different types of illuminant' then available. Halstead continues:

> This work is very interesting as it must be one of the first systematic subjective experiments on colour rendering to be carried out. The sources were classified into three groups according to their similarity in effect to daylight. The 'good' group contained magnesium light and the electric arc, Welsbach lights were in the 'fair' group, and the 'poor' group consisted of gas, oil, and electric lamps and candles. All the 'poor' and 'fair' illuminants had colour temperatures lower than 3 000°K, and so were deficient in blue, and had an excess of orange and red emission. Paterson gave very detailed results of the colour distortions which he obtained, but in general these are consistent with what one would expect from incandescent sources with low colour temperatures. The 'good' lamps, having correlated colour temperatures in the range of 3 800–5 500°K, were somewhat deficient in blue emission compared with daylight, but on the whole gave acceptable results. However, as Paterson wrote at the end of the nineteenth century, 'The spectroscopic analysis of the lights emitted by the various illuminants no doubt reveals the excess or deficiency of certain colour rays in their spectra, but it would be very uncertain, and in many cases impossible, to foretell how any particular colour would appear when viewed under a given illuminant, solely from the knowledge of the spectrum given by the illuminant.' This statement made 80 years ago, is still true today, especially now that lamps with unusual spectral power distribution are becoming readily available.

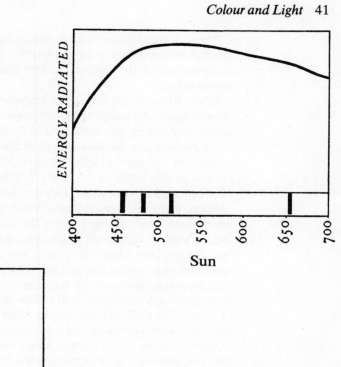

Sun

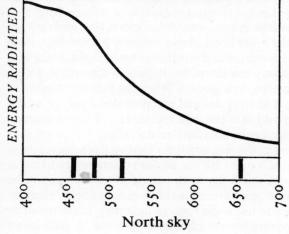

North sky

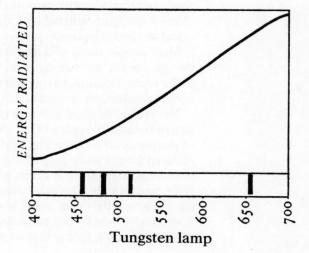

Tungsten lamp

**Figure 4.3 Typical results for three sources of light:
sun/north sky/tungsten lamp**

There are many ways of generating light, and the surface colours in the world around us are affected by the kind of light illuminating them and the spectral composition of the light from the illuminant, which can be revealed by the spectroscope.

When light travels through a transparent medium such as glass, its velocity is slowed down. Although all electromagnetic waves travel at the same velocity in a vacuum or in free space, their velocity through transparent materials depends to some extent upon the wavelength of the light. The ratio of the velocity of light in a vacuum to the velocity in glass determines the refractive index of the glass—usually between 1.5 and 1.7. When the light is refracted through the kind of prism used in a spectroscope, the change in the direction of light caused by its slowing up as it passes through the glass of the prism varies slightly with wavelength, the red light being deviated least and the blue light most. With ordinary white light such as sunlight, a typical continuous spectrum is revealed, but the spectroscope can detect the very great differences between such a spectrum or a similar one produced by a tungsten lamp or a gas discharge lamp. The tungsten lamp reveals the familiar spectral sequence of colours from red, through orange to yellow, then yellow-green, green, blue-green, blue and through to violet. The sodium lamp, on the other hand, shows two very narrow lines close together in the yellow part of the spectrum and no other coloured light, while with a mercury lamp, a spectrum of a very few sharp, bright lines in the yellow, green, blue and violet areas, is seen against a dark ground. When the light is brought to a focus with a lens, the spectrum is sharply defined and provides a very powerful tool to analyse the spectral composition of the light radiated by different sources.

Although a continuous spectrum can be obtained from a variety of sources, such as a candle, an oil flame, a carbon arc, the sun, north sky light, and others, yet these continuous spectra differ from each other by the amount of energy radiated at each wavelength in the spectrum, which depends, among other factors, on the temperature of the source. In order to measure the characteristic energy distribution in a spectrum, it is necessary to use some form of light meter, a detector or radiometer, rather like the exposure meters photographers use. A radiometer combined with a spectroscope makes it possible to investigate the special composition of the light radiated by different light sources and, to a certain extent, to calculate their effect upon surface colours.

Most people think of daylight as the best kind of light for matching colours, though a much 'warmer' light, such as tungsten, or candle-light, is often preferred in the home, because, having less energy in the blue and more in the red, it creates a more comfortable, relaxed and flattering atmosphere.

The reason daylight provides good matching and colour discrimination conditions is because it consists of light from all parts of the visible spectrum, with plenty of energy at all wavelengths, and also because the illumination level is high and diffused from a wide area of the sky. The colour of daylight is, however, by no means constant, since it varies with the time of day, the season, weather conditions, and latitude. Daylight, which includes both light from the sun and from the sky, is generally much more blue than sunlight itself. This is because of the scattering of light by fine particles in the earth's atmosphere. Colours in the sky at sunrise or sunset, redder than at midday, usually result from the scattering of fine

dust particles in the atmosphere removing most of the blue end of the spectrum from the light and, as the sun sets, the rays traverse more and more of the atmosphere, and the colour of the sunlight changes progressively from yellow, through orange to red, because of the ultimate elimination of all but the longest visible rays. The blue of the sky in the middle of the day results from sunlight being scattered by the molecules of the gases in the atmosphere, which, because they are so minute, scatter the light from the shortwave, blue, end of the spectrum more effectively than the longwave, red light. This accounts too for the blue of distant mountains, when the light reflected from the mountains is mixed with the blue light scattered by many miles of atmosphere, interposing a veil of 'blue sky', as it were, between the mountains and the observer.

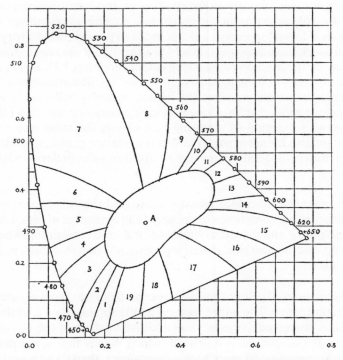

Figure 4.4 CIE diagram showing the chromaticity regions of spectrum colours (based on Evans, 1956)

Recent attempts to produce artificial light sources to imitate daylight have been fairly successful, and fluorescent lamps designed to have a good energy distribution right through the visible spectrum, are widely used when good colour rendering is essential. Yet because these lamps always include the mercury spectrum lines, they cannot give a perfect imitation of daylight, and may therefore lead to colour distortion of surface colours. Careful measurements have been made of the energy distribution of average daylight, both in the visible spectrum and in the ultra-violet, and the C.I.E. have defined the standard distribution of

daylight to enable colour measurements to be made and colours to be specified under standard daylight illumination. This has set lamp manufacturers the problem of producing a light source for use in the colour-measurement laboratory that imitates, as closely as possible, the spectral energy distribution of standard daylight, both in the visible and ultra-violet spectral regions, and until such a light source becomes available, the accurate measurement of the colours of certain fluorescing dyes and pigments involves very complex experimental equipment.

The problem is broadened by a final comment from Miss Halstead:

The assessment of colour rendering has now reached the stage where it is useful to ask the question, 'Where next?' Different groups of people seem to have different requirements regarding colour rendering. There are those, such as colour matchers, who require accuracy of colour rendering, whereas others, for instance the colour reproducing industries, require pleasantness of colour rendering. Is it logical to expect a single index to provide satisfactory information for all users, including specialists? How far should the requirements of the users influence the method of assessing colour rendering? These are questions which the experts will have to answer in the not too distant future. . . . Finally, the time is fast approaching when the lighting industry will have to expand its ideas on colour rendering. No longer is satisfactory lighting, from the colour point of view, a question of assessing how closely the lamp resembles some mythical standard. Metamerism, fluorescence, clarity, preference, etc., all have to be taken into consideration, and the future surely lies in developing an index of quality.

Too often, quantitative colour measurement, and the cost factor, control the quality of illumination, sometimes to the appalling detriment of the environment, particularly in public and industrial buildings and in street lighting, where harsh, unsympathetic and ill-considered lighting destroys human values in rural and urban areas alike.

Primary light mixture: all colour sensations derive from two types of light mixture, additive and subtractive. The image focused on the retina, when a white light or a white surface is perceived, consists of an additive mixture of the wavelengths of the spectrum. If the surface is coloured, which means that some parts of the spectrum are being reflected more highly than others, then those specific parts of the spectrum that are reflected are seen as an additive mixture on the retina when the light is brought to a focus in the eye.

This was first demonstrated by Sir Isaac Newton's classic experiment when he passed a beam of white light through a prism, separating out the different wavelengths to form a spectrum, and then showed that by passing the light back through a prism in the reverse direction, the wavelengths are recombined to reproduce the white light again.

The colour perception process, as Sir Thomas Young discovered, operates through a three-receptor, red-sensitive, green-sensitive, and blue-sensitive process in the retina. For this reason, it is possible with just three coloured lights—red, green and blue—to produce all the other hues by combining them

additively in the required proportions. These three spectral components, *red*, *green* and *blue*, when saturated, comprise the additive primaries.

One way to demonstrate the principles of additive light mixtures is to use a number of slide projectors and a series of colour filters so that different coloured light beams can be projected on to a white screen. Where the distinctively coloured areas of light are added one to another as they overlap, additive light mixture occurs.

Subtractive light mixture occurs when colorants are mixed together, or when there is a mixture of coloured light caused by the transmittance of white light through two or more superimposed coloured filters. The three subtractive primaries are: *magenta, yellow* and *cyan*.

Additive and subtractive light mixtures are closely related. Essentially, the difference between additive and subtractive light mixture lies in the means adopted to control mixtures of red, green and blue light, since the retina of the eye is so constructed that it responds to these mixtures. The red, green and blue light primaries, when combined, reproduce all the hues of the visible spectrum; added together they make white light.

When two projectors, masked by red and green filters respectively, are directed on to a white screen, where the red and green areas overlap, the combination is yellow light. When red and blue light are similarly combined, the result is magenta light, and when blue and green light are added together, cyan light is produced. These three colours, cyan, magenta and yellow, the three subtractive primaries, are complementary to the additive primaries in the following pairs: red/cyan, green/magenta, and blue/yellow.

A mixture of pairs of both additive and subtractive primaries produces the complementary of the third primary. So additively, red + green = *yellow*, which is the complementary of the third additive primary, *blue*; red + blue = *magenta*, which is complementary to *green*; and blue + green = *cyan*, which is complementary to the remaining additive primary, *red*.

Similarly, subtractively, magenta + yellow = *red*, which is complementary to the third subtractive primary, *cyan*; yellow + cyan = *green*, which is complementary to *magenta*; and cyan + magenta = *blue*, which is complementary to the remaining subtractive primary, *yellow*.

The appearance of additive mixtures of coloured light sometimes differs considerably from subtractive mixtures of colorants, or superimposed coloured light filters.

In additive light mixture, the more light waves from the three primary regions of the spectrum that are added together, the whiter the resulting colour. In subtractive light mixture, the reverse is true. The pigment primaries yellow, magenta and cyan, absorb, or subtract respectively, the blue, green and red regions of the spectrum, and for this reason they are sometimes described as minus primaries: that is, *yellow* = −blue, *magenta* = −green, and *cyan* = −red. Consequently, when a yellow filter or colorant subtracts the blue light of the spectrum, a magenta one subtracts the green light, and a cyan one subtracts the red light, there is then no light left in the spectrum, so that no light, or blackness replaces white light, or coloured light.

If any of the complementary pairs are mixed additively, white light is produced.

The reason is clear if the total spectrum is considered as composed of the three regions of red, green and blue light. In the first pair of complementaries, since cyan = blue + green light, red + cyan = red + blue + green light, which is identical in appearance to the total spectrum, or white light. Similarly, since magenta = blue + red light, green + magenta = green + red + blue light (or white light), and since yellow = green + red light, blue + yellow = blue + green + red light, which again is white light.

On the other hand, the complementary pairs mixed subtractively do not give white light as with additive mixture, but colours that are only predictable because they are familiar by experience to most people, who have, at one time or another, mixed dyes or paints together, or have looked through superimposed filters of glass or some other transparent material in the complementary colours. It is therefore expected that when colorants are mixed, blue + yellow produces a green colour, red + cyan produces a brown colour, and magenta + green produces also a brown colour.

Both additive and subtractive mixtures of hues nearly adjacent to each other in the spectral sequence produce the intermediate hue, but the additive mixture is slightly desaturated, or mixed with white light, and the subtractive mixture is slightly darkened, owing to the subtraction of white light.

Additive mixture is fundamental to the process of colour perception, yet it is subtractive mixture which in most cases determines the spectral-reflectance characteristics of coloured surfaces, and therefore the spectral composition of the light entering the eyes. Both additive and subtractive mixtures are equally important to colour perception, and ultimately, all sensation of colour derives from the two types of light mixture, additive and subtractive, which continuously interact.

The visual sense operates only when light is reflected by some material agency to the eye of the observer. If the material is itself white or colourless, it will either reflect or transmit the whole of the white light, or reflect a coloured part of it to the observer by refraction or diffraction. This is a physical process. If the material is coloured, it will subtract certain component light waves from the white light and reflect back to the observer the remaining coloured components, which will be experienced as a sensation of colour attached to the material. When we observe the world around us, both processes are generally at work, and the world appears coloured because of this.

The spectral composition of the light from a coloured light source almost always consists of quite a wide range of wavelengths from the visible spectrum, and the sensation of colour associated with the source or the surface is determined by the additive mixture of these spectral components when they are brought to a focus on the retina.

Experiments with three-colour additive mixture suggest that whiteness is generated when all three receptor processes—the red, the green and the blue—are equally stimulated. The existence of three types of colour receptor in the retina is not absolutely certain, but nearly all colour scientists accept that this is highly probable. Some visual physiologists have carried out measurements on individual receptors to determine which parts of the spectrum are absorbed most strongly, and have certainly confirmed the existence of receptors that absorb

maximally in three different regions of the spectrum. The main support for the theory, though, has come from experiments carried out basically with three projectors fitted with red, green and blue filters. These can be used to demonstrate that mixtures of pairs of the additive primaries produce their complementary subtractive primaries, and also that the combination of all three in the correct proportions produces white light. If the amounts of the three primaries are varied with resistors controlling their respective intensities, most of the intermediate hues and saturations can be produced.

Such experiments confirm that the retina must record the light falling on it through three types of receptor, which it is convenient to refer to as the red-sensitive, green-sensitive and blue-sensitive receptor processes as originally suggested by Thomas Young at the beginning of the nineteenth century. The receptors actually respond over quite wide bands of the spectrum, but their highest sensitivity does occur respectively towards the long-wave, red, end, in the green, and in the blue.

Just as it is possible to analyse the spectral composition with a spectroscope and light detector, so the spectral reflection characteristics can be measured. The results can be shown by plotting a curve giving the percentage of light reflected at each wavelength through the spectrum. It is easier to see this when the curve is plotted on a coloured representation of the spectrum than when it is plotted on plain graph paper, when only those experienced in such work will get a clear idea of the significance of the curves.

Since the wavelengths which are reflected will be additively mixed on the retina when the surface is perceived, the curves can give an indication of the colour of the surface. In the case of red, green and blue surfaces this is fairly obvious, because the main reflection is shown by the curves to be in those parts of the spectrum. With a yellow surface, though, it is not so obvious. A typical yellow surface reflects between 60 and 80 per cent of all wavelengths from the red to the green in the spectrum, and it is only in the blue and violet regions that heavy absorption occurs; yet although the high reflection is not confined to the narrow yellow band of wavelengths, the surface looks a saturated yellow. This is because of the additive mixture of red and green light which also produces a saturated yellow. This combination is occurring in the spectral composition of the light reflected by the yellow surface, so that although such a wide band of wavelengths covering a considerable range of hues is reflected by the surface, they are integrated in the eye, and, by the visual process, produce the sensation of yellowness.

The explanation may be intellectually, or scientifically, acceptable, but the effect is remarkable, for by adding a red light to a green one, light of a totally different colour has been achieved—yellow—which contains no sensation of redness or greenness. The effect is the result of, it is believed, some unique property in the visual response of the colour receptors in the retina, through which the sensation of yellowness is generated when the red and green receptors are equally stimulated.

If the intensity of the green light is decreased, and the intensity of the red light increased, the light mixture becomes orange. Conversely, decreasing the red and increasing the green, produces a yellow-green. When the red filter is replaced by a blue one, and blue and green light is mixed in various proportions, a predictable

range of blue-greens is produced, varying from a near-blue to a near-green. Similarly, with a red and blue filter, light mixtures ranging from a very reddish purple to a bluish purple, or violet, can be produced.

Another remarkable effect, however, results from the mixture of lights of complementary hue: red and cyan, blue and yellow, and green and magenta, all producing white light, devoid of any quality of hue.

With some coloured surfaces and with more complex reflection curves, it is not always easy to deduce what the colour of the surface may be from a study of spectral curves without making more detailed colour mixture calculations, but the laws governing colour appearance are still those of additive colour mixture.

One of the most important applications of additive colour mixture has been the setting up of an international system of colour measurement based on the fact that colours can be matched by an additive mixture of red, green and blue light. While the basic fact of three-colour mixture can be demonstrated by a simple arrangement of three projectors fitted with red, green and blue filters, a more sophisticated instrument is required if accurate matches and measurements are to be made and certain conditions are to be satisfied, if the measurements are to be meaningful to workers in other laboratories, and if the results are to be expressed on the standard international system.

Figure 4.5 The colour-mixing system of the Wright colorimeter (additive light mixture)

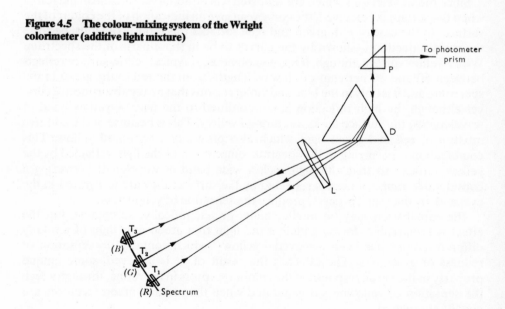

Measurements of length or weight or volume are made by comparing the object to be measured against a standard scale. Such measurements are made against a scale callibrated in metres or kilograms.

On the same principle, with visual matching, standard colours have been arranged in various forms of colour atlas, with which other surface colours can be compared. However, the number of colours that can be visually distinguished can be counted in millions, whereas even the most comprehensive colour atlas yet devised, that introduced by I.C.I. Ltd, contains less than 30 000 colour standards. The atlas is linked to the I.C.I. Instrumental Match Prediction Service in which dye recipes are computed to match customer's samples. The colours in the atlas have code letters and numbers by which they can be identified, and the appropriate information telexed to I.C.I. for computation of the dye recipe. Such a colour atlas provides a valuable and valid set of working standards of colour.

But no atlas can provide a fundamental colour scale for general use, because the colours in the atlas may fade, or become dirty or discoloured with use. An atlas intended as a set of working standards is often calibrated against some more fundamental standard, and one method of calibration is to measure the spectral reflection curves of all the standards in the atlas. This is very valuable but does not itself provide a complete colour specification. What is needed is the expression of the colours in a standard red-green-blue additive mixture system.

James Clerk Maxwell first suggested that it was possible to plot all colours in a two-dimensional diagram, which he demonstrated, in the middle of the nineteenth century, by a chart in the form of an equilateral triangle, known as the Maxwell Colour Triangle. From this triangle the C.I.E. Chromacity Diagram has evolved. In 1931 the C.I.E. made the system standard by first defining the standard observer in terms of the average colour-matching characteristics of a number of observers, and tabulating the results. Experimental techniques and colour-measuring instruments have had to be developed so that colour specification can be obtained as nearly as possible in accordance with those that would be obtained by a standard observer. Secondly, a standard red, green and blue colour was agreed, in terms of which the colour match or colour specification could be expressed. These, when agreed, were given the symbols (X), (Y) and (Z).

On this system, colours can be specified by three numbers giving the amounts of (X), (Y) and (Z), which, mixed additively, would be needed to match them. For some purposes it is more convenient if, instead of their actual amounts, the proportions of (X), (Y) and (Z) are given instead, and these proportions are symbolised by x, y and z. Since x, y and z must add up to unity, it is possible to plot the colours in the two-dimensional diagram which is now called the Chromaticity Chart.

The C.I.E. Chromaticity Chart is plotted with rectangular co-ordinates x and y. The location of the colours in the spectrum are shown and also the distribution of the more saturated colours towards the centre of the chart.

The complete specification of a surface colour not only involves its chromaticity (x, y), but also its percentage reflection, which is given the symbol Y. One disadvantage of the Chromaticity Chart is that light and dark colours of the same chromaticity plot at the same point on the chart, but their Y values distinguish them.

The C.I.E. system of colour specification is widely used in industry and for defining colour standards. One example of this is the standardisation of the colours of traffic signals, and of the signals used on railways. Red, yellow and

green signals are generally used, and their colours have been internationally agreed and plotted on the C.I.E. Chromaticity Chart. This is done by defining areas on the chart within which the signal colours must lie. The colours must also be of the required intensity. The specification allows some tolerances for manufacturing purposes, but the tolerance areas must not be so large that the signal colours could be confused by drivers.

One of the most dramatic applications of additive colour mixture is colour television. Most colour reproduction processes are three-colour processes, but colour photography and colour printing rely on subtractive mixture to obtain the final picture. Not so colour television. The screen in the television receiver consists of a vast number of tiny dots of three kinds of phosphor material which becomes luminescent under electron bombardment from the electron gun of the cathode-ray tube. One of the phosphors emits red light under electron stimulation, the second, green light, and the third, blue, so that when the screen is activated, it consists of a mosaic of red, green and blue phosphor dots which are too fine to be resolved by the observer. This means that an additive mixture of the red, green and blue light is reflected on to the retina of such intensity that, if the three phosphors are equally stimulated, the screen will appear white.

At a short distance behind the phosphor screen, a shadow mask, consisting of a metal plate, with a large number of tiny holes in it, is placed so that the electron beam can be directed at any given moment, on to either red, green or blue phosphor dots. As the electron beam scans across the screen, its intensity is modulated according to signals received from the television camera by the transmitter to give the required intensity of red, green and blue light on the receiver screen. The camera is itself a three-colour device consisting essentially of a camera lens, a three-way beam splitter, and a red-sensitive, a green-sensitive, and a blue-sensitive image tube. The images formed on the three image tubes are themselves scanned electronically, and red, green and blue signals, corresponding to the red, green and blue components in the scene being televised, are fed into the television transmitter. It is these signals which modulate the electron beam in the colour receiver to reproduce the scene in colour on the receiver screen. Where a red area of the scene is being transmitted, the red signals are strongest, and the red phosphor dots at the appropriate point on the receiver screen are stimulated. Where a yellow part of the scene is being transmitted the red and green signals are stimulated to give a yellow colour in the corresponding part of the image at the receiver, and similarly with other colours.

A colour television system therefore operates like a point-by-point colour-matching device, in which the colour at each point in the scene is matched at the receiver by an additive mixture of red, green and blue lights in the required proportions. The system is also analogous to what must be happening in the human eye, with the red-, green-, and blue-sensitive image tubes in the television camera corresponding to the red, green and blue receptors in the retina of the eye. So close is the analogy, that, in theory at least, the spectral sensitivities of the image tubes should correspond to the spectral sensitivities of the retinal receptors for perfect colour reproduction. Colour television is therefore a very direct application of the principles of additive colour mixture.

Another and quite different example of additive colour mixture is stage

lighting. The projection of coloured light on to a stage is optically very similar to simple experiments with three projectors with red, green and blue colour filters, but, although it is optically possible to produce any colour with these three coloured lights only, in practice the operator would find it very inconvenient to be restricted to the three additive primaries. A sophisticated production requires a whole battery of coloured lights, but the colours the lighting man obtains on the stage are governed by the laws of additive mixture, and this allows him great scope for colour effects.

The theory of additive colour mixture is also connected with the ability of the dye chemist to produce still brighter dyes than those already on the market. The highest reflection that a perfectly white surface can have is 100 per cent, since clearly it cannot reflect more light than falls on it. There is a limit also to the reflectance of, say, a red surface of a given chromaticity. Ideally, such a surface would reflect 100 per cent, from the dyer's point of view, of the light at the red end of the spectrum, down to 600 nm and then completely absorb all the remainder of the spectrum. The red colour would be determined by the additive mixture of all the wavelengths from 750 to 600 nm, and these would integrate to give a saturated red. This surface would not only have a red colour of maximum saturation, but also maximum reflectance for that particular red.

The same principle can also be applied to all colours in the chromaticity chart, so that for any chromaticity there is a maximum reflectance which a surface can possess, excluding the use of fluorescing dyes. The dye chemists can therefore compare the theoretical maximum reflectance with that which can be achieved with existing dyes, and so determine where there is still scope for the development of new dyes approaching more nearly to the theoretical limit. If the problem is extended to include fluorescing dyes, this again involves additive colour mixture, since dyes must be chosen which fluoresce at wavelengths which add brightness without desaturation. For example, the fluorescing light of orange safety jackets is also orange, so that the jackets become a still brighter orange. If the fluorescence had been blue, the overall reflectance would have been increased, but the added blue light would have desaturated the orange colour, and the jacket would have lost some of its protective vividness.

Although the experienced dyer is extremely capable of detecting, by empirical methods, small differences of colour between two patterns, and in deciding the changes necessary in the dye mixture to secure a better match, his practical expertise may be increased by a knowledge of colorimetric methods.

Colorimetric methods are on the whole simpler to apply in the paint industry than in the dyeing industry, and here the specification of a paint colour by means of a tri-stimulus equation is standard practice, and applies to the production of oils, varnishes and pigments, both in the comparatively small-scale production of artists' materials and in large-scale industrial production. Colour measurement is also used for quality checking of paints for fading or other kinds of deterioration, again for large- and small-scale production, and has an interesting application in the assessment of paint quality, both chemical and visual, of valuable paintings.

The applications of colorimetry are far reaching and highly various. Sometimes it is the absolute colour quality of a surface that is important, and sometimes small differences in colour are the critical factor. For certain applications it is the

spectral composition of the light emitted that has to be determined. Colorimetry may be used broadly as a guide to the visual quality of an object or as a guide to the properties of the object.

In colour photography, colour television and colour printing, colour reproduction is obviously of paramount importance, as it is in communication techniques such as signalling glasses, flags and various kinds of colour-coding, and for camouflage and uniforms for the services or industry. For these and many associated purposes, colorimetry is now used.

Colorimetry is also in constant use in the field of chemistry, for the analysis of chemical components and their mutual reactions, and the effect of heat application. Colour changes are often indicative of chemical reactions, and measurement can provide quantitative information about the products of the reaction. In medicine and all forms of biochemistry, as well as in the vast and ramifying activities of the chemical industries, colorimetry is now an indispensable tool that has largely superseded visual assessment.

Colour quality is still usually assessed by the eye in agriculture, fishery and food production generally. People automatically judge the quality of fruit and vegetables, fish, flowers and other fresh goods, but with manufactured products it is not so easy to judge quality by colour, owing to the various coloured additives that are used. Small-scale farming still depends on visual judgement, by the farmer and by the customer, but in large-scale farming, such as sugar, tobacco, wool, cotton, tea and coffee, accurate colour checks are often needed at various stages of production. After colorimetric assessments have been made, and standards approved, charts of standard patterns are generally made available for field and factory application. Spectrophotometry is now widely used in the chemical analysis of food, and colour measurement for its grading.

One further and very important application of colour measurement is in astronomy and meteorology, where science sometimes seems to border on science fiction. 'The colour of an object seen from a distance depends on the light incident on its surface, on its spectral reflectance characteristics, on the atmospheric absorption between the object and the observer, and on the air-light caused by the scattering in the atmosphere,' writes Professor Wright in *The Measurement of Colour* (1958). 'Since the visibility and recognition of an object are affected by its apparent colour, the subject is of some importance in meteorology.'

In astronomy, distances and the chemical composition of the heavenly bodies, are estimated by measurement of colour emission, and the technique has helped in the evolution of some of the spectacular advances in the science of astronomy and its applications.

Subtractive colour mixture: the three subtractive, or colorant, primaries are red, yellow and blue—more accurately referred to as magenta, yellow and cyan. Subtractive colour mixture, using three dyes or pigments, really operates on exactly the same principle as three-colour additive mixture, and this fact is denoted by the alternative description: minus green, minus blue, and minus red. The colour of a minus red dye, that is one in which there is a main absorption band in the red part of the spectrum, is cyan, and different concentrations of a cyan dye transmit different amounts of red light. The cyan dye is therefore the device by

Figure 4.6 Reflection values of chemical (subtractive) primary colours

which the amount of red light in the mixture is controlled. Similarly, a minus green dye, that is a magenta dye, is the means by which the amount of green light in the mixture is controlled, and a minus blue dye, that is a yellow dye, controls the amount of blue light. Mixing these three dyes, therefore, has exactly the same function as the three projectors fitted with red, green and blue filters in additive colour mixture.

When two of the subtractive primaries are mixed, for instance when cyan and magenta dyes of high concentration are mixed, red and green are subtracted and blue remains. With a mixture of magenta and yellow, the green and blue are removed and red remains. The third pair, cyan and yellow, remove the red and blue, leaving green. There is therefore no conflict with the results of additive mixture in which yellow and its complementary, blue, give white. In subtractive mixture, white is obtained only when the three dyes are mixed together in zero concentrations; that is when no dyes at all are present, which corresponds to the additive mixture of the red, green and blue lights at their maximum intensities. Black is produced in subtractive mixture by mixing all three dyes together at their maximum concentrations, when the red, green and blue bands of the spectrum are completely absorbed, corresponding, in additive mixture, to the three projector lights being extinguished.

In colour photography and colour printing, the final picture is reproduced by means of the subtractive primaries, cyan, magenta and yellow, but the required colour information about the subject to be reproduced is obtained from a three-colour camera, in which the red, green and blue components are recorded. This is similar in principle to colour television, since there is no difference in principle in these processes of three-colour reproduction: colour television, colour photography and colour printing. All use red-sensitive, green-sensitive and blue-sensitive devices in the camera and all reproduce the colour pictures by controlling the amounts of red, green and blue lights in the final picture. The difference between the processes is that in colour television the receiver screen is made up of tiny red, green and blue lights in the form of phosphor dots, whereas in colour photography and colour printing, the red, green and blue components of the picture are controlled by absorption in the cyan, magenta and yellow colorants. The practical consequences of this difference in method of controlling the three colour components is enormous, but the overall principle of the systems is the same.

In colour photography the method by which the three images are recorded in the camera is by means of red, green and blue-sensitive emulsions, which, in most modern commercial processes, are coated on a film base, one on top of another, to form what is known as an integral tripack. With such a three-layer film, the three images can be recorded in a single exposure, but the film has then to be processed so that cyan, magenta and yellow images are formed in the three layers. This involves the use of colour couplers, which may either be incorporated in the layers of the film itself, in which case a single developer is used, or in separate developers, in which case the development is carried through in three stages. This is a highly intricate process, considering the thinness of the emulsion layers, and the need to avoid diffusion of the dyes, if adequate definition of the final picture is to be achieved. The high quality that, in fact, is achieved is the result of masterly research in the laboratories of the photographic manufacturers.

In colour printing, the final picture is reproduced by printing images in yellow, magenta and cyan inks, one on top of another, or very closely adjacent, on a white paper base. Separation negatives of the original scene are first obtained, either by taking three separate pictures of the same scene, or by using a colour transparency from which to derive negatives photographically or by means of a photo-electric scanner. Metal plates are then etched from these negatives in such a way that when they are inked with their respective cyan, magenta and yellow inks, they transfer the appropriate amounts of the three inks on to the paper to give a satisfactory colour print.

Different methods of colour printing, for example letterpress, lithography and photogravure, are distinguished by the manner and form in which the plates are etched, and by the means adopted to control the amount of ink printed at any particular point in the picture. In letterpress and lithography, the amount of ink is controlled by the size of the dots into which the image on the plates is broken up, while in photogravure, the plates are in the form of a honeycomb of tiny hollows or cells whose depth varies according to the amount of ink to be transferred, and seen through a magnifying glass the dot structure of the colour print can easily be identified. It can also be seen that the three sets of coloured dots do not lie exactly on top of each other but extremely close together, and to that extent the colour mixture is partly additive, since it involves the additive process of optical light mixture.

A very important application of subtractive colour mixture is the use of colorimeters acting on the subtractive principle of the absorption or subtraction of light from an initially white beam of light. The most successful subtractive colorimeters are the Lovibond Tintometer series of instruments in which sets of red, yellow and blue glass slides provide the primaries. Every instrument contains a selection of permanent colour glass filters in the primary colours, red, yellow and blue, and all instruments have filters capable of 700 steps in red and yellow, and 500 steps in blue. By varying the proportions of these filters, the operator is able to match and record any colour. The number of different colour combinations obtainable with the slides, which are manufactured to extremely fine tolerances, is 9 million. Although the subtractive colorimeters do not equal the accuracy of the photo-electric spectro-photometer, capable as it is of measuring the spectral energy distribution of any light beam, the Tintometer is itself indispensable for a great deal of practical colour measurement, particularly in the field of chemistry.

The applications range from those of the simplest instrument which is capable of measuring the colour visually, of any liquid, solid or paste samples, and for such measurement which is based on the visual matching of the sample against the superimposed coloured glass slides. No scientific training is required on the part of the operator. The Standard Tintometer is recommended for everyday quality control in industry, but where industrial colour specifications are based upon the C.I.E. system of colour specification, Lovibond Tintometer instruments are available by which readings may be transferred by the use of interpretation graphs, to and from the C.I.E. and Lovibond systems, using a collection of colour filters which correspond to a C.I.E. colour specification.

A series of specially matched colour scales are available for the colour-matching comparison and grading of fats, oils, beers, and other specialised applications. The Lovibond system of colour measurement using accurately graded glass colour filters, and the spectacular colour-matching abilities of the human eye, has also been adapted by employing flexible glass-fibre optics to the production of a subtractive colorimeter for the measurement of colour areas down to 3 mm in diameter, expressing the result in international C.I.E. units. This application is useful for the identification of minerals, for forensic researches, and for the control of the quality of colour reproduction in the printing and photographic industries, where small-scale measurement is required.

The quality of many foodstuffs is graded on the basis of colour tests. The Lovibond Tintometer was in fact originally developed by Lovibond in 1880 to test and control the quality of the beers which he manufactured. Other foodstuffs, besides beer, which are graded by colour include fruit and vegetables and vegetable oils, such as cotton-seed oil, olive and palm oils, used in the manufacture of margarine. Colorants added to foods are also tested in this way. The Lovibond Comparator is also used, in combination with the required chemical reagents, to test both the chlorine and the fluoride content of drinking water. Other examples of coloration resulting from the presence of impurities which can be identified by colour tests, are the water in swimming pools, river pollution, and toxic gases in the atmospheres of factories.

A more direct application of subtractive mixture is the commercial production of dyes and pigments, which involves subtractive mixture on a very large scale indeed. A mistake made in the dye recipe of the pigment formulation can prove very expensive. Colorists with long experience can often produce a nearly correct mixture very quickly, and if it does not quite match the standard to which they are working, they can usually make the small adjustments to the recipe to give an acceptable match after a few trials. However, the procedure is of such commercial importance that the use of sophisticated colour-measuring equipment and computer-controlled processing to carry out certain of the operations previously undertaken by the colorists has proved economically viable in spite of the high capital costs involved. It is, however, unlikely that modern technology can ever completely replace the trained colorist, since the ultimate criterion of whether two dyed materials match is whether they appear to do so to the human observer, irrespective of instrumental data. The eye, after all, must be the final arbiter.

The mixing of paints is now carried out on quite a big scale in hardware stores using paint-mixing machines, particularly in America where colour co-ordination is widely practised, and where a very large variety of colours, systematically

arranged, is available. With a relatively small number of basic colours, it is possible to obtain a wide range of colours by mixing in the machine 3 or 4 pigments called stainers, of very high concentration, selected from perhaps 10 or 12 with different bases in the correct proportions according to a given formula.

In oil paints and emulsion paints, the pigments are more opaque than in water colours, so that the laws of subtractive mixture are not so closely obeyed. It is possible to make calculations to determine the colour that will result from the mixture of opaque pigments, but it takes a computer to do it, and even then the result is only approximate. All the same, the days of the experienced colour mixer on the job are numbered, partly because of the scale of much modern building, and also because standardisation is now an economic necessity.

Optical colour: a beam of ordinary white light contains radiations from the whole of the visible spectrum, and it will appear coloured when certain parts of the spectrum are reduced in intensity. This reduction may be produced either by chemical absorption in a coloured medium or by the physical interactions of the light itself.

When the energy of particular wavelengths in a beam of white light is reduced or removed by absorption caused by the chemical constitution of a colorant contained in or transmitted through the surface, the absorbed energy is converted into heat in the colorant, though the rise in temperature is minute. This kind of chemical colour appears when light passes through a stained-glass window, or illuminates a painted surface.

When the spectral composition of a beam of white light is changed not by chemical absorption but by the interaction between the light waves themselves, the colours seen are called *physical* or sometimes *optical*, to distinguish them from chemical colours. When they refer to plant or animal coloration, they are called *structural* colours. Ways in which the spectral composition of white light is changed are called *optical phenomena*.

Light scatter: light is scattered when it strikes fine particles or free molecules which take up the energy of the light and re-radiate it over a wide angle. When the particles are very small they scatter some parts of the spectrum more intensely than others, the shorter, blue wavelengths being scattered more than the longer, red, wavelengths as the particles get smaller.

Refraction: white light is bent or refracted when it passes from one medium, such as air, at an angle into another, such as glass. The refraction results from the change in the velocity of light when it enters a different medium. White light passed through a colourless medium such as a glass prism, by bending the beam of light, separates the component lightwaves, fanning them out to reveal the colours of the spectrum to the observer. The medium of the glass bends the red, long waves least, and the violet, short waves, most, with the other colours of the spectrum in between.

Interference: colour effects occur when two or more beams originating from the same source interact with each other. Where the waves are in phase, colour intensities are re-inforced; when they are out of phase, the colour intensities are reduced. Such colours are seen in nature in certain birds, insects and fishes—for example, kingfishers, dragonflies and rainbow fish. Here the colours are so vivid

as to be remarkable, since the process of light interference can produce intensely saturated hues, though sometimes the effect is on a microscopic scale.

Exactly the same phenomenon is responsible for the coloured fringes seen in thin films of oil on dark surfaces, such as roads or water. Sometimes the fringes are irregular in shape, sometimes almost circular, but in either case the fringes provide a contour map of the variation in thickness of the transparent film, which is why an oil slick, constantly changing in thickness, changes colour.

Multilayer interference occurs in nature to produce the iridescence and metallic lustre seen in certain insects, birds and fishes. Another example is the delicate colouring seen in mother-of-pearl, where thin-film interference takes place in the laminated secretions of calcium carbonate of the oyster shell. The interference colours are here desaturated or diluted with the scattered white light from the base of the shell, but this is characteristic of the delicate beauty of the colouring.

In pearls themselves, the colour is also an optical effect and might perhaps be described either as multilayer interference or three-dimensional diffraction. A matrix structure within the pearl gives rise to multiple light reflection or scattering with regular path differences between the components of the reflected light, and hence to interference effects.

Diffraction: no essential difference exists between the phenomena of interference and diffraction, only a difference in emphasis. The term diffraction is used for the phenomena identified with the spreading of a light wave as it interacts on itself—for example, on passing through a narrow slit or aperture—whereas interference occurs when two wave-fronts from the same source interact on each other—for example, the beams reflected from the front and back surfaces of a thin film.

Light falling on any surface marked by straight or parallel lines in the form of very fine, evenly spaced, grooves or ridges, is scattered over a wide range of angles. When light from numerous wavelengths passes from one to another of the adjacent lines, some wavelengths are in phase and re-inforce each other producing greatly increased brightness. Surfaces with this property are called diffraction gratings.

The angular width of the spectra revealed as hues of varying intensity is determined by the precise geometric structure of the diffraction grating: the more perfect the structure, the purer the spectral colours. In scientific, industrial and commercial use, there are many different types of diffraction gratings made from glass, perspex, acetate and other colourless transparent materials. Diffraction gratings are also an essential part of the natural order, where vivid interference effects caused by surface structure in the feathers of birds, the wings of insects and the scales of fish are particularly striking.

Absorption: the molecules of chemical colorants contain a group of atoms called chromaphores (from the Greek meaning 'colour-bearing'). They have the property of subtracting energy from the light waves of the visible spectrum.

Molecules are composed of atoms, and atoms are composed of a central nucleus surrounded by electrons circling in a number of orbits fixed at definite distances. They require fixed amounts of energy to displace them from one orbit to another; that energy can be derived from light.

The electrons in the chromaphore group of atoms can be displaced by energy

present in the various wavelengths of the visible spectrum. The amount of energy absorbed or subtracted from white light by the electrons in a particular dye or pigment determines the remaining energy transmitted back to the eye in the form of light, producing a sensation of colour in the observer.

Transmission: light that is transmitted is passed through a transparent or trans–lucent medium to the observer. If the medium, such as glass, is colourless, the composition of the white light, as it passes through, is unaltered and remains white light. If the medium contains colorants, the absorption process takes place and certain wavelengths are removed from the white light. The remaining wavelengths, however, are transmitted through the medium in the form of coloured light, instead of being reflected back from the surface. Ordinary colour-less glass transmits white light through the windows of most buildings, but in cathedrals and churches light is transmitted through stained-glass windows, sometimes with very dramatic effects, since these introduce some of the purest hues outside nature.

Polarisation: plane polarised light is light in which all the vibrations are taking place in one direction only, say vertically, compared with ordinary unpolarised light in which the vibrations are occurring in all directions at random. Polarisation controls the vibration of light waves, which travel in one direction but vibrate in several. By the use of certain crystals, waves vibrating in all but one direction can be blocked out, and this enables the chemist to make complicated analyses quickly and accurately. Iceland spar polarises light, splitting the beams of white light passing through it into two slightly divergent beams with the vibration directions of the two beams at right angles to one another. Most crystalline substances polarise light. Ground to thin transparent sheets and placed between Nicol's prisms of Iceland spar, they exhibit brilliant spectral hues, which change colour when the prism is rotated.

This characteristic is used by geologists to reveal the composition of rocks. When doubly refracting materials, such as mica, are examined in polarised light, some beautiful and dramatic colour effects occur. Mica is formed of six-sided crystals, and has an extraordinary cleavage, splitting readily into extremely fine layers consisting of tightly packed translucent leaves.

Plane-polarised light can be produced with a sheet of polaroid such as that used in the manufacture of certain types of dark glasses. If two polaroid sheets are arranged with their vibration directions at right angles, no light can pass through the two layers and darkness results. If, however, a sheet of mica, or some similar material, is placed between the two sheets of polaroid, light will pass through, and quite probably the crystalline structure will be revealed in areas of brilliant colour of different hues. These colours arise when polarised light, entering the mica, breaks it up into two components which travel through the mica at different speeds. This is why mica is referred to as a doubly refracting material, since its refractive index varies as light passes through it in different directions. After the light has passed through the mica it is no longer plane-polarised, so that the second sheet of polaroid—or analyser as it is generally called—will allow some of the light through. The mica has, in fact, converted the plane-polarised light into elliptically polarised light, because the two components which have travelled through the mica at different speeds, will, in general, emerge out of phase. How

much out of phase depends on the wavelength, so that the analyser will cut out some wavelengths and not others, which is the prerequisite for producing coloured light. How much out of phase also depends on the thickness of the mica, so that different thicknesses will reveal different colours. This is why a sheet of mica between crossed polaroids will have different areas of colour unless the mica sheet has been cleaved with such accuracy that it is of uniform thickness. The technique is an important one in crystallography when doubly refracting crystals are being examined.

Polarisation techniques are also used as a means of analysing the stresses in mechanical structures, and for examining the strains in glassware that may arise from internal contraction of the glass during cooling. The distribution in the stresses can be recorded in a model from the pattern of coloured fringes as seen through the analyser.

Fluorescence, phosphorescence and ultra-violet light: the phenomena of polarisation, fluorescence and phosphorescence are strikingly exhibited by certain minerals including fluo-spar (from which the adjective fluorescent derives). This is a mineral which becomes phosphorescent when heated.

The action of ultra-violet light on the atoms of certain minerals stimulates electrical reactions which cause the previously colourless minerals to emit light known as fluorescent light. Ultra-violet light is sometimes called 'black light' because it cannot be seen, but renders visible in darkness naturally fluorescent substances, or objects painted with fluorescent chemicals. One of many spectacular examples is a neutrally coloured zinc ore, willemite, which, when stimulated by ultra-violet light, emits a green light from manganese and red from calcite molecules. Another is the shell of a bird's egg, which appears a rather neutral colour in daylight but emits a vivid pink glow under ultra-violet light.

Natural phenomena: the most familiar of natural colour phenomena is perhaps the light scatter occurring in the light of the sky. The atoms of a gas, unlike those of a crystal, have not ordered positions; the brightness of the sky results from light scatter on an enormous number of atoms disposed at random in the earth's atmosphere. Without the particles contained in the atmosphere of the earth to reflect sunlight, the sky would appear black. The colour of the sky is extremely variable, partly because the aerial particles are illuminated, not only by direct solar rays, but also by light dispersed from other parts of the atmosphere and from the surface of the earth.

The blue, alone, of the sky, is highly variable, even on a cloudless day, the blue deepening towards its zenith, and also according to the elevation of the observer. The normal blue is diluted with white light reflected from particles, and when the sun is overhead the red, longer wavelengths, scatter, and blue predominates. It was John Tyndall who discovered Tyndall's residual blue, by observing that, whenever particles of gases are sufficiently fine, the light emitted laterally is blue in colour, and, in a direction perpendicular to the incident beam, it is completely plane-polarised. Small particles of saline and other matter (including organic material) also contribute to the blue of the sky and to the bluish haze suffusing distant landscape.

Light scatter explains not only the blue of the zenith, but the brilliant orange and red colouring of the setting sun, and illuminated clouds at sunset, when the

angles of the rays of the sun to the earth cause the comparative scatter of short-wavelength blue light and the predominance of the longer waves of red light. Brilliant sunsets after volcanic eruptions are partly caused by dust of unusual quality or quantity in the upper regions of the atmosphere.

One of the best-known and arresting of natural colour phenomena is the rainbow, which is caused by the refraction and dispersion of sunlight in raindrops. Rainbows are formed not only in fine raindrops, but also in any fine spray of water—over a fountain or waterfall, for instance. A ray of sunlight is first bent as it enters each water droplet, is reflected once on the inner periphery of the droplet and then is bent and redispersed as it emerges into the air. A fainter, outer rainbow is sometimes produced when the light is bounced twice within a droplet, and here the colours are reversed in order.

A rainbow is seen when the sun is shining from one part of the sky and rain is falling in the opposite area of the sky, and, when the sun is low in the west and heavy rain is falling from dark clouds in the east, rainbows are sometimes particularly dramatic and may make a complete semi-circle over the horizon.

The sun's rays are refracted in each spherical raindrop so that they emerge from the front of the raindrop in the direction of the observer. The small variation of the refractive index of water, on different wavelengths, causes the red rays to be refracted in the raindrops in a slightly different direction from the blue rays, with the other colours intermediate in the spectrum. The colours in the rainbow follow the same sequence in the spectrum, though they are not as pure and saturated as the spectral colours produced from a prism.

The colours seen in soap bubbles originate in the different phenomenon known as interference. The wall of the soap bubble consists of a thin film of water, and the colours seen are a series of coloured fringes corresponding to the variations in thickness from top to bottom of the bubble. When light falls on the bubble, some 3 or 4 per cent of the light is reflected from the surface of the film, and another 3 or 4 per cent from the back surface. Although the film may be only a few thousandths of a mm thick, this is sufficient to make the light reflected from the back of the film a few wavelengths behind the light reflected from the front of the film, since the wavelength of light ranges from about 0.4 of one thousandth of a mm in the violet, to about 0.7 of a thousandth of a mm in the red. If the difference in the light path is such that the vibrations of the two reflected beams are in phase, then they will re-inforce each other, and produce a bright, saturated reflection. If, on the other hand, the two beams are out of phase, they will interfere with each other and no light will be reflected, so that when the soap bubble is being illuminated by white light, containing all the wavelengths of the spectrum, some parts of the spectrum will be in phase and therefore highly reflected, while other parts will be out of phase and not be reflected at all. This means that the reflected light will be coloured, since removing part of the spectrum from a beam of white light leaves the remainder coloured. The part removed from the spectrum depends on the thickness of the wall of the soap bubble, and if the thickness varies, a series of colours, each corresponding to a particular thickness, will be seen.

The sequence of coloured fringes repeats itself with increasing thickness of the film as the path differences between the interfering beams is progressively 1 wavelength, 2 wavelengths, 3 wavelengths, and so on. This sequence of fringes is known as the 1st, 2nd and 3rd order spectrum, but although the hues of the fringes

more or less repeat themselves, they become paler in colour as the path difference increases.

In another phenomenon, phosphorescence, surfaces continue to glow when the light stimulus is withdrawn. The effect is familiar in colour television. Natural phosphorescence is sometimes experienced during darkness at sea, making a sea voyage, or a night swim, something to be remembered. The light from fireflies and glow-worms is another example of natural phosphorescence.

In the artificial field, the presence of neon and other gases can be contained in tubes and excited to luminescence by electric discharges passing through the tube at low pressure to provide a comparatively recent source of street lighting and, sometimes, of interior lighting. Neon gas emits a characteristically bright orange-red light; other gases give different high-intensity colours, such as the so-called 'electric blue' from xenon gas.

Scientists use the various colour phenomena by bending, reflecting, refracting polarising, and generally controlling the wavelengths of light, so making colour a most versatile and valuable tool, by means of which they can explore and exploit the chemical and physical properties of the earth and of outer space.

Gems: one of the most important properties of a gem is its colour. The value of the diamond, however, is enhanced by its lack of colour, and it depends for its spectral brilliance on expert cutting that exploits its unique optical properties. The high refractive index of the diamond is responsible for its brilliance and, for refraction, dispersion and lustre, the diamond has no equal.

Many gems are crystalline, and crystals are classified according to their symmetry, into seven systems, all possessing the property of bending rays of light. Gems, other than those crystallising in the cubic system, refract light into two rays, and these are classified as anisotropic. Singly, refracting gems of the cubic system, such as diamonds and garnets, and non-crystalline gems such as opal, are termed isotropic. Certain stones—zircon and tourmaline, for example—are doubly refracting, showing the edges of the back facet in duplicate. Most of these are dichroic, each of the two rays producing different colours by selective absorption.

Colour is often caused by minute traces of pigment present as impurity, so that one type of mineral can occur in several colours. Ruby and sapphire are both varieties of the same crystal formation, corundum, but they are coloured with different oxide pigments.

Not all gems are crystalline: obsidian is a natural black volcanic glass, and opal is a non-crystalline jelly of hydrated silica. Some are formed, not in the earth but in the sea, and these include coral, pearl and amber. Coral and pearl, unexpectedly, are crystalline in structure.

Some formed crystals are huge—beryl sometimes weighs several tons. Others, such as jadeite, agate, and turquoise, are crypto-crystalline gems formed of submicroscopic crystals loosely interlocked. Amber is a fossil resin of pine trees, and its colours and opacities resemble those of honey: from clear, deep, and pale creamy yellow, to molasses black.

In summary, then, we can say that the distinctive molecular structure of a gem provides its characteristic colour, modified, in some instances, by chemical colorants.

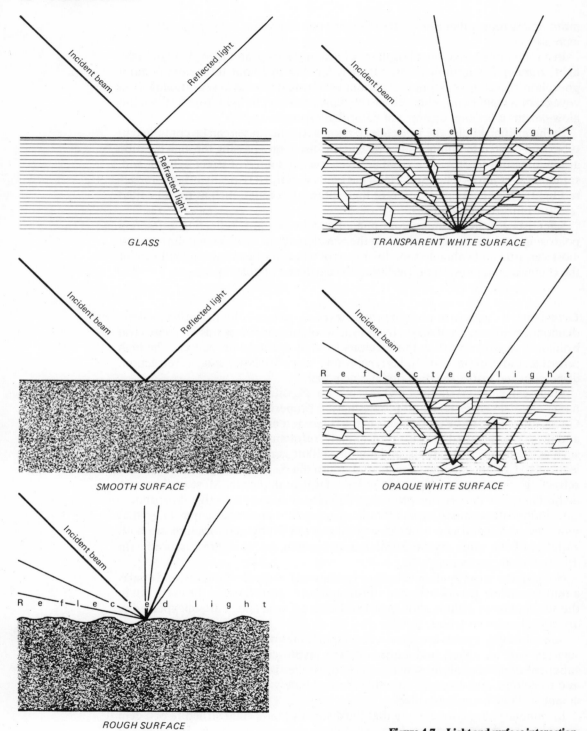

GLASS

TRANSPARENT WHITE SURFACE

SMOOTH SURFACE

OPAQUE WHITE SURFACE

ROUGH SURFACE

Figure 4.7 Light and surface interaction

Colorants and structural colours: in his *Introduction to Colour* (1948), Ralph M. Evans remarks: 'In almost every instance of a coloured surface in nature, the cause of the selective absorption is produced below the outer surface by particles varying in size from molecules to those large enough to be seen by the unaided eye. For these large particles, the effect is greatly accentuated by multiple reflection between particles before the light emerges.' The same is true of dyes and pigments, both natural and man-made.

Dyes and paints depend for their colour not only on the selective and reflective powers of colorant molecules, but on the disposition, size and geometrical formation of the particles that determine the physical distribution of light. Besides being absorbed and reflected, light may be scattered, refracted, diffracted, transmitted and polarised, and subject to fluorescence and phosphorescence according to the chemical and physical structure of the various molecules contained in the dyes or paints.

The colour quality of dyes and pigments depends not only on the selective and reflective powers of pigments, but on the disposition, size and formal quality of the particles that determine the physical distribution of light that is scattered, diffracted, absorbed, refracted or transmitted with characteristic effect upon the colour reflected back to the eye.

History of optical theory: colour phenomena, always a source of wonder to mankind, have long attracted the attention of scientists, and Newton was again foremost in observing and analysing some of these phenomena. Many of his conclusions in this field have been the basis of far-reaching scientific research and achievement.

For the ancients, the theory of optica was metaphysical rather than scientific. The first surviving scientific principle was propounded by Hero of Alexander (284–221 B.C.), who demonstrated that a ray of light took the shortest possible course between object and eye: the principle of least action. The first great theoretical discovery, the constant ratio of the angle of light incidence and refraction, known as the refractive index, was discovered by Willebrord Snell and published after his death by Descartes. This discovery was applied by A. J. Fresnel as a basis for his proposition: 'The velocity of light is inversely proportional to its refractive index.' Grimaldi discovered and named the phenomenon of diffraction: that light passing through a fine aperture spreads out on the further side. The greatest of all the founders of light theory was Isaac Newton, who discovered the theory of the light spectrum by passing through a glass prism a fine beam of sunlight, dividing it by refraction into its component colours. By passing the coloured light back through the prism, he also showed that although the colours could be reunited into homogeneous white light, no single colour could be changed. By this means he demonstrated that white light is a compound of all the spectral colours. Newton was the first to investigate the colour phenomena associated with thin plates, such as soap bubbles, by placing a slightly convex lens on a flat area of glass, observing that at the centre a succession of brilliant rings appeared, becoming progressively narrower and fainter until they became invisible. Where monochromatic light is substituted for white light, a dark centre is surrounded by a large number of rings of the same monochromatic hue, the size of

the rings depending on the colour of the light. If two coloured illuminants are used, such as red and blue, alternate rings of red and blue are seen, and where the rings overlap, purples and darker colours are reflected.

Newton's observations were confirmed and extended by Christiaan Huygens who, besides advancing scientific knowledge of refraction, and double-refraction, was the first to remark the phenomenon of polarisation, and by Fresnel, who later produced the theoretical laws of refraction and reflection. Fraunhofer, the Bavarian optician who discovered line spectrograms of the elements—later named Fraunhofer lines—studied the phenomenon of diffraction by means of wires stretched between fine screws, with which he analysed the solar spectrum and became the father of the science of spectroscopy.

These advances were followed by the invention of Nicol's prism (the nicol), which has made it easy to produce polarised light, and which became the standard instrument in the study of polarisation.

Huygens, the founder of the wave theory of light, succeeded in explaining the principles of refraction, double-refraction and reflection. Huygen's discoveries were furthered by those of Young at the beginning of the nineteenth century. One of Young's great contributions to optics was the principle of the superposition of light waves: 'When two undulations from different origins coincide, either perfectly or very nearly, in direction, their joint effect is a combination of the motions belonging to each'—a principle that is fundamental to the understanding of refraction, diffraction and interference phenomena.

The work of Fresnel has also contributed much to the understanding of light, and was devoted to establishing, and rigorously defining, the principles of optics. His work was advanced by James Clerk Maxwell, and the revision of Maxwell's theory at the end of the nineteenth century by Lorentz, whose work on electrons introduced the enormous body of work of twentieth-century scientists evolving from this concept, including that of Einstein.

Colour and texture: perceived colour is a combination of chemical and structural factors modified by the form and tactile quality of the surface of the object. Quality of surface depends much on scale.

The two main classifications of texture are rough and smooth. The rough textures may be coarse or fine, soft or hard. Rough textures give more visual vibrancy to colour, because they give variety of tone value through uneven distribution of light, whether in small scale, as in sand, or in the larger scale of rustications on a building. Smooth surfaces, too, may be roughly divided into hard and soft—for instance the polished surfaces of marble and glass, or the bloom on grapes and the softness of flower petals. However smooth these may appear to eye and fingertip, the micrograph can reveal the characteristic molecular structure that contributes to the quality of the perceived colour, just as, on a large scale, form and surface structure affect the perception of colour in landscape.

Whatever the scale, the principles are the same: colour, light and texture combine to reveal surface quality to the observer by the association of light with the physical and chemical properties of objects to create colour experiences of inexhaustible and marvellous variety.

Biological Colour

Normal interaction between sunlight and the chemical composition of all the surfaces of a plant above soil level provides for the photosynthesis of carbohydrates by the pigment chlorophyll, contained in green plants in which light energy is used by the plant to convert water, carbon dioxide and minerals into simple sugars elaborated into energy-rich starches, proteins, organic acids, fats and other chemical compounds necessary for the survival of the plant. Green plants, with the help of chlorophyll, can synthesise carbohydrates from water and carbon dioxide by absorbing the energy of sunlight, and can synthesise proteins containing nitrogen and sulphur from inorganic sources, and hydrogen, oxygen and carbon from organic sources.

Chlorophyll is also active in the absorption of actinic rays—the chemical or decomposing rays of the sun—which set up vibration-causing counter-vibration in matter susceptible to it, and produce cellular decomposition, a necessary process since all living cells release energy from food and structural components that are necessary to life. Plant and animal organisms need light energy that is stored as chemical energy in organic products, especially in the manufacture of protoplasm requiring amino-acids for growth, repairs, reproduction and other dynamic processes. Carbohydrates are broken down as a source of energy.

The American scientist John Ott, researching into the effects of light and colour on plants and animal life, observes: 'Life on this earth has developed in response to the full spectrum of natural sunlight, and variations in the wavelength distribution of sunlight filtered through glass seems to result in variations for normal growth development in both plants and animals.' The effect of coloured light on plant life was first brought to public attention by General Pleasantson of Philadelphia, U.S.A., in 1876.

Today the subject is being widely researched, notably by Philips Research Laboratories in the Netherlands, the U.S. Department of Agriculture, and by various universities in Europe and America. It has been observed that plants thrive mostly on the wavelengths of light that are visible to man, and that whilst visible red and blue light stimulate growth, infra-red light inhibits it, and ultra-violet light is inimical to it. Maximum absorption of red light results in maximum plant activity.

Under the influence of light, the stomata located in the epidermis of leaves open and absorb carbon dioxide and give out surplus oxygen, and this process is intensified in the presence of blue, rather than red or green, light. Green light, indeed, has a fairly neutral effect upon plant activity, but blue light intensifies evaporation and photosynthetic processes.

Now that natural sunlight is being supplemented and sometimes replaced in modern horticulture by artificial light sources, the effect of such substitutions on plant and animal life is being carefully studied. Direct sunlight is rich in the red region of the spectrum; diffused through clouds it is rich in the blue.

Experimentation with the growing of flowering plants completely under artificial light is increasing. John Ott has shown that control of the flowering period of plants such as the chrysanthemum and the poinsettia can be achieved by the regulation of exposure of the plant to light. By cutting off the light source in summer and lengthening winter exposure to light artificially in greenhouse culture, all-year-round flowering is possible, and the technique is now widely used in horticulture. Experiment also revealed that blue light causes the morning glory to open, but that light from the specific band of wavelengths at the red end of the spectrum causes the buds to collapse. Ott also discovered, significantly, that regular fluorescent light withers the female but not the male flowers of the pumpkin, and that bluish fluorescent light withers the male flowers but causes the female flowers to blossom.

Without the process of photosynthesis, the atmosphere of the Earth would be devoid of oxygen and most living things would disappear from the Earth in a few years. We tamper with the process at our peril. It is estimated that the oxygen of the Earth's atmosphere represents some 450 million years of photosynthesis by green plants.

The first plants evolved more than 600 million years ago in the Cambrian era. They were simply structured, without differentiation into stems, leaves and roots, and are represented today by various algae including seaweeds and stonewort.

Plants evolved no further until they colonised land some 200 million years later. These earliest plants reproduced by spores instead of seeds, and it is not until the mid-Devonian period that seed-bearing trees appeared.

Around 135 million years ago, flowering plants, or angiosperms, appeared, and with flowers and algae all the potential for colour in plants, such as we see in the plant world today, was achieved. The angiosperms evolved, as in all evolution, as a means of successful propagation. Most angiosperm flowers have male and female parts, with elaborate mechanisms to ensure cross-pollination and dispersal effected by insects, birds and mammals, when these in due course made their appearance on Earth.

Although life and the quality of the Earth's atmosphere now depend on photosynthesis, it is probable that green plants evolved long after the first living cells appeared. Such cells probably evolved from the molecules synthesised from carbon, nitrogen, hydrogen, oxygen and other elements, and the action of ultra-violet radiation from the sun.

Complex organic molecules known as *porphyrins* have evolved into light-sensitive coloured molecules or pigments, such as the chlorophylls of green plants, bacteriochlorophyll of photosynthetic bacteria, hemin (the red pigment of blood)

and cytochromes, a group of pigment molecules essential both in photosynthesis and respiration. Primitive coloured cells then evolved mechanisms for using the light energy absorbed by their pigments. Green plants, having a mechanism for utilising 30 per cent of absorbed light energy, are the culmination of this evolutionary process.

Generally in complex plant structures, water and dissolved mineral nutrients absorbed by the roots ascend into the leaves through the xylem vessels, and photosynthetic products, mostly sugars, descend through the phloem cells and are distributed through the plant structure. It would be impossible to determine how and why all the colours of plants and animals have evolved—why, for instance, the pigment chlorophyll is green, and some of the carotenoids are yellow, red and orange, though it may be possible to associate the colours with different functions.

Most coloration in plants depends primarily upon the reflected and transmitted wavelengths of light. The light absorbed by the plant serves as an energy source and may be used in biochemical reactions such as occur in photosynthesis, or merely contribute to the thermal balance of the organism, black surfaces absorbing heat energy from light, and white surfaces reflecting most of the light energy, so keeping the organism cooler. Total reflectance imparts whiteness to many blossoms because of air spaces (aerenchymous cells), or the whiteness may result from white pigments.

Obviously, we do not know the precise function of colour in every organism, plant or animal, but though some colour may appear to be without evident purpose, it is unlikely that any coloration could totally escape the processes of natural selection.

In both animal and plant life, colour may be either biochromatic or structural. Biochromatic colours result from the presence of chemical particles or pigments which selectively reflect light, while structural colours result from the action of light on the physical structure of surfaces. Generally, both biochromatic and structural factors contribute to the colour appearance of plant and animal organisms.

Natural pigments may be broadly grouped into: (1) nitrogenous, which include the chlorophylls; and (2) non-nitrogenous, which include the carotenoids, the most widely distributed of all natural pigments.

Chlorophylls are the main light-absorbing molecules in green plants. Other pigments, such as carotenes and carotenoids, can absorb light and supplement or replace chlorophyll as the light-absorbing molecules in some plant cells, but the light energy absorbed by them must be converted to chlorophyll before chemical energy can be released.

After many years of research the chemical synthesis of chlorophyll was accomplished in 1960, but it is a very expensive method of production, compared with the natural conversion of sunlight by plants into chemical energy.

Many forms of green chlorophyll exist, including those contained in green algae, in photosynthetic bacteria, and protochlorophyll produced in plants with inadequate light. A species of blue-green algae produced the first cells fusing to form fertile egg cells, thus introducing the mechanism of sexual reproduction. Phytochromes are chemically combined with proteins enabling chlorophyll to remain resistant to light.

Carotenoids are pigments mostly in the yellow, orange and red spectral areas,

and are almost universally distributed in living things. Usually insoluble in water, the carotenoids are synthesised by bacteria, fungi, algae and other plants, and in the petals, pollen, fruit—and in some cases the roots—of such plants as carrots, and are displayed in tomatoes, citrus and other fruits.

Other plant pigments include the *anthocyanins*, which produce the red colouring of buds and young shoots, and purple and red colours of autumn leaves when the green chlorophyll decomposes, temperatures are low and the light is intense. Anthrocyanins also appear in blossoms, fruits and roots—for instance the beet. Colour changes in autumn often begin with a yellowing of leaves because of the 'unmasking' of xanthophyll and carotene by the decomposition of the chlorophyll.

The *quinones* (associated with respiratory enzymes) include napthocyanines, from which vitamin A is obtained, and produce yellow, orange, red or purple in leaves, barks, seeds and roots. Other quinones are green and appear in bacteria, fungi, and some higher plants.

The *anthroxyanins* appear in the flowers of clover, in onion skins, apple tree bark, and tea leaves, and some yield strong natural dyes varying in colour according to the type of mordant used.

Another group of plant pigments, the *flavenoids*, impart yellow colours to the flower petals, and sometimes, orange, red, crimson and blue and other colours.

Man, like all other animals, owes his survival to plant pigmentation for the supply of oxygen and for chemical energy. Though man is an omnivorous animal, a completely vegetarian diet can provide all the essentials for health. Many of the required minerals and vitamins for the human diet are associated with plant pigmentation. In certain circumstances, at high altitudes for instance, or when the air is polluted with carbon monoxide, man has the ability to synthesise extra red blood cells containing haemoglobin. Some green plants also contain haemoglobin.

It is natural that man, a visually orientated animal, should be interested in biological colour. The interest is practical as well as aesthetic. Colour is used as a guide to quality and condition in fruit and flowers, and as an indication of disease or malfunction in crops. Insufficient minerals are indicated by abnormal coloration. The study of genetics in plant life has contributed much to improvement in crops. The theory of modern genetics in plant life was founded on the work of Gregor Mendel, a Moravian abbot who based some of his experiments in the field of heredity on the pigmentation of plants.

The principal apparent function of colour in the flowers of plants is to attract bees and other insects in order to promote pollination. The colour of fruit attracts insects, birds and other animals which helps seed distribution. The chief agency for pollination, the bees, are optically sensitive to ultra-violet light, but blind to red light. Certain colour combinations invisible to man are visible to, and may attract the attention of, bees. In response to certain colour combinations, bees instinctively extend the proboscis or feeding organ into the flower for nectar. The eye of the bee is apparently more capable of perceiving the colour and pattern of flowers rather than their geometric shape and sharp outline.

Since insects, unlike vertebrates, are sensitive to ultra-violet light, they can distinguish a large range of patterns and colours outside that part of the spectrum that is visible to vertebrates. Because of this, certain flowers that are indistinguish-

In visible light

In ultra-violet light

Figure 5.1 Honey-guides visible to the bee in ultra-violet light. (Above) Sorrel, *Oxalis articulata* **(pink); (below) tick-seed,** *coreopsis* **(yellow)**

able in colour appearance to vertebrate observers frequently reveal specific patterns in the ultra-violet wavelengths recognised by the insect as honey guides. For instance, two yellow flowers, the greater celandine (*Chelidonium majus*) and the bulbous buttercups (*Ranunculus bulbosus*), which both absorb ultra-violet and reflect yellow in the honey-guide area, appearing black to the insect but yellow to other observers, whilst the remainder of the flower petals, reflecting both yellow and ultra-violet, appear yellow to both types of observers. Usually the pigments responsible for the honey guides are flavanol glucosides, which reflect yellow and absorb ultra-violet light.

Flowers are not only pollinated by insects, which are sensitive to ultra-violet light, but by birds, which are not. Few insects are sensitive to red and, generally speaking, insects are not much attracted to flowers pollinated by birds. Humming birds are useful pollinators, feeding both on insects and also on nectar provided by brilliantly coloured tropical flowers. Birds tend to be attracted to pure hues in flowers, particularly red, orange, yellow, blue, violet and white. The longer life-span and working day of birds compared with insects is of advantage to the flower, extending its period of pollination.

It is now presumed that the colours—or more accurately, the brightness patterns of many flowers—act as a warning to grazing animals of poisonous or distasteful properties of plants such as woody nightshade and buttercups. Such colours are called aposematic and, as in certain animals, some harmless plants have pseudo-aposematic or false warning colours that animals avoid. The plant also uses other forms of defence associated with odour, taste and poisonous substances.

In order to survive as species most plants must be pollinated, and many advertise the presence of their flowers to potential pollinators by means of colour, though some plants, the gymnosperms (mainly conifers) produce pollen without flowers, and some are pollinated by wind or water. Plants sometimes mimic insects, a device encouraging cross-pollination in the bee and fly orchid.

Plants achieve these sometimes contradictory properties by colour combinations and patterns in the visible and ultra-violet areas of the spectrum, but the function of colours in plants is not always clear. For instance, the display of colours seen in deciduous forests in autumn —spectacular in northern America— the end products of chemical processes, or the colours of certain deep-sea organisms such as sponges or corals, which only reveal their brilliant red, orange and purple colouring when artificially illuminated, are some of the mysteries of colour in nature about which comparatively little is known.

Throughout the natural world, structural and biochemical interactions combine to give marvellous colour variation to plant life and to the environment.

Animal chromatology: in this every characteristic is assumed to have arisen from its selective value in the struggle for survival. It is therefore functional, though the function may not always be apparent to the observer.

Natural selection operates by the survival of those genotypes which are best adapted to the conditions which the selection pressure represents, sometimes through the agency of millions of generations of a species, sometimes through a much more immediate response to environmental change or threat. The effect of

selection is to eliminate or exaggerate individual differences in order to bring about ever-increasing divergences along various lines of adaptation; thus, step by step, complicated adaptations are produced, particularly in the form of mimicry and warning colours. Selection of individuals in which a given characteristic is best developed will gradually sort out a strain possessing the most favourable assemblage of factors. The study of living creatures in their natural surroundings reveals the severity of the competitive struggle for survival, and the reality of natural selection. No other explanation of the often surprising similarities in appearance of structure and colour seems possible except that of gradual convergence through the selection of suitable variations. Evolution by natural selection does not explain variation, but accepts its existence as affording the material for selection

Figure 5.2 Iridescence and interference: illustrated by the dragonfly (*Aeschna cyanea*)

to work on. Geneticists have calculated that a chance resemblance tends to be preserved if it is capable of saving one animal in ten thousand in predatory encounters, or of otherwise advancing the propagation of the species.

Much colouring in animals is determined by the requirements of either deception or advertisement; there are many causes and a great variety of use.

The two types of coloration are: (1) *schemachromes*, which are optically or structurally produced colours; and (2) *biochromes*, which are colours produced by coloured molecules or pigments.

Schemachromes result from one or more of three phenomena: interference, diffraction and light scatter. The colours caused by interference and diffraction are iridescent— that is, they glitter with different colours according to the angle of vision. A non-iridescent colour looks the same from any angle. Iridescent colours are all structural, the majority being caused by interference, but sometimes, as with the searcher beetle, diffraction of light by a grating is responsible. Interfer-

ence colours are produced when light is reflected from both the outer and the inner surfaces of a film or tissue. The lightwave component that travels through the tissue, to be reflected off the inner surface, has further to travel, and, because of this, some wavelengths will be out of phase with equivalent wavelengths reflected off the outer surface. These eliminate each other, leaving only those in phase which reinforce each other to give brilliant colours. Different colours are seen on varying either the angle of the incidence of light, or the position of observation. Such birds as the peacock show this form of colour in social use for sexual display. The dragonfly, and many other insects, use it as camouflage; the reflectance and colour, changing rapidly in flight, make it difficult for a predator to estimate its distance, size or shape.

Figure 5.3 Wingcase of the ground beetle (*Iridagonum quadripunctum*) acts as diffraction grating

Non-iridescent colours are caused by Tyndall scattering—the scattering of the shortest wavelengths by a layer of minute particles. As the shortest wavelengths are blue, this results in blue scattered light, which, when seen against a darkly pigmented background, shows up as bright blue. Many birds exhibit blue from light scatter, including kingfishers, parrots and budgerigars. Tyndall blues, associated with orange or red pigment, produce purple, as in the kingfisher. Associated with yellow pigmentation, the phenomenon produces the green of most feathers, of frogs and lizards. Texture, too, modifies the intensity of colours. Feathers may have a so-called 'powder' on them, making the colours appear muted. Associated with a dark melanin-pigmented background, a fine 'powder', resulting in light scatter, can give a deep, soft blue.

Tyndall light scatter is the cause of the blue colour of the sky, and also of the blue of some human eyes. The 'eye-shine' of certain nocturnal creatures, whose eyes glow at dusk, are caused by diffraction, which can also cause, as Newton

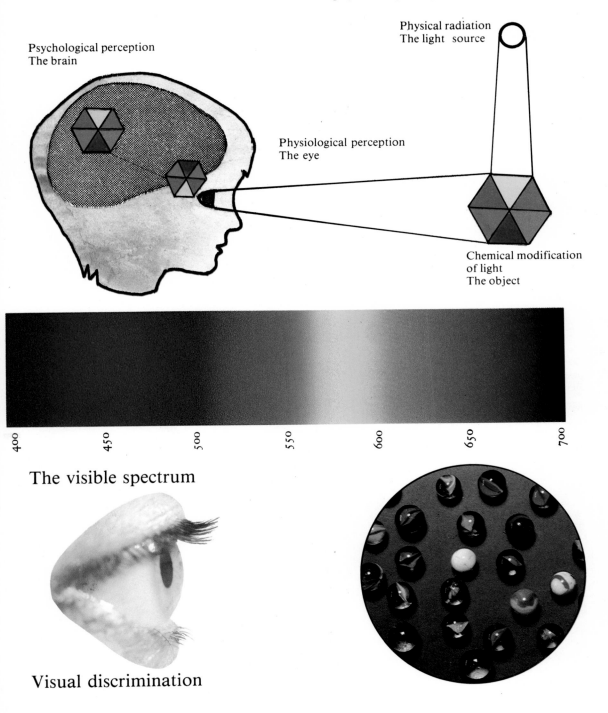

Colour Perception
Physical, chemical, physiological and psychological processes are involved

Physical radiation
The light source

Psychological perception
The brain

Physiological perception
The eye

Chemical modification
of light
The object

400 450 500 550 600 650 700

The visible spectrum

Visual discrimination

Colour Dimensions

Two-dimensional expansion of single hue

⭘ White

⭘ White

Red

Grey

⬤ Black

⬤ Black

Monochromatic triangle

Hue

Scale of hues

Three monochromes

Colorants

Dyes combine with substrate

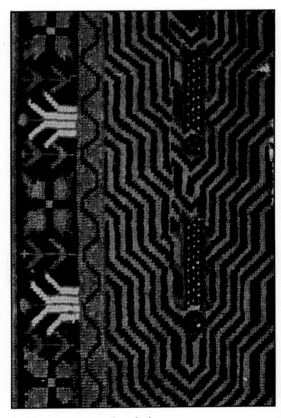

Persian carpet, garden design

Pigments provide a new surface

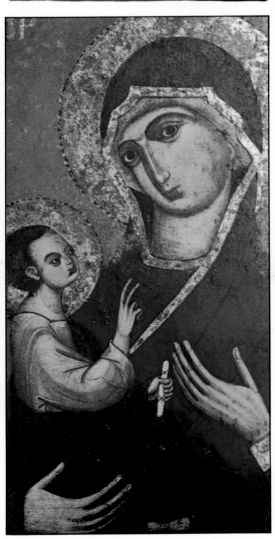

Virgin and child. Venetian Byzantine school

Primary Light Mixture

Additive Light Mixture

Additive primaries are saturated blue, green and red light

All three light primaries added together give white light

Colour complementaries added together give white light

Subtractive Light Mixture

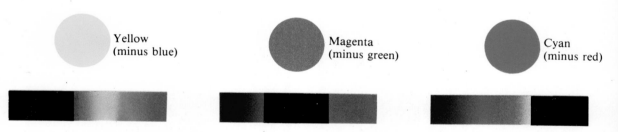

Yellow (minus blue)

Magenta (minus green)

Cyan (minus red)

Pigment primaries absorb blue, green and red regions of spectrum

Any two subtractive primaries give complementary of third primary

Three primaries subtract all components of white light, giving black

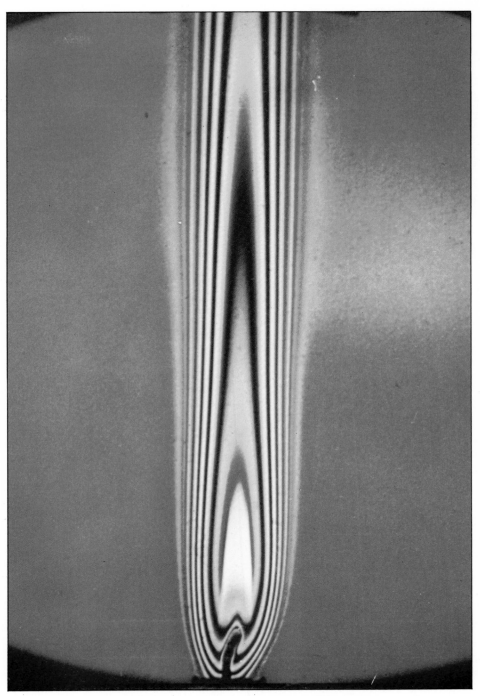

Interference effect in a candle flame

Symbolism
Medieval heraldry

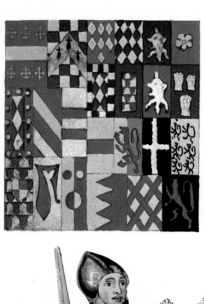

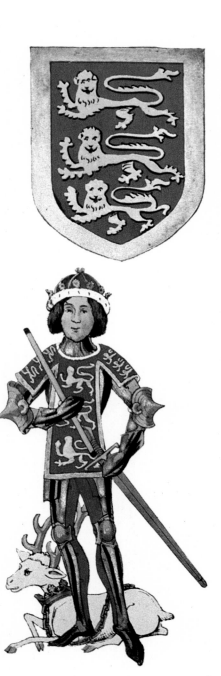

Thomas Beauchamp
Earl of Warwick KG

Thomas Holland
Duke of Surrey KG

Colour–Science and Art

Ancient Egyptian painting: limited palette

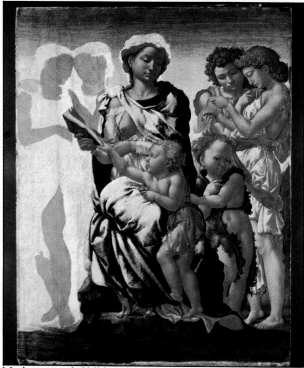

Madonna and Child, Michelangelo: medieval painting technique (The National Gallery, London)

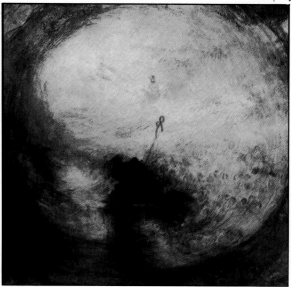

Light and Colour (Goethe's Theory), Turner: revolutionary influence (The Tate Gallery, London)

Pointilliste study, Seurat: colour science in practice

Colour and Environment

Colour in the natural landscape ...

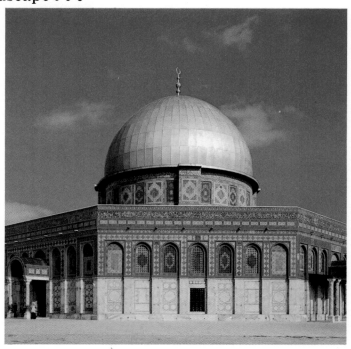

... and in the man-made world

observed, the spectral colours exhibited by a spider's web. The whiteness found in many seashells and corals and in the teeth and bone structures of many animals results from total and equal light scatter. The whiteness of white moths and butterflies results from reflection from surface scales, ribbed and reticulated. Random scatter of light gives a matt white; reflection from a regular structure gives a pearly lustre, sometimes appearing silvery. Greyness is usually the result of optical mixture of white and black in feathers and hair. Blackness is the consequence of total light absorption.

In general, schemachromatic colours are produced by the break-up of white light into various wavelengths by extremely fine geometrically disposed chemical structures. Brilliant changeable hues and iridescent colours are caused by the interference of incident light entering through thin laminations of alternating chemical composition reflected back by multiple inner surfaces. Such bright specular colours are typical of many birds and insects, as well as the inner nacreous surfaces of molluscs, pearls and many tropical fishes. These colours are sometimes dependent on microscopic layers of moisture between laminations, and if dehydration occurs by heating or gradual desiccation, the colours disappear. The spectral colours manifested in the 'metallic' colours of the chitinous wings of certain insects is determined by the relative thickness and spacing of the laminations. Relatively thin laminations tend to exhibit blue and green-blue colours, viewed from a given angle, and species with thicker laminations tend to exhibit orange, red, copper or gold.

Most of the colours of skeletal materials result from light interference rather than diffraction, though chromatic diffraction of sunlight by ultra-fine natural gratings on wing surfaces does occur in certain beetles. The surfaces of the scales on the wings of butterflies, such as the South American morpho, have tiny longitudinal vanes, geometrically disposed, causing the light interference responsible for their spectacular colours, and so also do those of the peacock and humming bird.

Schemachromes are often associated with biochromes. The colours of the wing covers of certain beetles, for instance, depend on the layer of melanin on the under surface of the wing for their specular brilliance.

Certain organic molecules absorb particular fractions of the visible light spectrum, transmitting or reflecting the residual unabsorbed fraction to give the compound its characteristic colour. Such molecules are called *biochromes* or natural pigments.

Animal pigments are stored principally in the skin and glandular tissues of animals and in certain lipid deposits, but the same biochromes are often secreted in the chitinous, cheratinous or calcareous structures of bone or shell, feathers, fur or hair.

The skeletal biochromes can be separated into chemical classes and distinguished as: *melanin, phenoxazones, sclerotins, porphyrinic, bilichromic, tetrapyrroles, pterins, polycyclic quinones* and *carotenoids*. Among the most common of these, the *melanins* are dark, reddish, tawny or yellowish. They give not only the coloration so characteristic of many animals but also provide a dark background to accentuate conspicuous spectral colours of schemachromatic origin in birds and insects. Black melanin pigments occur in claws, feathers and scales, and conspicu-

0.5 μm

Figure 5.4 Reconstruction of part of a wing scale of the male of the butterfly, *Eurema lisa*. Laminate ridges projecting upwards are responsible for the ultra-violet reflection. Pigment granules responsible for the yellowish colour of the scale project downwards (after Ghiradella, *et al.*)

ously in skin, fur and hair. Another melanin pigment colours the fur of the red squirrel and the feathers of Rhode Island fowl. It is the principal colouring agent in human skin and hair of all ethnic types.

The *sclerotins* produce a similar range of colours to the melanins. They are often found in eggshells and in crustaceans, and are associated with a protective hardening process.

Porphyrins are frequently in the pink or red colour range, and these pigments, too, are found in the shells of birds' eggs, and in certain sea shells, especially in the calcareous shells of molluscs, where they give rise to pink, red or ruddy coloration and the red fluorescence of many shells.

The *bilichromes* are mostly green, and are found in certain butterflies and locusts, in the praying mantis, and also in the blue or blue-green shells of birds' eggs.

Bilirubin, a red pigment (yellow when diluted), is present in the red and yellow colouring of skin and eyes, and it is the pigment of the human jaundice condition.

Biliverdin is believed to be responsible for the blue or blue-green shell pigmentation of the eggs of gulls and other wild birds, including that of the emu, which is dark green, ageing almost to black. Red and violet biochromes are also present in various sea animals, sometimes absorbed from pigments assimilated from a diet of other pigmented sea life.

Pterins contribute white, red or orange to the wings or body integuments of various insects.

Quinones are pink to deep red, and are found in sea-urchins and deposited in the skeletal parts of animals absorbed into their systems from their diet.

Carotenoids are the most widely distributed biochromes in nature, exhibiting yellow, orange or red in the integument of many invertebrates. They may also be

blue, green or purple, or other colours, in crustaceans and molluscs for example. They appear in the skin of lower vertebrates, especially fishes, and in amphibians and reptiles, though they are rare in mammals. They are conspicuous, too, in the exposed skin and brightly coloured feathers of many birds, in many crustaceans, crabs, shrimps and lobsters, and in the pink flesh of salmon and the skin of goldfish, as well as in some sea anemones, turtles, and certain beetles and ladybirds.

In some parrots and budgerigars, the barbs and barbules of certain feathers contain fluorescent pigments. The principal fluorescent colours are sulphur yellow, green, and yellow-gold. The yellow pigment melanin, structural blue, and a fluorescent pigment may all be present at the same time.

Many thousands of animals display in the integument, in fur, feathers, scales, or hard skeletal structures, colours synthesised, selectively assimilated, or modified from their food. In birds the colours of the feathers and bill may be determined by the level of hormones. Thyroxine and the sex hormone of the pituitary gland may also play a role. Chromatophores, which provide for rapid colour changes, are found in a number of lizards, amphibians, crustaceans, insects and molluscs. The most rapid changes occur in the octopus, squid and cuttlefish. Colour changes may take place in seconds and are partly the result of expansion and contraction of the skin cells by muscular action.

As in humans, emotional states sometimes effect colour changes, and some squid and cuttlefish exhibit spectacular displays of colour when emotionally disturbed. Unequal dispersion of pigments over parts of the body can cause colour patterning and colour can also be an indication of age and condition in animals as in plants. In man, this is illustrated by greying hair, but other animals and birds may also change colour with age. Captive birds may have their brilliance of plumage marred by captivity, as a result of a diet reduced in carotenoids or some other nutritive factor. This often occurs in flamingoes in captivity.

Aquatic animals derive rich supplies of carotenoid substances from algae and other plants. Even carnivorous fish, at great depths where there is little light, display rich colours because of the presence of pigments derived from photo-plankton, which have generated carotenoids in higher depths of illuminated water.

The interaction between insects and flowers is related to the perceptual qualities of the insects' compound eye, which shows maximal response to flickering coloured stimuli, and to the visual capabilities of colour signal receivers, such as the response to ultra-violet light of the bee. Between birds and flowers the interaction is usually related to the presence of insects and nectar associated with the flowers and attractive to the bird. Sometimes, however, normal response to flower colours usually accepted as warning colours is inhibited for various reasons. The bee-eater, for instance, is attracted to flower patterns of yellow/black, or red/black, normally accepted as danger signals by most birds, because the poisonous insects associated with these colour combinations form the greater part of the diet of the bee-eater.

Cryptic coloration includes both camouflage and disguise, though sometimes the classifications appear to be indistinguishable.

Camouflage breaks up the shape, outline and shadows of an animal, making it

blend with its general background. Disguise makes an animal appear like some other object, such as a twig, leaf or piece of lichen. Such effects are usually convincing only if the animal remains motionless against a matching background and in a suitable position. Because of this, many moths and other nocturnal creatures are well camouflaged, whereas those that are active during the day, such as the scarlet ibis and most other birds, rely on other means of protection. Many song birds adopt brilliant nuptial plumage for the breeding season, and dull, 'eclipse' plumage for the autumn and winter. Those animals that lie in wait, or stalk their prey, like the tiger, have highly developed camouflage, but not those which hunt using speed and endurance.

Disguise involves the mimicry of inanimate objects in the environment, such as leaves and sticks, and is confined mainly to insects, probably because insects are more likely to resemble these in size and shape than most other animals.

Nocturnal insects are usually motionless during the day, making them ideal mimics of inanimate objects. Leaves of all types, healthy, dead, rotten, half-eaten and fallen, have all been mimicked. The prickly stick resembles dried dead leaves perfectly, having flat, leaf-like flanges all over its body. Its disguise is enhanced by its behaviour, sometimes gently swaying in imitation of leaves in a light breeze. Apart from this, it remains motionless in the hours of daylight, moving and feeding only at night. Other excellent leaf mimics are the long-horn grasshopper from Borneo, which mimics the shiny dark green of forest leaves, the South-East Asian walking leaf, that mimics half-eaten leaves, and the shorthorn grasshopper from Borneo, that mimics dead and fallen leaves. Many types of insects are disguised as the twigs or stems of the plants on which they feed, and many stick insects, when resting among them, are indistinguishable from twigs.

Of the few vertebrate leaf mimics, fish probably provide the most ingenious examples. The leaf fish is a general mimic, whilst the bat fish resembles the mangrove leaves found in abundance in the mangrove waters it inhabits. Certain snakes are the only vertebrates able to imitate sticks, lianas, or vines; an example is the vine snake that lives in trees and bushes, ambushing small birds and lizards.

Many small cryptic animals have a second means of defence if discovered by a predator. This usually takes the form of a frightening display, involving the exposure of large, false eyes, or patches of colour, and threatening gestures. The impression of large, false eyespots on a caterpillar of this type suggests a much larger creature, such as a snake, warning most predators not to attack it. Others, such as the elephant hawk moth caterpillar, both look and act like a miniature snake when threatened, causing the predatory toad to inflate, as it would when meeting a snake, and avoid attacking the caterpillar. Various other insects and small animals expose brightly coloured areas when threatened, like the Australian frilled lizard which raises its red umbrella-like frill when alarmed, to act as an effective scare device.

The deflection marks of the butterfly fish are another means of defence, taking the form of large eyespots on the rear of the body, whilst the real eyes are concealed. As most predators attack the head of their prey, these marks deflect their aim to a less vulnerable area, often causing them to miss the prey completely as the fish appears to dart away, backwards.

Not all animals are cryptically coloured or disguised as inanimate objects: a

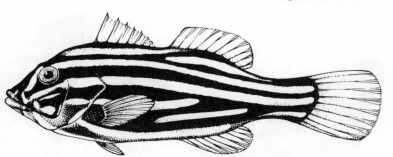

Figure 5.5 Disruptive colouring in fish
(*Grammistes sexlineatus*)

wide variety have other means of protecting themselves from predators. Their objective is not to conceal themselves but to be instantly recognisable by being as conspicuous as possible. This is usually achieved by bright saturated colours, such as red, orange, yellow, black and white, in various combinations. These serve as warnings to potential predators: in the case of the golden box fish, of poisonous secretions.

As with animals that are cryptically coloured, those with warning colours also use their behaviour to enhance their colour effects. The golden box fish helps to advertise itself by slow and deliberate movements. Others, like the monarch butterflies, protected by bad tasting or poisonous body fluids, cluster together when migrating in order to reinforce their warning colours and to come in contact with fewer predators.

Where two or more species with warning colours resemble one another closely, the defence is known as mimicry. Two kinds of mimicry are often distinguished: Batesian and Mullerian. In Batesian mimicry an unprotected species mimics a protected species so closely as to be mistaken for it by predators, thus gaining some immunity from attack. Mullerian mimicry occurs when two or more protected species resemble each other. Predators learn from experience which are the protected species. When several distasteful, or aposematic, species have a common appearance, fewer of each are killed or harmed as predators learn to leave them alone.

Many species of animals are widespread over various habitats and have survived only because they have become adapted by local colour variations to match particular environments. One of the best-known examples of this is the peppered moth, which varies in colour from pale buff to almost black. The pale ones are found in areas where trees are covered with light mottled lichens; the dark ones tend to settle on dark areas, such as those found on the soot-blackened bark of trees in industrial areas. Stick insects also have local variations of colour which blend with the various plants on which they are found.

The ability to change colour frees an animal from a specific background, enabling it to move around and change its own colour to match various surroundings. Some creatures can change colour rapidly and over an almost unlimited colour range; others more slowly and with only a few colours. Cephalopods, such as the octopus, squid and cuttlefish, are capable of the most rapid colour changes,

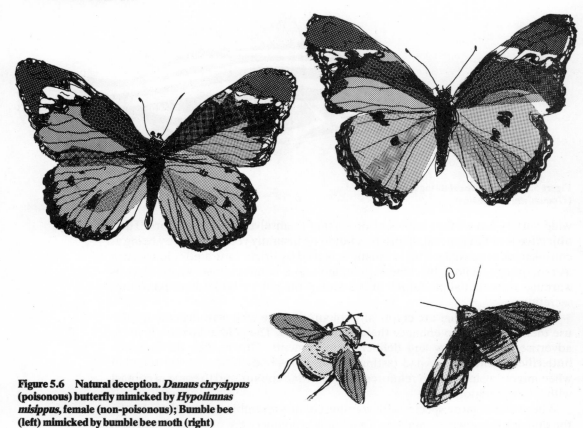

Figure 5.6 Natural deception. *Danaus chrysippus* (poisonous) butterfly mimicked by *Hypolimnas misippus,* female (non-poisonous); Bumble bee (left) mimicked by bumble bee moth (right)

taking only two-thirds of a second. Their camouflage colour changes are very advanced, and are capable of matching varying backgrounds as well as patterns of light and shade. When attacked they are capable of rapid and continuous colour changes that normally confuse the predator. If this is not successful, cuttlefish and squids discharge a dark sepia pigment from their sacs, turning the surrounding water black, and enabling them to escape. Flat fish, such as plaice and brill, are also able to adapt their colour, tone and pattern and to match various surroundings quickly.

The chameleon is well known as being adept at colour changes, although its range is more limited than is often believed, varying from pale yellow, through various greens and browns, to almost black. The ability to change colour is shared by many lizards and frogs. The American horned lizard, for instance, can match either the brown or the grey of its habitat.

Some animals, such as the flower mantids, are capable of only slow colour changes, effected by accumulating, over a period, appropriate pigments to match their flower environment. This capacity for change is limited to red, green and intermediate colours, and takes several weeks to change completely from one colour to another.

Some mammals and birds exhibit marked seasonal changes, especially those in sub-Arctic conditions. The North American snowshoe has a white winter coat and a brown summer one, to match the varying colours in its habitat; and this is true of other creatures living in this climatic zone, including stoats, weasels and ptarmigans.

Many animals change colour as they mature, meeting changing needs and conditions. Adult birds, such as oystercatchers, terns and plovers, hatch their eggs in the open and, if alarmed, escape by flying. Their eggs and young, unable to escape by flight, need cryptic coloration to remain undiscovered. The white coat of the young seal, born on the ice, serves a similar purpose, but further south, where there is no ice, and the young are reared on beaches where the white coat is conspicuous, this is not so easily explained. Perhaps the species has extended its range south relatively recently, or has fewer predators in this region.

The use of colours for camouflage is only of limited benefit unless it is combined with countershading, disruptive coloration, or shadow effacement, the most developed forms of concealment employing all three.

Cryptically coloured animals are vulnerable to discovery by the natural shading of bodies caused by sunlight. As this is mainly from above, it tends to make the top of the animal appear light and the underneath dark, with the sides various shades between the two. It has the effect of making the animal stand out against its background as a solid object, even if the colours of both are similar. Such shadows are neutralised by countershading, which works in the reverse way: the top side is dark whilst the underside is white or very pale, and the sides graded from pale lower down to dark higher up. The effect is to make the animal appear flat, with its natural shadows eliminated, making it difficult to see against a similar background. In most cases the countershading is effected by gradations of colour, as with the impala, but in some cases it is achieved by patterns— the stripes of the zebra for instance. From a short distance the stripes, which are wider above than below, blend to a uniform grey, which, during the half light of dawn and dusk, is very effective, for then the zebra is most at risk to attacks from lions.

Unless conditions are perfect, even an animal with both a close colour match and countershading, will show up as a patch of colour with recognisable outlines. The outline can be disguised by contrasting spots, stripes or irregular patches that distract the eye of either prey or predator, suggesting unreal forms which bear no relation to the actual shape of the animal. Many snakes, such as the gaboon viper, show a very complete form of disruptive camouflage when the snake is transformed into a collection of the leaf-like shapes on which it relaxes. This form of disruptive camouflage is widespread throughout the cat family. Disruption of the outline may be effected by a stripe down the middle of the animal's back, breaking up the form into two apparently unrelated and unrecognisable areas. In all cases of disruptive coloration, the patterns are found to cut across the structure of the body, superimposing on it another structure resembling that of the background.

Light not only causes shadows to play on the animal itself, but also casts conspicuous shadows on the background. Moths rest with their wings flattened and spread against the object on which they are resting, so reducing both their profile and shadow to a minimum. Butterflies, however, rest with their wings folded vertically, maximising profile and shadow, but their rest is generally brief.

Many other animals, either when stalking their prey or when alarmed, also press themselves against the ground for the same reasons. Probably the most advanced examples of shadow effacement are found in fish. Flat fish and rays have developed flattened physical forms which enable them to lie on the seabed without casting any shadow.

Methods of concealment and protection by means of colour are enormously widespread and varied throughout the animal kingdom and, although no one form is totally successful, these means are essential to the survival of many species and to the balance of nature in general.

Between certain birds and flowers an interaction occurs which is usually related to the presence of insects and nectar associated with the flowers and attractive to the bird. Sometimes, however, normal response to flower colours usually accepted as warning colours is inhibited by other factors. For instance, the bee-eater is attracted to patterns of yellow/black and red/black, normally accepted as danger signals for most birds, because it feeds on insects poisonous to most birds, and associated with precisely these colour combinations.

One of the many interesting uses of colour in animals is the display of colour in fish or birds to indicate territorial claims and to inhibit violent action potentially damaging to both parties, rather like the colours worn by opposing military or sporting factions. Mating colours, though primarily displayed to attract a sexual partner, may serve the same function to warn rivals. A highly original use of colour is made by the bower birds, which have bright courtship coloration generally, but some species, instead of displaying bright plumage, decorate an elaborate bower with leaves, petals and any brightly coloured impedimenta. These attract the female but do not have the disadvantage of betraying the presence of the male to the chance predator. Magpies notoriously share this kleptomania for brightly coloured objects. It is known that birds share with man a highly developed colour vision but what motivates their selection of coloured material is not known.

6
Colour and the Eye

Before the appearance of mammals and primates relatively late in evolutional history, the interaction of plants, insects, reptiles and birds provided living colour on the Earth. The potential for colour sensation in an observer existed in some living tissue before colour vision evolved, notably the red of haemoglobin and the green of chlorophyll in vegetation, colours which appear to be incidental to biochemical function. But the coloration of plant and animal life and the colour vision of animals were, on the whole, evolutionarily interdependent. Visual response to colour was variously selective, associated with pattern, and linked essentially with survival of the species as a product of natural selection.

Until the advent of *Homo sapiens*, with his ability to apply colour artificially and to change the natural environment, the colours which clothed the mineral surfaces and enlivened the watery places of the Earth were organic colours reflected from the tissues of plant and animal life. They included colours of foliage, flowers and fruits, of the plumage of birds, the wings of insects, and the scales of fishes and reptiles. These colours evolved with increasing variety and sophistication as, reciprocally, colour vision and colour discrimination evolved.

Visual capacity in every living creature is conditioned by factors governing its survival. It is estimated, for instance, that the brain of the frog is informed about only four factors: straight edges, moving convex forms, change of light contrast, and rapid darkening, all relevant to his survival cycle in the context of nutrition, sexual activity and self-preservation. Other visual appearances are irrelevant to the frog's existence and do not register on his brain. The princess of the fairy tale would simply not exist for the frog. Experiments reveal the frog's avoidance of green and pursuit of blue surfaces when he feels endangered, indicating that his colour discrimination is directed towards the comparative safety of blue water, as opposed to green vegetation, where predators are more likely to be concealed. The basic source of the visual sense is response to light, a response that is a property of protoplasm on which life is founded.

A sense of light is known to activate even unicellular animal life, such as the *Amoeba proteus*, which not only responds to white light but is accelerated by red light and decelerated by green light. This response to light is based, it is thought, on chemical processes in the cells, affecting the degree of fluidity, the viscosity of

the protoplasm, the permeability of the cell wall and the activity of the enzymes and hormones. Light-absorbing pigments intensify chemical reactions, acting as transformers of energy. Microscopically small and primitive insects can distinguish between light and darkness, though only in a very limited way, through a few eyespots, or ocelli. More highly evolved insects can distinguish shapes, though this ability is strictly limited by distance; bees can tell leaves from flowers at a distance of not more than a few inches; ants recognise other ants only at considerably smaller distances. The framework of reference of such insects is confined to survival signals and symbols that in no way correspond to the complexity of human vision but relate to primitive lines or dots, light or dark, symbolising for them significant homing signals, or in the case of the bee, and other nectar-attracted insects, flower patterns symbolising homing guides and a supply of food.

There are various types of visual organ. Primitive light-receptor organs form part of the sensory equipment of certain small creatures such as caterpillars, spiders and worms. In the case of the bee, these supplement the complex eye, and act as a light meter to acquaint the bee with the direction of sunlight and other data, enabling it to journey within safe limits.

Some lizards have a median eye in the form of a translucent horny scale, which, in response to the wavelength of the transmitted light, causes the pineal gland to produce more, or fewer, hormones, which in turn produce a change in the skin of the reptile, forming a natural camouflage. One very primitive reptile, the New Zealand lizard *Sphaenodon punctatum*, called by the Maoris *tuatara*, has a cyclopian eye besides its two normal eyes. The organ of this reptile (which is regarded as a living fossil) shows traces of a lens and a retina, and light-sensitive cells with ganglion cells are present in primitive form. Because of its light-sensitive median eye, the blind worm is not totally blind. Certain fish, too, have a median eye to supplement the ordinary eyes, and these appear to be hyper light-sensitive. Eels and lung fish have light-receptive organs in the tail, acting as a warning device because the tail is vulnerable to predators. 'Blind' cave fish have a similar device, and the clam has a light-sensitive region in the soft parts, which responds to light stimuli on the surface of the skin; sensitivity depends on the number of light-sensitive cells. Some of the sea anemones follow the arc of the sun by means of light sensitivity. Thousands of facets, or *ommatidia*, make up one complex eye in the insect. Each *ommatidium* contains several visual cells, and is screened by light-proof pigmented cells. Light penetrates through a lens and a crystalline cone on to rhabdons—fibres which conduct the light on to the visual cells and down towards the tiny brain. The bee has 15 000 facets or *ommatidia*, each of which is capable of observing only its own sector of the screen of squares visualised by the total eye. At each moment the sun is observed by a single lens only, enabling the bee to navigate. Navigation is aided, too, by the ultra-violet vision of the bee, which allows it to locate the sun even through cloud. Although the more primitive insects are conscious only of changes between light and darkness, others more highly evolved can distinguish shapes, colours and patterns, though these are strictly limited to those essential to survival.

Acuity of vision depends on the comparative density of visual cells in the *fovea centralis*, which varies from one animal to another. The elephant and rhinoceros,

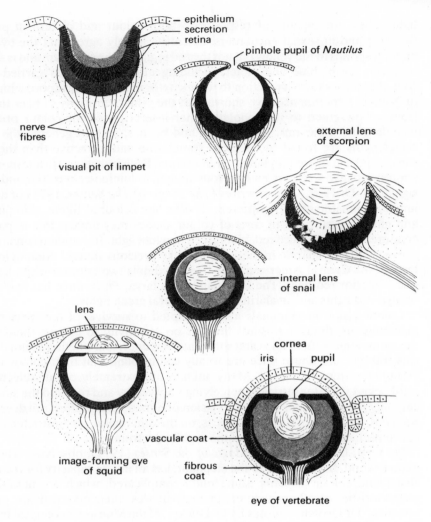

Figure 6.1 Various primitive eyes on the same basic plan. A lens forms an image on a mosaic of light-sensitive receptors

having a low concentration of such visual cells, have extremely blurred vision compared with lions and other members of the feline tribe, whose visual acuity at least equals that of man. In birds of prey acuity is very much greater. Sharp acuity of vision, for both feeding and flight purposes, is afforded by the provision of two foveal areas in the retina of certain birds, and further protection is provided by red, orange and yellow pigmented droplets, which, by cutting out blue light at full sunlight, and red light at dawn and sunset, reduce glare and dazzle.

Colour vision is well developed in reptiles and exceptionally well developed in birds, which are warm-blooded reptiles. Fish, too, have colour vision. Their behaviour is influenced by colour, and they are adversely affected by fluorescent

light. They are capable of response to both colour and pattern in prey and predator and in sexual encounters. Scientists largely agree that the eye of the insect responds to the yellow but not the red region of the spectrum and is sensitive to green, cyan, blue and violet, including ultra-violet. Tests carried out on fruit-flies have shown a reaction to wavelengths in frequencies approaching those of X-rays. Experiments have shown that the visual sensitivity of bees to extend from yellow-green to ultra-violet. Other insects tested for colour preference include ants, silkworms, cockroaches and beetles, and, in general, the shorter wavelengths are found to be more stimulating and attractive than the longer wavelengths in the red region of the spectrum. Both insects and fish respond, with appropriate eye structure and nervous system, to luminescent colour and pattern signalling. Dr H. E. Grüner writes (*The Magic of The Senses*, 1971) of deep-sea luminous inhabitants: 'By different devices like coloured filters, skin pigments, and glittering mirrors, all sorts of colour shades may appear in one particular creature. It may produce red, blue-green or white light. Its luminous organs, when active, will then sparkle in these colours like precious stones.' Among luminous insects, the Central American click-beetle exhibits two anterior white lights and one posterior red light. The Brazilian beetle larva, *Phrixothrix*, has two anterior orange-red lights and an alarm signal of several green lights.

Colour vision in mammals also is adapted to survival of the species. Many mammals are thought to have little or no sensitivity to colour; these include raccoons, lemurs, field mice and some rats. It is uncertain whether or not dogs and cats, rabbits and house mice are totally colour blind, but their colour vision is certainly extremely limited. Many animals are extremely colour selective: the red-backed vole, for instance, perceiving only yellow and red, and the small civet cat, only red and green. The colour vision of horses, and giraffes, red deer, sheep, squirrels, pole-cats and guinea-pigs, is, on the other hand, less restricted and they can apprehend a wider section of the visible spectrum.

Dr V. B. Droscher in *The Magic of the Senses* (1971), observes: 'The whole animal world, from the ant to the elephant, has an innate capacity for recognising shape and colour patterns, some quite complicated, which are unmistakable characteristics of other members of their species, their mates, rivals, prey and enemies.' Dr Droscher quotes Dr G. Ducker, of the Munster Zoological Institute: 'The sense of colour is best developed in monkeys. A full appreciation of colour, as with man, has been proved for *Catarrhini* like the rhesus monkey, pig-tailed macaque, baboon, Java monkey, and also for the common marmoset, which belongs to the *Platyrrhini*. With other *Platyrrhini* investigated, such as the capuchin monkey, spider monkey and squirrel monkey, a shortening of the spectrum at the red end became apparent, so that their colour vision could be compared with a red-blind human being. In the chimpanzee, colour vision is at least as good as in man.'

A trained human observer can distinguish around 250 hues, about 17 000 grey, white or black modifications of the hues, and up to 300 greys between black and white. Such colour discrimination, running into millions of colours, requires a sensory and nervous system that is complex in the extreme.

The physiological process by which the eye can distinguish one wavelength in the spectrum from another by its colour, or distinguish one coloured surface from

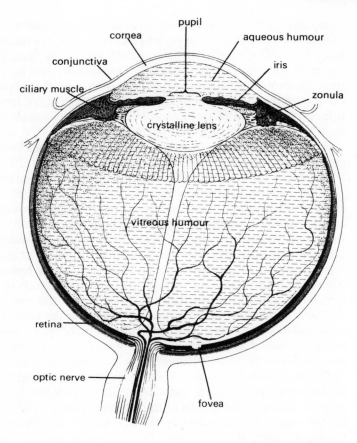

Figure 6.2 Section through the human eye

another, operates through retinal light receptors which give a characteristic response for each distinct colour. This does not mean that, for each of the many hundreds of thousands—even millions—of colours that can be distinguished, there is a particular type of colour receptor. That would be impossible, even though there are more than 100 million receptors in the retina. What it does mean is that a different pattern of nerve signals is generated by the colour receptors for each colour the eye can discriminate.

It is still by no means clear just how the retina does this very remarkable task, since the retinal tissue is an extremely delicate and complicated structure, and the receptors themselves, which are the key to the problem, are so tiny that it is very difficult indeed to study the chemical and electric changes that occur within them when light falls on the retina. It is known, however, that there are two types of light receptor in the retina, called the rods and the cones, and that the cones are responsible for colour perception.

The cones, of which there are about 6 million, are mainly located in the centre of the retina, and in particular in the fovea, a small dip in the retina which defines the

visual axis of the eye and which is used for seeing fine detail. The rods mainly occupy the extra-foveal and peripheral areas of the retina, and although there are more than 100 million of them, they do not give very sharp or detailed vision. On the contrary, they function chiefly at low illuminations and, by acting in groups, their combined response gives a visible signal even though very little light is falling on the retina. While they have this very high light sensitivity, they cannot distinguish one colour from another, which is why colour gradually drains away from a scene as dusk falls and night comes on.

At ordinary levels of illumination, however, the rods become inactive and the cones take over, giving good visual acuity or sharpness of vision, especially at the fovea, and a fully operative system of colour discrimination and colour perception. Because the eye has this maximum acuity at the fovea, the visual axis is like a sharp pointer, and in order to see the full detail in a scene, the eye has to dart across from point to point in the scene to build up a complete image of it. Similarly, the complete gamut of colours in the scene is only apprehended as the eye scans across the whole field of view. Only a very small section of the field of vision can be registered sharply by the eye, in one area only of the retina, the *fovea centralis*, where the cone-shaped cells are concentrated at a density of 15 000 to the square mm, which is sufficient for really sharp viewing of this tiny area. Nothing beyond this area is clearly seen. Some compensation for the limitation that this imposes is provided by almost imperceptible, extremely rapid, movements of the eyeball by means of its three pairs of muscles, in such a way that the whole scene encompassed by the field of vision can be almost simultaneously scanned.

The eye is never completely still: it performs involuntary tremor movements useful for two reasons. The individual cells of vision are divided by optically dead areas, forming on the screen of the picture a minute grid of black lines, which is blurred out of consciousness by the tremor. Also, the individual cells, because of chemical action, 'tire' if continuously exposed to a visual image by a fixed stare, causing the image to fade after a few seconds, or even disappear altogether. The tremor provides relief by bringing other cells into activity.

In some ways the eye is similar to the mechanical camera with an automatic distance meter. The muscular accommodation of the lens is linked with the convergence of the two visual axes of the separate eyes directed at the same point. The focal distance constantly lengthens or shortens as the lens adjusts to distance, and, at the same time, the aperture, or pupil, of the eye, controlled by the muscular expansion or contraction of the diaphragm, known as the iris, widens or narrows, regulating the amount of light admitted through the aperture. The eye adjusts to factors of height, direction, distance, parallax, diaphragm, and image analysis. Light falling on the retina at medium brightness stimulates the nervous system after a reaction period of 30 milliseconds. The nerve pulses take 5 milliseconds to reach the brain, and the brain takes a further 100 milliseconds to transcribe the information. The retina, examined microscopically, closely resembles the nerve structure of the brain; it is, in fact, evolutionally a part of the brain and acts as a projection for visual information. Part of the nerve system is adapted to registering light stimuli, and part of the control of the eye. In every human eye, the optical image strikes about 130 million visual nerve cells, each of which transforms its share of the image into a sequence of electrical discharges, or impulses: the brighter the light, the faster the cell discharges.

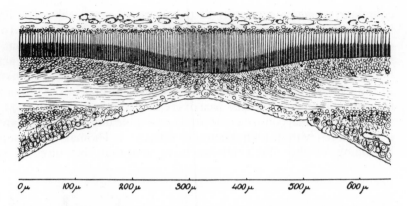

0μ 100μ 200μ 300μ 400μ 500μ 600μ

Figure 6.3 **Section through the central fovea of the human eye (from Polyak's *The Retina*)**

The electrical signals are first passed on by nerve fibres to the other two types of nerve in the retina, the bipolar and ganglion cells, and only then are passed on to the brain by a thick nerve bundle running from the retina to the brain and carrying about 1 million nerve fibres. About $1\frac{1}{2}$ inches behind the eye, the two optic nerve bundles from the left and right eye intersect at a point which is called the chiasma. About 1 inch behind the chiasma, the nerve fibres end in the primary visual centre, where each optic-nerve fibre appears to have its specific point of entry. From here, new nerve fibres extend to the visual cortex of the brain. There are 130 million nerve centres in the retina but only 1 million nerve fibres, so that the information is transformed in the primary visual centre, which acts as a kind of relay station. From each cell, the axon, an outgoing pathway ending in a terminal button, branches out like the delta of a river to touch neighbouring nerve cells on their incoming pathways, which are called dendrites. The points of contact between nerves are called synapses. When an impulse activates a nerve end, one of two chemical substances is released. One of these substances excites the new nerve cell, the other inhibits the excitation of the cell. Nerve cells are either excitatory or inhibitory, and every nerve end contains either one substance or the other, and is able only to excite or inhibit accordingly; by this means a nerve cell either accepts or refuses the transmission of incoming electrical impulses. These processes, which have been traced by incredibly intricate experiments involving electrical recordings from individual animal fibres, take place in millions of nerve cells simultaneously, all mutually affecting each other, at the rate of 10 changes a second. The perceived image is divided into millions of reactive fields formed from the activity of excitation centres consisting of excitatory or inhibitory cells. The nerve fibres pass from the primary visual centre and reach the visual cortex of the cerebrum. The cortex of the human brain is highly convoluted, giving a surface area of 20 square feet, and containing no less than 14 000 million nerve cells responsible for sensory perception, emotion, thought and creative power. From these nerve cells evolve intelligence, personality and character.

Seven types of nerve cells exist and they are arranged in seven layers defining boundaries of function—visual and auditory perception, for instance. The visual cortex of the human cerebrum is divided like a honeycomb into innumerable

columnar segments consisting of thousands of nerve cells. The light-sensitive nerve cells, or rods, located at the back of the eye, are closely packed over the back of the retina, but are more widely spaced in the central field of vision. The rods are super-sensitive to light but not at all to colour, giving only achromatic or non-colour perception, as in a black-and-white photograph. The colour receptors in the eye are the cones, and these are also located in the retina and at great concentration in the rod-free area of greatest colour sensitivity, the fovea.

It has now been confirmed beyond reasonable doubt that there are three types of cone, each with its own spectral sensitivity, as Thomas Young surmised at the beginning of the nineteenth century, and that this three-receptor system

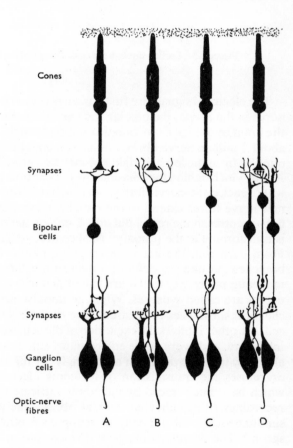

Cones

Synapses

Bipolar cells

Synapses

Ganglion cells

Optic-nerve fibres

A B C D

Figure 6.4 Retinal cones and associated neurones. A and B, diffuse types of connection between the neurones; C, connection between cone and ganglion cell via bi-polar cell found mainly in the central area of the fovea; D, complicated interconnection that can occur (after Polyak)

represents the initial stage of the visual process of colour perception. Experiments with additive light mixture provided strong circumstantial evidence for a three-receptor process, and recent research, in which the spectral absorption taking place in individual cones has been measured with a micro-spectrophotometer and has established the existence of three types of cone in the retina of monkeys and men. One type has its maximum sensitivity in the blue part of the spectrum, the second in the green, and the third towards the red. Each wavelength generates

responses in the three receptor systems which are characteristic, in their relative values, of that particular wavelength, and not imitated by any other wavelength. In this way the possibility exists for the generation of a continuous range of hues through the spectrum.

Until recently, the exact mechanism by which the eye recognises colour was not precisely known, for not until 1963 did the research of several scientists, working independently, and confirming Young's hypothesis, reveal fairly conclusively that there are, in fact, three types of colour-vision cells, each containing a different visual pigment responding to a different section of the visible spectrum; the exact areas of spectral sensitivity, however, are still argued. The selective sensitivity of these cells varies greatly in different animals, for instance, in man, fish and insect: a bee characteristically perceives green, blue and ultra-violet, but not red, and a goldfish, or a rhesus monkey, perceives no ultra-violet, having colour vision similar to man's.

In addition to the three-receptor process, two other processes contribute to complete colour perception. The first of these is the transmittance of the signals generated in the colour receptors to the visual cortex in an identifiable form, and the second is the distinct colour sensation arising from the signals received in the visual cortex. If the signals become confused, or scrambled, in their passage from the receptors across the retinal tissue and along the optic nerve to the lateral geniculate nucleus before the visual cortex is reached, any possibility of perceiving the individual hues in the spectrum would be lost. Also, unless some process in the visual cortex creates, as a visual sensation, the unique qualities of redness, greenness, yellowness, blueness, whiteness and blackness, and their intermediate colour sensations, then the possibility of perceiving different colours could not exist.

The physiological process of colour perception consists of a continuous chain of events, no one link being more important than another, but not all the links are fully understood. There is a very strong presumption that some form of coding of the signals takes place in the synaptic layers, rather as if the retina functions like a computer. Some form of coding appears to be inevitable, since the optic nerve would not otherwise be able to control all the information being continuously recorded in the retina.

According to present knowledge, colour vision is thought to be a two-stage process. First the visual cells work on the tristimulus principle originally put forward by the great English scientist, Thomas Young, and developed later by another great scientist, the German Helmholtz. Second, the succeeding nerve chains, by means of the excitatory and inhibitory system, codify the received information on the principle of complementary colours, hypotheses investigated by Goethe, followed by Schopenhauer, Chevreul, Helmholtz, and also by Hering. The latter first formally proposed the complementaries as a functional part of the physiological visual system, in his opponent-colour theory that postulated three pairs of processes each consisting of two opposed colours: red/green, blue/yellow, and white/black.

The respective merits of the Young–Helmholtz and Hering hypotheses have been hotly debated for decades, and seem now to have been resolved by an acceptance of both. Experiments by Rushton of England in 1962, and by

MacNichol in the U.S.A. and others have vindicated the Young–Helmholtz theory at the retinal level. The Hering opponent-colour theory is supported by electro-physiological experiments behind the retina, along the optic nerve and in the higher nervous system of the brain, indicating that there are brain cells responding in an on/off way to blue/yellow, red/green, or black/white stimuli, and this theory has been developed by several scientists, including the Swedish psychologist Svaetichin, the American neurologist De Valois, and by the work of Hurvich and Jameson of the University of Pennsylvania. The subject still provides a fertile field of research.

The visual process is not a static process in which a given beam of light always produces the same response in the retina and visual cortex, but a dynamic process in which the sensitivity of the receptors is being continuously monitored or adapted according to the level and colour of the illumination on the retina. This is a form of adaptation to the environment and is an important factor in maintaining a considerable measure of constancy of appearance of the environment in spite of changes in the illumination. Compared with daylight, the spectral energy distribution in the light from a tungsten lamp has very much more energy in the red end of the spectrum than in the blue, yet the eye compensates for this when in a room illuminated by tungsten light, because the red-sensitive receptors lose some of their sensitivity as they adapt to the strong red component in the energy distribution, whereas the blue-sensitive receptors gain in sensitivity under the blue-deficient energy distribution. The appearance of the room is not, therefore, greatly different and certainly not as different as might have been expected under tungsten light compared with daylight, although minor differences may be apparent.

The eye is capable of tremendous adaptability to changing light conditions. White paper reflects 10 000 times as much light under noonday sunlight as under candlelight. By full sunlight it can be extremely difficult to read fine print because of the brilliance of the illumination, and by full moonlight, almost impossible because of the weakness of the illumination. These conditions are nearing the outside limits of keen vision governed by power of illumination. Under both these extremes of illumination, colour vision is diminished: it is almost non-existent by moonlight, and completely so by starlight, when cone and foveal vision no longer functions. Night vision is dependent on the activity of the rod cells, which are highly sensitive, and daylight acuity and colour vision is dependent on the cone cells. In twilight conditions, both rods and cones are operative, though colour discrimination is unreliable.

By means of general adaptation, the eye can accommodate to wide variations of illumination, the time needed for adaptation varying according to the degree of contrast. The light sensitivity of the rods is due to light absorption by the photosensitive pigment rhodopsin contained in the rod cells. Rhodopsin is decomposed by bright light so that its concentration is reduced, causing insensitivity of the rods in conditions of bright illumination such as daylight. The bleaching process is so rapid that the eye can adapt fully in a few minutes, but rod sensitivity is only fully regained when the normal nutritive processes of the eye have built up the required concentration of rhodopsin in the rod cells, which takes about half an hour to adjust from sunlight to complete darkness. The mathematical relation

between sensation and stimulus is expressed in Fechner's law, contained in Fechner's *Elements of Psycho-physics* published in 1860.

After-images are another example of the adaptation process of the retina and visual system. A prolonged, steady gaze at an appropriately illumined coloured area produces a state of local adaptation on the retina. When the gaze is transferred to a uniform white area, the previous pattern is seen, but in its complementary colour. This occurs because the receptors previously most stimulated have lost their sensitivity. As the receptors regain their sensitivity, so the colours in the after-image change. If the initial stimulus is sufficiently powerful, a cycle of colour changes takes place, and this phenomenon is known as successive contrast. When light penetrates a normal human eye, the yellow spectral rays converge on the retina, the blue rays converge to the front of the retina, and the red rays to the back; because of the differences in wavelength, the distance between the red and blue focal points is approximately 0.6 mm. This physiological fact may affect certain other adaptations the eye makes to chromatic associations.

The greatest chromatic difference between two colours is that between complementary colours. The additive light primaries, red, green and blue, are complementary to the respective subtractive primaries, cyan, magenta and yellow. On a correctly divided colour circle, diametrically opposed colours are complementary.

The pairs of complementary colours red/green, and yellow/blue are fundamental to colour vision. The great German poet and philosopher Goethe was fascinated by visual perception and was deeply involved in experiments with the phenomena of simultaneous and successive contrast relating to complementary colours and incorporating the after-image.

The after-image, in both simultaneous and successive contrast effects, is a physiological means of exaggerating the differences of contrast, phylogenetically evolved as an aid to clarity of vision, and it was Goethe who remarked: 'Every decided colour does a certain violence to the eye, forcing the organ into opposition.' The opposition to which the eye is forced is the sensation of after-image inherent in complementary colour relationships—a psycho-physiological process. Visual concentration on an isolated and fully saturated yellow surface causes the red and green receptors, which transmit the sensation of yellow to the brain, gradually to lose their sensitivity. When the gaze is shifted to a white surface, the after-image is blue because the blue receptors are not yet stimulated. A concentrated and prolonged stare at a blue surface diminishes the sensitivity of the blue receptors; then, when the gaze is shifted to a white surface, the red and green receptors are stimulated by the long and medium wavelengths and a yellow after-image appears. Similarly, concentration on a red surface, for not less than 20 seconds, stimulates only the red receptors in the retina, and transference of the gaze to white paper then produces a green after-image. Alternatively, concentration on a green surface produces a red after-image. When the areas of complementary colours are adjacent, rapid scanning of the juxtaposed areas stimulates equally all three types of retinal receptors, as though by white light, and there is subsequently no loss of receptor sensitivity or visual fatigue. For instance, in the rapid scanning of adjacent blue and yellow surfaces, the short wavelengths of the blue surfaces stimulate the blue receptors, and the combined long and medium

wavelengths of the yellow surfaces stimulate the red and green receptors, almost simultaneously, producing a sensation of whiteness or desaturation of the complementary hues. Adjacent areas of red and green surfaces produce similar effects.

The phenomena of simultaneous and successive contrast are stimulated by visual factors other than complementary colours. For instance, contrast in value between achromatic greys, quintessentially between black and white, produces a similar phenomenon, except that value, and not hue, is the operative factor, so that visual concentration on a black area produces on a neutral grey ground a complementary white image, and vice versa. The same effects occur with contrasting intermediate greys, though the effect is not so pronounced. In achromatic after-image, the sensation is more often the result of stimulation of rod, rather than cone, cells; after-images deriving from less saturated, or greyed, complementary colours occur, but are less striking.

Conditions of total darkness contrasted with bright sunlight, or black surfaces against white, represent the extremes of achromatic contrast. Blue and yellow represent the extreme of chromatic contrast, since at full saturation these two complementary colours contrast in both hue and value, yellow being the lightest, and blue the darkest of the hues. The red and green complementaries are, by comparison, equal in value, and for that reason, visually more confusing.

Johannes Itten, famous as a founder member of the Bauhaus and as a teacher of colour theory in Germany and Switzerland, identifies, in his *Elements of Colour* (1970), seven kinds of colour contrast: (1) contrast of hue; (2) light–dark contrast; (3) cold–warm contrast; (4) complementary contrast; (5) simultaneous contrast; (6) contrast of saturation; (7) contrast of extension (area).

These visual phenomena operate in three dimensions, and the process is universal and continuous. By means of these syntheses the mind receives a picture augmented and enhanced in three colour dimensions. Like all related phenomena, they are the product of both physiological and psychological responses, and depend for their understanding upon graphic illustration.

Edwin Land, distinguished American pioneer in colour photography and in applied polarisation, has studied the mechanism of colour vision for 25 years and has reached certain revolutionary conclusions in his retinex theory regarding colour-vision processes. Land uses a series of four photographic processes involving an ordinary black-and-white photographic process corresponding to rod vision, and a further three processes using three filters corresponding to the wavebands to which the three separate pigments of cone vision are sensitive, that is, in the long-wave (red), the medium-wave (green) and the short-wave (blue) spectral areas respectively, which together cover the whole of the visible spectrum in three broadly overlapping curves. He affirms that in the observation of any given colour, rods and cones combine in responding to the lightness value inherent in any given colour, and that differences in the ratio of the four separate rod/cone evaluations of the value dimension determine the quality of the colour sensation.

In an article in *The Scientific American*, December 1977, Land describes the eye as functioning with involuntary reliability to see constant colours in a world illuminated by shifting and unpredictable fluxes of energy, and in which 'virtually every scene is lighted unevenly, in which the spectral composition of the radiation

falling on a scene can vary enormously, and in which illumination as brief as a lightning flash suffices for the accurate identification of colour'. He points out that the hypersensitive system based on the rod cells in the retina functions at light levels as much as 1 000 times weaker than the systems based on the cone cells, and that although the rods can be stimulated at light intensities below the cone threshold, the photosensitive molecules comprising the visual pigments of the cone cells cannot be stimulated without exciting the rods.

Land concludes: 'The reason that colour at any point in an image is essentially independent of the ratio of the three fluxes on three wavebands, is that colour depends only on the *lightness* in each waveband, and lightness is independent of flux. . . . How could the biological system generate a hierarchy and spacing of lightness values given only the flux from each point in a scene and knowing nothing about the pattern of illumination and nothing about the reflectances of objects?'

If one looks at black-and-white photographs taken through retinex filters, (Land equates 'retinex' with retina plus cortex) one sees a dramatic difference in lightness for most objects, between the photograph representing the short-wave system, and either of the photographs representing the other two systems. And yet it is the comparatively small differences between the long-wave and the middle-wave lightnesses that are responsible for the experience of vivid reds and greens. Such reliable and sensitive responses to small lightness differences provide the basis for the colours seen under anomalous conditions far removed from those the eye has evolved to see.

Only those with normal colour vision react in a standard or normal way to colour contrast. The most important reason for differences in colour vision between one person and another is the way in which defective colour vision is transmitted from one generation to the next: about 8 per cent of human males are affected by some degree of colour defect, while the number of colour-defective females is much smaller, probably less than a half per cent. Defective colour vision, or colour blindness, as it is often rather misleadingly called, is almost certainly the result of the absence, or reduced sensitivity, of one or other of the three colour receptor processes in the retina. This leads to reduced colour discrimination so that colour defectives see fewer distinct colours than those with normal colour vision. The commonest form of defect gives rise to reduced colour discrimination between the red/yellow/green range of colours, so that sometimes red and green colours are confused if they are of the same intensity or luminosity.

The first serious study of colour deficiency was made by John Dalton. His paper, presented in 1794 and entitled *Extraordinary Facts relating to the Vision of Colours* included, as a result of observations on a pink geranium, the following passage: 'The flower was pink, but it appeared to me almost an exact sky-blue by day; in candle-light, however, it was astonishingly changed, not having then any blue in it, but being what I called red, a colour which forms a striking contrast to blue. Not then doubting that the change would be equal to all, I requested some of my friends to observe the phenomenon; when I was surprised to find that they all agreed, that the colour was not materially different from what it was by daylight, except my brother, who saw it in the same light as myself. This observation clearly

proved that my observation was not like that of other persons; and at the same time, that the difference between daylight and candle-light on some colours was indefinitely more perceptible to me than to others.'

From this account, Dalton would now be classed as a protonope, and the mention of his brother is an early indication that the condition is hereditary. Characteristically, as a protonope, he was more sensitive to changes of illumination than the normally sighted.

Dalton's description of the spectrum, contained in another passage, defined his colour deficiency more clearly. He listed six main hues seen by the normal observer as red, orange, yellow, green, blue and purple, but remarked that he himself saw only two distinct hues, yellow and blue, with purple as a possible third. This was because he was a dichromat, having only two active types of colour receptors instead of the usual three of those with normal colour vision, who for this reason are called trichromats. Professor Wright comments: 'I suppose that from the philosophical point of view, this attempt to enter the private visual world of a person with a different visual system from one's own, is the most fascinating part of the business. Certainly, when I read Dalton's paper I have the impression that this is what fascinated him, rather than the cause of his abnormality. To me, one of the most interesting questions is whether the visual cortex of a colour defective could generate redness and greenness and blueness, if only the right types of signal were being transmitted along the optic nerve. To judge from cases reported in the literature of subjects who have appeared to be colour defective in one eye, and normal in the other, the answer is "Yes", but they may not be typical of subjects who are colour defective in both eyes.' He also observes that the genetics of colour vision have yet to be unravelled.

Three main categories of colour vision exist: *normal trichromat*; *dichromats*, of whom there are three separate types: (a) protonopes, (b) deuteranopes, and (c) tritanopes; *monochromats*, of whom there are two types: (a) cone monochromats, and (b) rod monochromats.

Each type of colour vision has characteristic spectral sensitivity, wavelength discrimination, and colour-matching ability. Normal trichromats have adequate colour discrimination over the whole range of chromaticities, protonopes tend to confuse red, grey and bluish green, deuteranopes tend to confuse purple, grey and greenish blue-green, and tritanopes confuse yellow, grey and mauve. For monochromats all colours are confused.

There are also protonomalous observers, who, in order to match monochromatic yellow light by a mixture of monochromatic red and green light, require an excessive amount of red, and deuteranomalous observers requiring more green light than normal in order to do so. Although all these characteristics are capable of definition, and can be tested in various ways, it must be said that for every type of observer there are individual differences in colour discrimination. Also, however sophisticated the colour-vision testing technique, no individual observer can ever actually experience the colour sensations of another. Colour in this context is completely subjective. It is always difficult to grade the ability to identify a given colour, or to discriminate between colours, and certain standards of illumination and testing are recommended. Among those testing devices most in current use are sets of cards selectively printed in variously coloured dots

incorporating a symbol such as a letter or a number, which can only be recognised by normal viewers, or, alternatively, only by those with a particular type of colour-vision defect because of the precise colour relationships of the dots. The Ishihara test (Nippon Ish Shuppan Ltd) is one of the best known of these, with supplementary Farnsworth charts relating to particular defects designed on the same principle. The A.O.–H.R.R. test (American Optical Co., Southbridge) is an American version. The very comprehensive Farnsworth–Munsell 100 Hue and Dichotemous tests (Munsell Co., Baltimore), while ideal for the diagnosis of many types and degrees of defect, require fairly sophisticated monitoring.

Colorimetric instruments are also available, using spectral stimuli for diagnostic purposes, which give excellent results but require even more specialised administration. What is now emerging, from a mass of diagnosis, observation and experiment, is a very much more professional approach to colour-defective vision, and with it a more sensitive appreciation not only of the difficulties encountered by colour-defective subjects but also of their individual potential for specialised aptitude applications. For instance, it is now recognised that, because of superior value discrimination and particular colour anomalies, it is almost impossible to deceive certain types of colour defective by conventional military camouflage never spotted by the normal observer. Often, without expert diagnosis, the colour defective can be quite skilful at concealing the defect, just as the illiterate often manage to conceal their difficulties, but it is now possible to specify, more positively than previously, precisely which occupations are barred to specific types of colour defectives and why certain diagnoses may close some doors but open others. Diagnosis is also a help in anticipating difficulties that may arise in education that involves the use of colour—such as, for instance, map-reading, various kinds of colour-coded charts and diagrams, and also visual analysis of physical and chemical phenomena, when the option of colorimetric readings, or spectral curves, is not available.

Once diagnosis is obtained, most of these educational difficulties can be overcome, and the choice of a career is simplified.

7
Colour and the Mind

A famous passage from Newton's *Opticks* defines the visual process: 'For the rays, to speak properly, are not coloured. In them there is nothing else than a certain Power and Disposition to stir up a sensation of this or that Colour. So Colours in the Object are nothing but a Disposition to reflect this or that Rays more copiously than the rest; in the Rays they are nothing but their Dispositions to propagate this or that motion into the Sensorium, and in the Sensorium they are Sensations of those motions under the Forms of Colours.'

The physical stimulus, physiological response and psychological sensation are presented by Newton in terms that are still valid today.

The three stages of the process of colour perception consist of:

(1) the light entering the eye and the factors which determine the spectral composition of light—that is the *physics* of the process;
(2) the response to the light in the retina and visual pathways—that is the *physiology* of the process;
(3) the colour actually perceived and the psychological response to the colour appearance—that is the *psychology* of the process.

But the actual sensations of colour are beyond definition. In his book *The Rays are not Coloured* (1967), Professor Wright explains: 'We come up against the ultimate mystery of the colour sensations themselves. What is redness? What is green-ness? We simply do not know. We cannot describe them in terms of any other parameter. What we can say, however, is that colour is a unique form of data display, a method of information presentation which tells us about the world in which we live.'

Enlarging on the function of the visual process, he continues: 'The fact is that it is biologically vital to have as many clues as possible to the chemical nature of different substances, and colour is one such clue. A beam of ordinary white light has an immense capacity for carrying information about spectral absorption, and the retinal colour receptors provide an elegant means of recording this information and discriminating between one type of absorption and another.

The observer has no way of communicating a sensation of colour he experiences

as redness, green-ness, etc., other than saying that green-ness, for example, is the colour perceived when we look at grass. But this will not mean anything to someone with defective vision, and what green-ness is cannot be conveyed to such a person. And although it is reasonable to suppose that all those with normal colour vision experience the same colour sensations, this can in no way be proved.'

Colour as a psycho-physiological phenomenon depends again on three related processes:

(1) a cerebral sensation of colour experienced in the visual cortex as a colour image;
(2) the projection of the image into physical space;
(3) the identification of the colour image with the object, which materialises as a substance of a characteristic shape and colour at a distance from the observer.

This third phase of the transformation of the sensory into the substantial, achieved when the cerebral sensation of colour, experienced as a colour image, is transferred to something material, uniquely shaped and coloured, beyond the physical presence of the observer, is, again, incommunicable. It is an objective process, whereas the other two, experienced within the observer, are subjective processes.

When, however, he looks at coloured objects, the observer sees the colour as a very real part of the object; he sees a scarlet flower, a blue butterfly and so on. From that point of view, colour is objective. This is a fundamental aspect of the colour-perception process.

The subjective/objective aspects of colour perception have been explored by many writers on colour. David Katz in his *The World of Colour* (1935), observes: 'Colour phenomena are always characterised by objectification; they are always seen "out there" in space. This applies even to such phenomena as after-images, or the intrinsic visual grey, which owe their existence solely to conditions in the retina of the visual cortex, and are quite independent of external objects. When we speak of subjective visual sensations, we do so merely to indicate the absence of an objective stimulus source; we never imply that they possess an immanent property which permits them to be experienced as belonging phenomenally to our own bodies. No matter how intently we project ourselves into a subjective phenomenon, such as that of the intrinsic visual grey, we can never succeed in catching even a faint trace of the feeling that it is something belonging to our own bodies.'

Katz also distinguishes between the sensations of sound and colour. In *The World of Colour* (1935), he says: 'In a perfectly uniform (sound) tone, which is undergoing no qualitative or intensive change, we experience, in the strict sense of the term, a process. ... This temporal structure is not possessed by a colour experience; a colour which is presented in a stationary visual field, neither comes into being, nor disappears, as does a tone. ... A colour is experienced as something permanently there.'

In Switzerland a pianist called Robert Strubin, who, as a result of a heart condition, was unable to continue playing the piano, diverted his passion for music into paintings, by transcribing the notes of the music into colours. Regarded as an

Fig. 9.

Fig. 10.

Figure 7.1 Newton's colour circle and refraction and diffraction diagrams (from his *Opticks*, 1706). See pages 56, 57

eccentric, Strubin had the rare facility of being equally fluent as a pianist and as a painter. Unlike Kandinsky and Mondrian, who both attempted intuitively to convey sound effects in paint, Strubin worked methodically in direct transcription of musical scores, using selected favourite passages of music. For Strubin, each sound had an exact colour and an exact shape: either warm or cool, heavy or fine, emphatic or restrained. Rhythm was suggested by the rise and fall of patterns of colours, and by spacing. Unfortunately, Strubin left no record of his system, but his paintings bear comparison, as works of abstract art, with the paintings of distinguished modern artists.

More recently, the American educationist Dr Caleb Gattegno in *Towards a Visual Culture* (1969) has attempted the teaching of music by the association of sound with colours and shapes on the television screen. Dr Gattegno's *Words in Colour* (1969) method of teaching reading by the association of colours with phonetics is well known in the field of remedial and primary education.

Colour sensation is contrasted with both auditory and tactile sensation by Adrian Stokes in *Colour and Form* (1937): 'The visual world, principally in virtue of colour, allows us to create the perfect image of outwardness and of otherness. . . . Such quality distinguishes phenomena presented to the eye from those presented to the ear and to the sense of touch. . . . If we actually experience colour phenomena as subjective, we do so only with the help of certain secondary clues. . . . With touch phenomena, however, it is quite different. . . . Here we have a combination, seemingly indissoluble, of two components, one subjective, with a body reference, and the other objective, suggesting properties of objects. For this reason, I have described touch phenomena as bi-polar.'

Ostwald, too, compared the sensations of the eye with those of the ear: 'When the ear receives a complicated set of vibrations, it is able to resolve them, so far as they are capable of discrimination, into the simple constituent sine waves. The eye, however, is absolutely powerless to effect this sort of analysis. It unavoidably perceives any given mixture of light rays as a homogeneous sensation; so that a mixture containing all sorts of frequencies, which, in the world of sound produces a disagreeable noise, is, in the case of our eyes, seen as a clear restful white.'

The traditional concept of visual perception, developed by Immanuel Kant, which embraced an intuitive grasp of external reality similar to a grasp of mathematical propositions, was challenged by Hermann von Helmholtz, who hypothesised that perception required inferences drawn from available sensory and stored data, and that from these 'unconscious inferences', perceptual conclusions were reached with more or less accuracy depending on the difficulty of the problem to be solved.

Much depends upon the word 'intuition'. One definition of intuition as 'acute sensitivity to relevant data' narrows the margin of difference.

R. L. Gregory in *Illusion in Nature and Art* (edited by R. L. Gregory and E. H. Gombrich, 1973) puts a contemporary point of view: 'Eye and brain combine to give detailed knowledge of objects beyond the range of probing touch. Just how this is achieved, remains in many ways mysterious; but we know that specific features of objects are selected and combined to give an internal account of the object world. This must surely require processes of the utmost complexity. The ease with which we see, apparently by merely opening our eyes, hides the fact that

this is probably the most sophisticated of all the brain's activities; calling upon its store of memory data; requiring subtle classifications comparisons, and logical decisions for sensory data to become perception.'

Commenting that 'it is quite surprising how the brain gets totally left out of some psychological theories of perception', Gregory remarks that the illusion phenomena negate the Gestalt concept of perception, which included the idea of electrical 'brain traces' adopting the shape of perceived objects, and having dynamic properties which generated perceptual phenomena, called isomorphisms. Gregory asks:

How does the isomorphism idea cope with other features than shape? Consider colour: are we supposed to believe that when we see a green traffic light, part of our brain turns green? It certainly does not—and if it did, would it help us to see green? Only if there were some kind of 'internal' eye to 'see' the green traces: but this would generate an endless regress of traces and eyes, and traces and eyes . . . leading to an infinite distance, with nothing different from the start of the regress . . . The trouble is that for each illusion, there is a tendency to postulate special properties for the traces; but this is a weak kind of explanation. . . . Once learning is accepted as important for perception, any direct 'intuitionist' account fails: for no-one holds that we have immediate knowlege of the past. The past cannot be perceived directly; but if stored information, from past experience, is vital for present perception— if the present is read in terms of the past—then we are driven away from an intuitional or Gestalt position, towards a theory much closer to Helmholtz's notion of perception given by inference from sensory and stored data.

Helmholtz himself wrote: 'The simple rule for all illusions is this: we always believe that we see such objects as would, under conditions of normal vision, produce the retinal image of which we are actually conscious.'

Illusion apart, the psychological, emotional and aesthetic response to colour is highly complicated. As Professor Gombrich points out in his *Art and Illusion* (1960): 'We can never neatly separate what we "see" from what we "know".'

Visual information in the form of light energy is continuously reaching the retina, forming an image which is transmitted as a series of action potentials in the form of coded representation of the information to the visual cortex, where, it is presumed, these messages are decoded, to produce mental or visual images. The visual cortex, in fact, appears to act as a computer, assessing retinal information and relating it to acquired memory data, and creating conceptual images in a kind of visual shorthand that is probably connected with man's language of visual symbols.

It is difficult at any stage to draw a clear distinction between the exact function of the eye and the interpretation of the brain. Together they detect light and individual colours, projecting a mental image of constancy and stability in the outside world, in full colour, in three-dimensional form and space, so that, adapting to changing conditions of illumination, a distinction can be made between object and field, and between motionless and moving objects. Once the colours on the retina are separated in the mind and begin to take shape, a

psychological tendency arises towards simplicity, regularity and symmetry. This adaptation is probably made to facilitate recognition and remembrance, rather like a form of Pelmanism. The effect is a kind of shorthand of shape, simplifying complex shapes and imposing regularity and symmetry on irregular and asymmetric shapes, so that in its simplest form the mental image of, for instance, a near-circle becomes a perfect circle in the imagination, and a near-square becomes a perfect square, and so on, as clinical research has revealed. The converse of this adaptation is that the mind can conject from simple visual images a mental image of much greater complexity, and this has enabled man to use visual symbols from very early times, and from a very early stage of childhood.

Besides mental adaptation to the shape image, further adaptations are necessary to enable the observer to apprehend solidity, space and distance. Apart from the functional processes of the eyes in the visual apparatus, with their ability to co-ordinate and focus, and their placing to form a fused stereoscopic image from two slightly differing retinal images, the gauging of distance and solidity is inferred by means of mental processes which have cumulatively set up mental images and conditioned reflexes in the subconscious mind since the time of birth.

The mental processes are geared to postural reflexes connected with gravity and the orientation of the body to horizontal and vertical planes that enable the observer to maintain natural posture and to acquire the balancing skills needed for all kinds of complicated activities such as running, jumping, bicycling or skating. We have an innate awareness of the horizontal plane, and of the plane perpendicular to the horizon, familiar from early childhood, in the form of chairs, trees, houses and human beings, etc., which is essential for the accurate perception of space, and the ability to avoid moving objects. Much of the intricate process of visual observation is common to the human race, but it is qualified in great diversity by individual responses of perception, attention, memory and aesthetic sensibility.

A child is born with a functional mechanism of eye and brain. Within a few days of birth, the images recorded on the child's retina probably closely correspond to those recorded on the adult retina, but until experience and memory play their part in providing a framework of reference, the unadapted images are presented to the brain as a pattern of shapes and colours that moves, flickers and flows across the retina with the movement of the eyes and the body.

As Bernard Berenson wrote in his *Aesthetics, Ethics and History* (1948): 'The eye without the mind would perceive in solids nothing but spots or pockets of shadow, and blisters of light, checkering and criss-crossing a given area. The rest is a matter of mental organisation and intellectual construction.'

In his contribution to *Color for Architecture* (1976), entitled 'The Dialectics of Colour', in which he analyses current neuro-physiological findings on colour perception, Dr Peter Smith (University of Sheffield, England) examines the relationship between the brain and colour vision in the light of modern physiological research, and considers the functions of the limbic system and those of the higher brain or neo-cortex and their interaction. He explains that the limbic system embraces the organs within the mid-brain and brain-stem regions. It is believed that the limbic system is involved with processes of visual perception outside the capacities of rational mentation and conscious experience with which

the neo-cortex system is involved. The neo-cortex is divided into left- and right-hand hemispheres, each capable of independent sensation, perception, memory and learning processes, but with differing functions.

Dr Smith observes that the experiments of an American surgeon, Roger Sperry (J. Sault, 'The Human Brain', *Doctor*, 1972), offer conclusive evidence that: '... the left hemisphere is the centre of verbal and serial mathematical ability. It is the seat of logic and rational deduction. In contrast, the right side is efficient at processing abstract, non-verbal information, and handles spatial perception. It responds to texture, colour and tone, and is biased towards discovering patterns of coherence. Since it has a strong interest in the way things fit together to form a closed system, it may be said to be a decisive factor behind the aesthetic response.' The fundamental difference is summed up by Roger Lewin: "Sequential information processing occurs in the left hemi-sphere, and simultaneous processing in the right." ' ('The Brain's Other Half', *New Scientist*, 6 June 1974.)

This difference is reflected in the anatomical structure of each hemisphere. The cell and nerve patterns of the left side are noticeably more refined and sophisti-

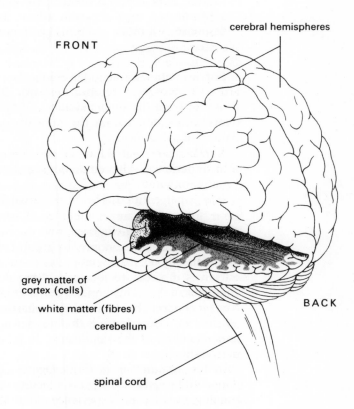

Figure 7.2 The human brain

cated than those of the right, facilitating high focal acuity. The wider scanning ability possessed by the right seems to be a direct consequence of its coarser structure. Dr Smith continues: 'From the point of view of colour perception, it is obviously the right hemisphere which is the relevant sub-system of the neo-cortex. This point, however, should be related to the fact that the primitive visual syntax of the limbic brain includes an ability to recognise certain colours strong in chroma and brightness. The primitive brain responds to anything that is exotic, things which glitter, and bright colours.'

Dr Peter Smith concludes that it now appears that the brain exhibits three attitudes to colour information:

(1) the response of the limbic system to shine and glitter and strongly saturated colours;

(2) the attribution by the limbic system of symbolic meanings connected with a symbolic programme with archetypal origins to certain of these colours and that these responses are intimately connected with a function of the hypothalmus that is responsible for the exteriorisation of emotional responses within the limbic system;

(3) the right cerebral hemisphere perceives colours more subtle and more sophisticated than those to which the limbic system responds, while the response is a more cerebral, less emotional response than that of the limbic system.

For aesthetic satisfaction in colour the mind requires stimulation from all three attitudes, evoking a cerebral response from the neo-cortex, and an emotional response from the limbic system. The aesthetic experience is a special kind of dialectic reaction within the mind to external stimuli which superimposes a pattern of coherence.

Katz believed that 'All visual percepts are influenced by knowledge that comes from experience. All men do not see alike because they are not equally aware or equally conscious.'

In a paper entitled 'The Non-Verbal Thinking of Children' (1957), Dr Margaret Lowenfeld, an eminent child psychiatrist, observed: 'It is one of the characteristics of intelligence, that the owner attempts, as if driven by an inner need for internal economy, to group his experiences together. We all do this automatically in cataloguing. As soon as we meet some new fact we say to ourselves in order to locate it: "that is something like an X with the added character of Y". This impulse starts at as early an age as we have been able to contact children, but it must be emphasised that the one essential characteristic of all children's experience is that it is new to them and comes . . . uncombined with understanding of the significance to other people of the sensorial experiences personally experienced.'

In his *Introduction to Physiological Optics* James Southall has commented: 'Good and reliable eyesight is a faculty that is acquired only by a long process of training, practice and experience. Adult vision is the result of an accumulation of observations and associations of ideas of all sorts, and is therefore quite different from the untutored vision of an infant who has not yet learned to focus and adjust

his eyes and to interpret correctly what he sees. Much of our young lives is spent in obtaining and co-ordinating a vast amount of visual data about our environment, and each of us has to learn to use his eyes to see, just as he has to learn to use his legs to walk and his tongue to talk.'

The emotional importance of colour to young children is the theme of two psychologists, Alschuler and Hattwick, in their book *Personality and Painting* (1947): 'Colour more than any other single aspect of painting has been of particular value in offering clues to the nature and degree of intensity of children's emotional life. One of the most readily perceived trends in children's paintings is that strong interest in using colour tends to be paralleled by strong emotional drives.'

Apparently, too, colour tends to be more intense and insistent among girls than among boys, who, in general, appear to be less emotional than girls. In experiments it was repeatedly found that those with strong emotional drives, who tended to use colour rather than form or line, also showed strong preferences for certain colours, and expressed themselves with colour and mass effects. The degree of freedom in expression, whether in drawing or colour, was closely related to the degree of emotional inhibition, as well as intellectual development.

In the experiments, some children consistently chose 'warm' colours—red, yellow and orange—and others 'colder' colours—blue, green and black. Data supported the view that emphasis of cold colours is not natural from the two to four year old who is well adjusted, but that once children have progressed normally from impulsive behaviour to the level of conscious control, and from mass techniques to working with line and form, a preference for cold or cooler colours becomes natural and no longer reflects inadequate adjustment. In general, at the nursery school stage, the consistent preference for red indicates relatively sound psychological adjustment, but when used very repetitively and to the exclusion of other colours, it can reflect an acute emotional experience either hostile or affectionate in nature. The choice of colour is, however, modified by the type of technique employed—heavy strokes indicating anger and disturbance, and light, circular strokes indicating gentleness and affection.

Yellow was found to be the characteristic choice of happy, extroverted children, and of those who were emotionally dependent and avoided independence. Blue was consistently favoured by those with emotional but highly controlled over-adaptive behaviour, who tended to be critical, assertive or undemonstrative. It paralleled self-control and the desire to be independent. Green indicated self-confidence and calmness— a blend of blue (control) and yellow (impulse). The choice of orange frequently indicated an active, adaptive relationship to the environment, a warm but not over-emotional relationship.

Multicoloured paintings showed originality, activity and good psychological adaptation. Sometimes warm colours were overlaid with cold colours, and this frequently indicated that warm emotional responses were being repressed. In particular, black was an indication of repressive feelings arising from fear or the desire to escape from painful emotions.

In education it is impossible to gauge the importance of colour in the lives of children, both as an environmental influence and also as a means of creative expression and of expressing and sublimating emotion.

Dr Lowenfeld has pointed out that the works of such artists as Chagall, Blake and Hieronymus Bosch, are rooted in, and provide a key to, the fantasy life of children. 'The great artist', she remarks, 'works with the same tools as our own experience could make accessible to all of us, but he produces results which are mysterious, and act powerfully upon us. Where the work of our patients very often reflects fear, horror and suffering, the work of these artists, even where we cannot understand it with our intelligence, affects some other part of our being in a way peculiar to itself, often calling out responses of which we did not previously know ourselves capable.'

The significance of colour as a dominant factor in visual perception is noted by David Katz in Faber Birren's *History of Colour in Painting* (1965), who found that colour rather than shape is more clearly related to emotion. He demonstrated this by arrangement of simple shapes—squares, triangles and circles—in three primaries—red, yellow and blue—which young children were asked to pair. He found that their selections were made according to colour rather than to shape.

Aldous Huxley remarks in his book *The Mind at Large*: 'It [the mind] evidently feels that colours are more important, better worth attending to than areas, positions and dimensions.' As Manet observed: 'There are no lines in nature—only colours and areas of colours.'

Hallucinogenic drugs, which produce paranormal perceptual effects by changing the chemistry of the blood and releasing inner image patterns of superabundant colour and light, are normally inhibited by the regular functioning of eye and brain. The stimulation of mind-expanding states can be induced by other circumstances than the taking of drugs: asceticism, migraine, nervous disorders, hunger, even prolonged choral singing can all create biochemical changes resulting in similar hallucinatory conditions. So can an artificial environment with stroboscopic lighting, brilliant revolving coloured lights and loud rhythmic sounds synchronised to gain maximal emotional response.

In his book *The Doors of Perception* (1963) Aldous Huxley has described the effects: 'One part of the mind remains critical and well orientated, but when the eyes are opened and closed, elaborately beautiful designs are seen—fields of brilliantly coloured jewels, vast and slowly changing geometrical constructions.'

Recently, interest has revived in the psychological response to neurophysiological aspects of colour by 'Op' painters, such as Bridget Riley and Victor Vasarely, and by kinetic artists whose continuously changing colour relationships produced by the use of coloured lights evoke non-static visual situations closely related to unadapted retinal images, and to the limbic areas of the brain.

Particular psychiatric disorders are sometimes associated with a predilection for certain colours, and, though research in this field is comparatively undeveloped, certain general areas of opinion have emerged—for instance, hysteria and anxiety complexes: green; manic conditions: red; melancholia: black; schizophrenia: yellow; paranoia: brown; and narcissism: blue-green.

In his book *Psychotic Art* (1950) Dr Reitman examines the work of psychotic painters, including van Gogh and Munch, and describes the changes in their use of colour before and after the onset of mental breakdown. One of the painters he discusses is the Victorian illustrator Louis Wain, whose conventional anthropomorphic portraits of cats were once well known. Dr Reitman notes: 'Wain's

Figure 7.3 *Fall* by Bridget Riley (Tate Gallery, London)

paintings became more abstracted when his general condition was worse.' The doctors who attended Wain diagnosed his illness as 'paraphrenia' complicated by 'organic dementia'. When he painted in hospital, Wain's paintings changed to highly ornamental abstract designs vaguely based on feline characteristics, but in exotic, unrealistic colours.

Light, as the source of colour, is the mainspring of the effect of colour on the human being. Felix Deutsch remarks in *Psycho-physical Reactions of the Vascular System to Influence of Light and to Impressions Gained through Light* (1937): 'Every action of light has, in its influence, physical as well as psychic components.'

In discussing this aspect of light, Faber Birren in his 'Psychological Implications of Colour and Illumination' (*History of Colour in Painting*, 1965), writes: 'Like all other living things, human beings have a radiation sense—even the blind. . . . The importance of light and colour to the psychological and physiological well-being of human beings is becoming recognised. It may be generalised that colour affects muscular tension, cortical activation, heart-beat, respiration, and other functions of the automatic nervous system, and certainly that it arouses definite emotional

and aesthetic reactions, likes and dislikes, pleasant and unpleasant associations. It has been found in clinical studies that flashing red lights induce epileptic fits, and pulsating stroboscopic light can produce headaches, nausea, and forms of nervous breakdown. Confinement and monotony may lead an animal to starve itself, to over-eat, to refuse to procreate, to devour or destroy its own kind or other species. Apes have been observed to withdraw within themselves in the manner of schizophrenics, or relapse into fatal lethargy.'

What is the effect on humans? Those who through circumstances are continuously deprived of visual stimulus—prisoners, hermits, solitary, long-distance sailors, travellers in deserts or other monotonous surroundings—often experience hallucinatory colour visions (sometimes similar to those resulting from drugs). The visions are affected by the preoccupations of the deprived individual—of food, angels, sex, and so on. R. L. Gregory, the well known writer on perception has written: 'It seems that in the absence of sensory stimulation, the brain can run wild and produce fantasies which can dominate.'

M. D. Vernon in *The Psychology of Perception* (1962), describing the effects of prolonged sensory deprivation on voluntary subjects in clinical conditions, remarks that after a few days without light, sound, or tactile stimuli, they suffered visual and auditory hallucinations. Babies in a monotonous hospital environment became confused and apathetic.

The implications of this hypothesis may be important in the interior design and colour schemes of large-scale social institutions—prisons, hospitals, schools and tenement housing.

Conversely, colour, it is claimed, can be used therapeutically to counteract neuroses, or even physical disabilities.

Cecil Stokes of California, created what he called Auroratone Films, in which flowing abstract forms in full colour were thrown upon a screen and accompanied by music, for use in the treatment of disfigured and handicapped patients. He found that most patients became more accessible; those whose speech was previously blocked or retarded, spoke more freely. In this state of accessibility it was possible for the psychiatrist to establish rapport.

Orthodox medicine, on the whole, ignores the use of vibratory light, with the exception sometimes of ultra-violet or infra-red light, which are both potentially dangerous to human tissue.

Dr Max Luscher, Professor of Psychology at Basle University, has made a special study of colour psychology for more than 20 years. He bases his 'personality test' on the theory that preferences for certain colours are related to the emotional impact of these colours; the colours people prefer, dislike, or are indifferent to, indicate certain personality traits. Luscher's colour test was presented at the International Congress of Psychology at Lausanne in 1947, and has since had a limited acceptance as a diagnostic aid by European psychologists and physicians.

In the full Luscher test, seven different panels of colours, containing 73 colour patches, are used in clinical research to afford information on the psychological and physiological condition of the individual. The shortened version of the test uses only one of the seven panels—the so-called eight-colour panel—both for

quick diagnosis of significant aspects of the personality, and for revealing psychological and physiological stress.

Luscher claims that his test can be used as a diagnostic instrument to uncover complexes and personal problems of which the subject is himself unaware. He believes that there are four basic colours, the emotional value of each being embedded in the human mind since primitive times. These colours are:

Yellow—since the life of primitive man was divided into the light of day and the darkness of night, the bright yellow of sunlight was associated with action and energy, for hunting and conquest. Yellow indicates an active personality, spontaneous, adaptable, creative.

Dark blue—the colour of the night sky, associated with sleep and security. Preference for dark blue indicates relaxation, passivity, tenderness and affection.

Red—Luscher, in general with most observers, associates the colour red with excitability, sexual desire, and the will to dominate. Those preferring red incline to be extrovert, erotic, competitive, enterprising, impulsive.

Green—the negative complementary of red, representing stubbornness, tenacity and resistance to change.

The four subsidiary colours of Luscher's test are:

Violet—preferred by the emotionally immature, and those with mystical and aesthetic tendencies.

Brown—a colour for those in need of security and physical comfort.

Black—representing the rejection of colour by those in revolt against fate, indicating renunciation or resignation, and

Grey—expressing neutrality, for the uncommitted and unresolved.

The test depends on the order in which colours are selected and combined and is sometimes dismissed as unscientific, but it rests on several years of clinical research, and a number of clinicians and psychologists have reported that they find the test of value as an adjunct to the orthodox clinical interview.

A practical approach to colour therapy is made in some psychiatric hospitals where spontaneous painting and modelling is encouraged for the mentally ill or disturbed patients. In the preface to Lydiatt's book on the subject (*Spontaneous Painting and Modelling*, 1971) Dr E. A. Bennet writes: 'For generations it has been noticed that some patients in psychiatric hospitals have an urge to express themselves in painting, modelling, or perhaps scribbling, provided material is available. No significance was given to this until a few perceptive doctors made an effort to understand the paintings, which at times resembled those made by children and had features found in primitive art.' At that time, art was still mostly very conventional and there was little interest in the art of children or primitives.

Dr Bennet continues: 'Neither the director nor anyone else knows how painting pictures "works". This of course might be said of other types of medical treatment. Whatever the explanation may be, it is true that in spontaneous painting

and modelling, restoration to health is assisted.' There is no aesthetic intention in such work, though sometimes this may be discerned.

The author of this book, E. M. Lydiatt, for many years directed art therapy centres in psychiatric hospitals. She became interested in the work of Jung, and much of her work is based on Jung's precepts. The illustrations of the book are a fascinating sample of psychotic paintings, and of the emotional significance of colour in these circumstances. In some cases, descriptions of their own paintings by the patients themselves, and of the feelings they experienced at the time, are added. Miss Lydiatt comments: 'Art can work in the same way as active imagination, that is, the unconscious and the conscious come together in the creation of a symbol, and this is health-giving and restoring.'

According to the Indian scientist Ghadiali, everyone is surrounded by a coloured aura, visible to 'sensitives' and sometimes to others. The aura absorbs white light and distributes the different coloured rays (or wavelengths) contained in white light, according to the several needs of the body.

The history of chromatherapy goes back to ancient Egypt where the effect of coloured light on human health was studied, and chromatherapy practised, in the temples of Thebes and Karnak. It was also applied in ancient China and India. Pythagoras and Galen are said to have practised it, and later, the Arabian physician Avicenna.

Those who currently practise chromatherapy generally put coloured light to the following uses:

Red—the element of fire, revitalises, stimulates and activates the circulation; helpful in cases of anaemia and paralysis.

Orange—stimulating but not as aggressive as red; used for the treatment of lungs, throat and spleen.

Yellow—generates energy; used for muscles, skin and the solar plexus.

Green—balance and harmony; used on the pituitary gland, the heart, and to relieve tension, and headaches.

Blue—antiseptic, cold and astringent; for colds, sore throat, rheumatism, hypertension and burns.

Blue-violet—cooling and astringent; used for pneumonia, and emotional and nervous disorders, and for eye, ear and nose complaints.

Violet—calming, slows the motor nerves, purifies the blood, and used for insomnia.

This is, necessarily, a very incomplete and inexact list of the applications of chromatherapy, and, as with all fringe medicine (and much that is orthodox), it is arguable that such benefits as are claimed for chromatherapy are psychosomatic.

Although colour has a particular significance for psychotic and emotionally disturbed people, colour is recognised as a strong emotional factor in the lives of most normal people. Certainly the psychological and emotional aspects of colour have the most popular appeal, and, although scientific and medical opinion may be sceptical of the rational validity of these aspects, the apparent universality of general interest, lends weight to what is essentially a subjective field.

Colour symbolism: in a medical paper (1964), quoted by Koestler in his *The Ghost in the Machine* (1967), the author, Dr P. Maclean, deduces that the limbic system contains information structures—'ancestral law and ancient memories'—and attributes to the limbic brain a capacity for symbolic responses with particular reference to colour, associating a colour, such as red, symbolically with blood, fighting, flowers, fire, etc.

Kurt Goldstein, writing on tendencies in reaction to colour, observes: 'One could say red is inciting to activity and favourable for emotionally determined actions; green creates the condition of meditation, and exact fulfillment of the task. Red may be suited to produce the emotional background out of which ideas and actions will emerge; in green those ideas will be developed and the actions executed.'

Symbolism appears to be an integral part of human comprehension and communication. Colour symbolism usually derives from one of the following sources:

(1) the inherent characteristic of each colour perceived intuitively as objective fact;
(2) the relationship between a colour and the planetary symbol traditionally linked with it;
(3) the relationship which elementary primitive logic perceives.

Modern psychology and psycho-analysis place more weight upon the third of these, regarding symbolic impressions formed in the mind as fortuitous. Jolan de Jacobi, in a study of Jungian psychology, has this to say: 'The correspondence of the colours to the respective functions varies with different cultures and groups, and even among individuals: as a general rule, however . . . blue, the colour of the rarefied atmosphere, of the clear sky, stands for thinking; yellow, the colour of the far-seeing sun, which appears bringing light out of an inscrutable darkness, only to disappear again into the darkness, for intuition, the function which grasps, as in a flash of illumination, the origins and tendencies of happenings; red, the colour of the pulsing blood and of fire, for the surging and tearing emotions; while green, the colour of earthly, tangible, immediately perceptible growing things, represents the function of sensation.'

Because of the subjective character of colour psychology and symbolism, an almost inexhaustible fund of material relating to what amounts to the mythology of colour symbolism has been written. Jung's own definition of the word 'symbolism' is 'The best possible expression for a complex fact not yet clearly apprehended by consciousness'.

But at what stage in human consciousness does symbolism emerge? A number of young apes were used in a research project run by Allen and Beatrice Gardner at the University of Nevada, U.S.A. The apes lived with a human family from the time of their birth, and were taught a sign language similar to the deaf-and-dumb language. It is claimed that one young chimpanzee at the age of 3½ had a vocabulary of 117 words. She was able to conceptualise her sign language by simple symbols of, for instance, a bird or a cat, interpreted as ideographs rather than as representational drawings.

Desmond Morris, in his fascinating book *The Biology of Art* (1966), records a comparative analytical study of the spontaneous graphic expression of prehistoric and primitive man, young apes, and young children from all parts of the world. Dr Morris reveals that as soon as graphic material can be manipulated by the young of any of these groups, graphic expression is attempted, and he notes that such graphic expression is governed by certain biological principles.

It appears that at its most primitive level, graphic expression is a biological and psychological compulsion, universal in form and content, and that inherent physiological and mental characteristics compel the mind (in a way perhaps rather similar to Noam Chomsky's universal law of language) to seek, in the use of graphic material, aesthetic satisfaction—harmony, balance, rhythm, and symmetry, in obedience to natural law.

It is a property of the eye not only to seek, but by a proces of synthesis, to build harmony from the raw material of light and three-dimensional colour. The conscious use of this power to synthesise is the primary function of the aesthetically trained eye, relating to colour, form and shape. Mental picture making is an inherent property of the visual process consciously or unconsciously resolving heterogenous visual material into an image that is visually satisfying and meaningful.

Dr Morris illustrates his book with paintings by young chimpanzees and young children, showing the similarity in their manipulative ability and graphic expression in the early stages of their development.

The muscular factor controlled by facility of natural movement has a direct effect upon graphic expression, and an indirect effect upon visual perception. The psychological factor is also influential in the perception of colour at an early stage.

Eric de Maré in his book *Colour Photography* (1968), writes: 'Different colours have certain meanings which are universally accepted. How can red and orange be anything but warm, as fire is warm, or green and blue be anything but cool, as woods and lakes are cool? Colours can convey moods to us all—of conflict or tranquillity, sadness or gaiety, warmth or coolness. They can whisper or shout, be male or female, tender or brutal, sweet or sour, boring or stimulating. We all know what is meant by "seeing red" or "feeling blue", just as people did in the past when they spoke of "choleric red" and "melancholy blue".'

This is a personal and poetic interpretation of colour symbolism. Few colours, in fact, have meanings that are 'universally accepted', since colour is fundamentally functional and can have localised meanings. Eskimos, for instance, as Margaret Mead has pointed out, have 17 separate words for white to distinguish their different snow conditions. In the West the bride wears white; in China white is worn for mourning.

Certainly colour symbolism has been a conspicuous feature of western civilisations, as John Ruskin has observed in one of his late nineteenth-century lectures (*Aratra Penteleci*): 'Colours have been the sign and stimulus of the most furious and fatal passions that have rent the nations; blue against green, in the decline of the Roman Empire; black against white in that of Florence; red against white, in the wars of the royal houses of England; and at this moment, red against white, in the contest of anarchy and loyalty in all the world.'

Of all colours, the symbol of red is the most universal. So, as Maré continues: 'Red is the most positive of colours, the most violent, aggressive and exciting. It attracts the eye more strongly than any other. It was the first colour to have been given a name in early languages, and it has been used more often than any other in primitive art. The word red is one of the few colour names which occur among the first 500 most frequently used words in the English language, the other two being black and white. (Fourteen colour names in all occur in the first 1 000 words.) As everyone knows, red stands for danger, perhaps because it is not only alerting, but penetrates mist better than other colours. It is also associated with warfare; the battle flags of the Roman legions were red, and we had scarlet soldiers' tunics for centuries. It is also associated with revolutionary ardour, as in the Red Flag, and even the kindly Salvation Army knows the rousing force of their strange slogan: Blood and Fire.'

Few westerners would disagree with this lively evocation of red.

Traditional esoteric thinkers, such as the alchemists, regarded colour symbolism as the expression of a principle working at the deepest levels of reality. The alchemists ascribed three main phases to the Great Work, which symbolised spiritual evolution: (1) prime matter (black); (2) mercury (white); and (3) sulphur (red), culminating in the production of the 'stone' (gold). Black represented fermentation, putrefaction, occultation, and penitence. White, illumination, ascension, revelation and pardon; and red, suffering, sublimation and love; and gold, the state of glory. The alchemic order proceeded in the order of: yellow, blue, green, black, white, red and gold. Dante, who was acquainted with traditional symbolism, clothed Beatrice in green, white and red—expressive of faith, hope and charity, corresponding to the three alchemic planes.

In symbolism, the purity of a colour corresponds to its symbolic purity; the primary colours to primary emotions, and secondary and mixed colours to symbolic complexity. Black and white are often represented as symbolising diametrically opposed principles: the positive and the negative—the binary symbol of the Chinese Yang-Yin; Jung's animus and anima, and black and white are traditionally associated with the Gemini sign of the zodiac. In the tarot pack, the two sphynxes in the seventh enigma are white and black. The colour symbolism of card packs—white, black and red—is ancient and powerful.

Mythology abounds in white and black horses, birds and knights, black symbolising the occult, and germination in darkness. Black also sometimes symbolises time, and white, timelessness and ecstasy. White also symbolises intuition, spiritual affinity, and the spiritual centre, or paradise. White in its positive aspect symbolises the sun; in its negative aspect, the moon.

In graphic symbolism, the symbol is usually black on a white ground. When two colours are contrasted in a given symbolic field, the inferior colour (in the alchemic order) is regarded as feminine, or terrestial, in character; the superior as masculine, or celestial.

Colour symbolism appears to be almost as old as any form of graphic representation. In their original use, colours were restricted to a very few pigments known to prehistoric man and, being so limited, they probably acquired a psychological significance beyond our present understanding, and were almost certainly religious in association.

For thousands of years graphic symbols preceded a written script as a form of visual communication. In the Egyptian hieroglyphics seen in paintings preserved in tombs, the development from symbol to letter is clearly shown, and in this form is still closely associated with colour symbolism. The use of hieroglyphics cut into stone, such as granite, precluded the use of colour.

Even before the ancient civilisations, in prehistoric times, graphic symbols were already in use. The need to communicate was probably associated with a wish to identify with a particular tribe or religious sect, an indication of man's need to live gregariously in communities, perhaps for protection, perhaps to satisfy deep-rooted psychological drives.

Primitive man from prehistoric times onwards has marked his person with identifying daubs or tattoos, or, alternatively, has arrayed himself in garments, headgear or weapons, to symbolise his social organisation. The Maoris, for instance, tattooed their faces with patterns signifying tribal relationship and status. In India, caste is indicated by the red caste mark on the forehead of the Brahmin. A Red Indian's tribe could be identified from his ceremonial regalia or from the way in which he habitually wore his hair, feathers, beadwork patterns and the weaving of tribal blankets. It is easy to forget that originally such symbols were the only means of identification, and that at times life and death could depend upon their recognition. Symbols, so ancient and so universal, are obviously essential to man, and are probably associated with the visual symbolism, or mental shorthand, that is a part of the psychology of visual perception in man. One of the oldest known symbols is the swastika, which occurs almost universally. Its original meaning is sometimes said to be 'King of the Mountains', but it has been widely used to promote good luck. It is still in use in heraldry and by many tribes. It is seen as fret on buildings of classical Greece, often on a blue ground.

Another very ancient symbol was the Star of David, sometimes called Solomon's Seal, whiich signified the union of the divine with the earthly. The religious symbolism of the sun is dominant in many religions. The sun was the supreme deity associated with light and fertility. Gold in religious vestments symbolised veneration for the majesty of the sun. In Egypt yellow and gold were symbols of the sun, the colour red represented man, green represented eternity in nature, purple the hue of the earth, and blue represented the sky and celestial light, and it signified justice also. In Egyptian mythology the gods Osiris and Horus, father and son, were represented by green and white; Set, the deity of evil by black; Shu, who separated the earth from the sky, by red; and Amen, the god of life and reproduction, by blue. The races of man were represented by colours too: red for Egyptians, yellow for Asiatics, white for northern people and black for Africans.

The Egyptian artist was concerned not so much with aesthetics as with a precise language of colour. Until recently literacy was confined to a small number of people, and colour symbolism provided an immediate form of communication. The Egyptians, who set great store by the interpretation of dreams, based much of their interpretation on the symbolism of colour; significance was attached to dominant colours in dreams. Associated with black, such colours signified the reverse of the traditional symbolism, so that red, normally signifying ardent love, would be reversed to mean hatred.

It is interesting to consider the ancient symbolic meanings of colours in dreams:

White—happiness in the home.
Black—the death of someone close to the dreamer.
Dark blue—success.
Royal blue—an order to be imparted to the dreamer.
Pale blue—happiness.
Light green—bad omen.
Dark green—serenity, gaiety.
Deep yellow—jealousy and deceit.
Pale yellow—material comfort.
Brilliant red—ardent love.
Dark red—violent passion.
Light red—tenderness.
Purple—sadness.
Deep violet—the dreamer will acquire power.
Pale violet—the dreamer will acquire wisdom.
Brown—sadness and danger are imminent.

In the drama of ancient Greece, actors wore purple to symbolise the sea-wanderings of Odysseus, and scarlet to symbolise the bloody warfare of the *Iliad*. Greek mythology depicted the four ages of man as gold, silver, copper and iron. Polychrome in wall paintings and in sculpture was limited not only by availability of pigments, but more, by the convention of symbolism. Pictorial and sculptural representation was deeply symbolic and religious. Zeus was represented in purple, Athena in yellow, while red was sacred to Ceres and to Dionysus.

On the philosophical side, Pythagoras taught that the universe comprised four elements of earth, fire, water and air, each composed of characteristic particles. Those of the earth were cubical and symbolised by blue; fire particles were tetrahedral and red; water, icosahedral and green; and air particles octahedral and symbolised by yellow. A fifth solid, a dodecahedron, symbolised the ether, and the perfect sphere, divinity. Man himself was composed of coloured elements. Blueness for earth and the flesh and bones; redness for fire, bodily heat, water; greenness for bodily fluids; and yellow for air, the gases of the body. Leonardo da Vinci, who studied the ancient writings, designated yellow for earth, red for fire, green for water, and blue for air—a more easily acceptable colour symbolism for modern man.

The use of colours on Greek buildings, both inside and out, was highly stylised because of symbolic traditions. The background to metopes was blue; helmets and shields were blue picked out in red, and manes, harnesses and yokes were red. Capitals, cornices, friezes and relief sculptures were in red, blue, yellow, black or gold.

The red of priestly robes signified sacrifice and love or passion, blue robes altruism and integrity and white robes purity.

Although the Romans continued the tradition of colour symbolism in religious and state ritual and ceremony, the use of colour in art became more representational and more realistic, as you can see in the interiors of Pompeii, Herculaneum

and other more recently excavated Roman buildings. When Roman imperialism was still dominant, early Christian symbolism was practised as a defensive device for a persecuted minority, and later, when the power of the Christian Church became established, colour symbolism continued to flourish in Byzantine and Renaissance Art.

In the Old Testament red, blue, purple and white, symbolised the four elements of fire, air, water and earth respectively, and collectively they symbolised the being of God. The esoteric colour symbolism of the *Revelations of St John the Divine* related to the ancient Hebrew religion. The colour symbolism of Mediterranean cultures borrowed from older Oriental cultures.

The use of colour in China was deeply saturated with symbolic meaning. The five primary colours of China were red, yellow, white, black and blue or green. Five was the sacred number and the five happinesses, five virtues, five vices and five precepts of faith were all ascribed symbolic colours. The points of the compass were also prescribed symbolic colours: black for the north, red for the south, green for the east and white for the west. Many other cultures have associated colours with the points of the compass. In China the dynasties, too, were known by colours: brown for the Sung Dynasty, yellow for Ch'ing, and so on. In the forbidden city of Peking the walls are red, symbolic of the south, the sun and happiness; the roofs are yellow symbolising the earth. Red symbolised the positive essence, the heavenly and masculine principle, while yellow was the complementary negative essence, the earthly and feminine principle. Religious and dynastic ceremonial was also richly colour-symbolic. The emperor wore yellow robes when he worshipped the earth, and blue when he worshipped the sky. His officials wore coloured buttons on their caps denoting their rank. High officials rode in blue sedans, lesser officials in green. The grandchildren of the emperor rode in purple sedans. When the building of a home was completed, red fire crackers were exploded from the roof top to scare away malevolent spirits, and a piece of red cloth was suspended from the roof to promote felicity in the home. Green branches of pine were placed above the scaffolding to avert evil spirits and this practice is still traditional in parts of Europe today. In Chinese drama, coloured masks symbolised characterisations—a red mask for a sacred person, black for the ruffian and white for the villain.

Elsewhere in the Orient, gods were identified by hues: in India Brahma by yellow, Siva the Destroyer by black, and yellow was sacred to Buddha and Confucius. Green was sacred to Mohammed and is still the emblematic colour of Islam.

All over the world weapons, armour, standards and banners have provided vehicles for graphic symbols and, generally, these have been associated with colour as providing the most immediate form of recognition—the woad of the Ancient Briton no less than the purple and red of the Roman legionary. In Rome itself the distinguishing colours of charioteers in the arena, blue and green, became the basis of bitter political factions.

In the early Middle Ages the science of *heraldry* began to emerge. Heraldry is a formally organised form of graphic symbolism that has developed into an exact science. It has been called the shorthand of history, and with reason.

Religious colour symbolism in the early Middle Ages was regulated by the Church: white for purity, green for faith, red for strength or passion, blue for spiritual love or truth, gold for honour, purple for mourning and regality and so on, and this influenced the choice of colours by the lay nobility and colours for feudal livery, armour, banners and shields were adopted to express allegiance to the symbolised virtues. Particoloured costumes were worn because they were distinctive and easily recognised in battle, and this was important: since armour and helmet completely concealed the knights and feudal lords, and their follow-ers, the army contingents could be distinguished only by the colours they wore. The colours of the surtout worn above the armour were repeated on the shield, and coats of arms began in this way. The more strikingly contrasted the colours the better they served their purpose, so that arms were quartered in colours of maximum contrast. The same principle applies on the football field today. To wear a coat of arms was to lay claim to the estates to which it belonged and this right was jealously guarded and coveted. Retainers wore the appropriate livery or colours and badge, and owed duties and received patronage in exchange.

Designs and patterns were adopted to allow more variation. These were at first simple, often dictated by the structural reinforcement of the shield. They were therefore geometrical—the horizontal bar, the vertical pale, the cross, the diagon-

Figure 7.4 Heraldic metals, colours and furs (represented by different types of hatching)

al bend, the diagonal cross or saltire. Variations on these geometric elements and colours were adopted by the heads of individual families or clans, and heralds were required to regularise their use. As these colour and pattern combinations became exhausted more pictorial decorations were introduced.

The heralds used Old French names for their colours: *gules*—red; *azure*—blue; *vert*—green; *sable*—black; *or*—gold or yellow; *argent*—silver or white; *purpure*—purple; *vair*—squirrel's fur; *ermine*—black and white; and *tenne*—tawny or orange. Symbolic animals such as lions (sometimes called leopards), bears, hogs, stags, horses, eagles, swans, fish and serpents and many other devices were used and there were also fabled beasts, unicorns, mermaids,

cockatrice, basilisk, sea lions and sea horses and the like, besides symbols such as the sun or moon, the stars, knots, rings, feathers, horns and chains.

Plants and flowers were also much used as emblems: the rose, the marguerite, the daisy, the lily, the iris, oak leaves, the maple leaf and the shamrock among many others. All such symbols took many stylised forms and were given heraldic colours totally unrelated to nature.

Travels abroad, such as were taken by pilgrims or crusaders, brought new emblems from the Middle East—turrets and castles (sometimes perched on elephants) and the crosslets, nails or piles that symbolised participation in the crusades or in pilgrimages.

Many of the colours, emblems and devices of noble families or rich merchants became incorporated into the arms of citizen bodies, and corporations were accorded their own coats of arms, which were displayed and used to seal treaties and agreements. More recently modern cities employ a symbol referring to the industry on which the prosperity of the city is founded.

Some of the old heraldic forms are preserved in inn signs incorporating local coats of arms, becoming 'The Swan', 'The Bear', 'The Rose and Crown' etc. Heraldic symbols put to new uses are also found in the badges and signs of the military forces, and a great deal of heraldic ingenuity is displayed in the design of new emblems.

Royal standards have been displayed for thousands of years. They were used in ancient times in Egypt, Babylon, Assyria, India and China, and the standard of the Roman legionary cavalry was the purple Vexillam surmounted by the Imperial Eagle of Rome. English monarchs have flown their royal standards for many centuries. The Dragon flag of King Harold of England and the Gonfalen of William of Normandy are woven into the Bayeux tapestry, which commemorates the Norman Conquest. The standards have changed as successive monarchs have claimed or renounced territorial acquisitions. At the accession of James Stuart, England and Scotland were united for the first time under one monarch and one flag. The first Union flag symbolised the union—the red cross of St George on a white ground placed on a field formed by the Scottish white cross of St Andrew on a blue ground. In 1707 England, Scotland, Ireland (now Northern Ireland) and Wales united to form the United Kingdom of Great Britain.

The national flag of Wales is a red dragon displayed on a field of white and green, the traditional colours of the principality. It symbolises the failure of the Saxons to conquer Wales. Northern Ireland's Red Hand of Ulster symbolises the legend of the chieftain who severed his own right hand and flung it ashore to establish his claim to rule the country by being the first in a race to touch it.

Flags were introduced into America with the advent of the European explorers; Columbus arrived in 1492, followed by English, Dutch, French, German and Swedish settlers and later by those from many other European countries for whom America represented political and religious freedom and commercial opportunity. Several colonies were founded, united after the War of Independence in the Declaration of Independence of 1776 when Congress resolved that: 'The flag of the United States of America be thirteen stripes alternate red and white, that the Union be thirteen stars white in a blue field, representing a new constellation'. As new states were admitted to the Union, the Stars and Stripes evolved its present

form, displaying 50 stars in the canton, while its fly retained the original 13 stripes. Each state has its own flag with its own distinctive emblems symbolising the history of the state, and some of these embody emblems of the native Indian tribes they displaced. The national and merchant flag of the Union of the Soviet Socialist Republics is the Red Flag with the state emblem in the upper hoist—a five-pointed star outlined in gold above a crossed hammer and sickle also in gold, symbolising workers in industry and agriculture. All the republics have their own flags, most of which place horizontal stripes of various colours across the Russian national flag.

Today, besides all the national flags, some international flags have appeared. These include the now indispensable Red Cross for the relief of the injured in military encounters and civil disasters, providing neutrality for medical services. In countries where the Christian symbol of the cross is not recognised, other emblems such as the Islamic Red Crescent take its place. Whatever the emblem employed, the message is the same—the relief of suffering everywhere in war and peace. The flag of the United Nations Organisation formed in 1945 bears a map of the world, white on blue, and on each side the emblem of peace appears—the olive branch—but at the headquarters of U.N.O., member states hoist national flags alongside the flag of the United Nations.

At the first ascent of Mount Everest in 1955, the flags of the United Nations, Great Britain, Nepal and India were hoisted on the world's highest pinnacle, symbolising united effort and goodwill in this hard-won enterprise. A number of explorers have flown their flags over the North and South Poles and distinctive coats of arms have been designed appropriate to territorial claims.

Flags have now been taken not only to the ends of the earth but out into space and on to the moon. The first flags to reach its surface were scattered there by the Russian spacecraft Luna 1 in 1959. Luna 9 landed in 1966 carrying a pendant with the words 'U.S.S.R.' and symbols of the Earth, the moon and the spacecraft's path. Then in 1969 the Stars and Stripes was planted on the moon by American astronauts.

Visual signals have been used from time immemorial, and must certainly have predated Moses's signals of fire and smoke to the wandering tribes of Israel, and such signals are still used; indeed, beacons were made ready to ignite round the shores of Britain to warn of threatened invasion during the 1939–1945 world war.

A complex code of visual signals by means of coloured flags and lights is used internationally by land, sea and air. Sometimes their use is regulated by a formal code. Vessels at sea exchange salutes and communicate by means of flags. A red flag is a sign of danger, a green flag normally means safety but can give warning of a wreck. A red flag may also denote revolution, yellow is used for quarantine, a white flag truce or surrender, a black flag warns, and, associated with the skull and crossbones, it warns specifically of piracy.

Since the seventeenth century a series of flag signal codes for naval and commercial purposes have been evolved. In 1899 a British Board of Trade committee produced the first international code of signals, which provided a flag for every letter of the alphabet, enabling over 375 000 different signals to be made. The revised code of 1927 includes not only the 26 flags and the code and answering pennants, but 10 numeral flags, 10 numbered pennants and 3 substi-

tutes, as well as the codes and answering pennant of the old international code; and it also adds a fourth substitute, 9 special flags and 11 special pennants, thus enabling an almost unlimited variety of signals, largely depending on colour variations, to be made.

In our own time, colour symbolism, overt or intuitional, continues to penetrate our lives. Brilliant red still makes the heart beat faster, and colour in religious, national, military, or royal ceremonial still adds excitement to life. In industry colour codes are used to identify functional components of a factory or machinery, and, like the wasp, uses yellow and black, to indicate sources of danger. Commercial organisations compete with each other in advertising and packaging that includes much colour symbolism, and a whole new system of visual coding is now evolving with the development of computer techniques.

And how could traffic be controlled without the universal symbolism of red, green and amber traffic lights?

8

Colour-Science and Art

The science of colour is broadly concerned with three aspects of colour: *light, colorants* and *perception,* and though these fields of study interpenetrate, the physicist is generally concerned with light, the chemist with colorants, and the physiologist and the psychologist with perception.

The painter is concerned with all these aspects of colour science. Historically it was the painter who first made conscious use of colour in paintings that required light for visibility, colorants for execution, and perception for communication.

A technology of dyes and paints was already established in the ancient civilisations of the Middle East, and still earlier in those of the Far East. From the beginning, painters were both artists and technologists, and it was not until the nineteenth century that pigments and dyes were manufactured on a commercial scale to the specification of industrial chemists. Until the Industrial Revolution most painters were craftsmen and involved in the chemistry and manufacture of the materials with which they worked.

Fundamentally, a picture consists of a support and a design. Commonly the support is of fabric, paper or wood. If a dry pigment such as charcoal, chalk or graphite is used to mark the support, the result is a drawing. Paint is a mixture of powdered pigment and medium applied as a paint or a daub. Between the paint and the support a ground is often used—a flat coating applied to the support. Pigments are particles of insoluble coloured materials of various chemical constitutions. When the pigment granules are mixed with a minimum of adhesive medium, the paint is said to be 'lean'; when there is a large proportion of medium to pigment, the paint is 'rich', as in oil painting. Most of what can be learned from books about pigments, media and grounds and their application, is available in such works as Doerner's *Painting Materials and Their Use in the Picture* (1934), and in the books of Kurtwehlte and other well-known authorities on the subject.

Briefly, some pigments are taken from earth coloured by iron, yellow, brown or red; these are ochres or umbers. Some are mineral, such as white lead or cobalt blue. Some are dyes precipitated on a base, such as madder or crimson alizarin. These are all prepared in the form of powdered pigments.

Mediums include egg yolk and egg white, gum arabic, glues, oils, waxes and lacquers, of which the last two are probably the most permanent.

When executed with an oil-based paint, the painting is usually given a surface coating of pure oils such as linseed, poppy or wood, resins such as amber, copal or mastic, or waxes such as bees-wax, paraffin wax, or ceresin.

Most of the chemical substances of support, ground, pigment, medium and surface coatings of traditional forms of painting are subject in time to deterioration. In ordinary circumstances the pristine perfection of any painting lasts only a few months—at the most only a few years—until layers of added surfaces and accumulated dirt with attendant microbic action on the paint obscures the original. It takes decades for the constituents of an oil painting to become chemically inert.

Many of the techniques of ancient, medieval and Renaissance painters have been lost, together with the original aesthetic concept of the artist, because of scanty records, deterioration and loss of continuity in acquired skills, but much has been done in the twentieth century in technical research both to determine artists' materials and techniques, and to restore paintings to their original forms.

Training and skill are required to clean and restore paintings without inflicting damage on the originals. Many of the great national museums have specially equipped departments for the analysis and conservation of paintings, the best-known centre being the Doerner Institut. The methods used in such departments are highly technical and include micro-chemical testing to determine chemical composition, emission spectrometric analysis, X-ray fluorescence analysis, and visual red and ultra-violet spectrophotometry. The preparation of modern paints and media is also subject to sophisticated scrutiny in the research laboratories of industry.

Since the appearance of painting as a human skill, the painter has owed much to the science of chemistry, rudimentary at first, but becoming increasingly technical and complex. Today an almost unlimited range of pigments and vehicles is available, though a comparative study suggests that the very prodigality of choice may be an inhibiting factor to the painter and it may be that, without the discipline imposed by a colour palette restricted through external circumstances, the painter must find within himself a compensatory psychological or intellectual discipline.

To many people connected with colour in art, the exact colour content of certain paintings and other works of art is of very great importance. Scholars, historians, collectors and dealers, concerned with the authenticity of valuable paintings and their conservation, need to know how colours may have deteriorated or changed through exposure to light, or adverse climatic conditions, or through varnishing or restoration, and very specialised work is undertaken by means of chemical analysis to help determine these factors.

In research on colour in paintings and artefacts, colour measurement provides a useful technique using a visual colorimeter, such as that marketed by Tintometer, with a flexible extension designed for the colour specification of small localised areas of colour. A colour atlas, based on the three-dimensional concept of colour, is often used in association with colour measurement. The Munsell or Ostwald system is usually available.

A special-purpose mobile spectrophotometer, designed by Professor W. D. Wright, for the use of art curators and biologists, is also available. Professor

Wright described his instrument in a paper read at the International Colour Conference held at Troy in 1977: 'The primary aim of the measurements is to provide a record of the spectral reflection characteristics of key areas of a painting, against which colour changes occurring over long periods of time can be followed. Records are also being made of the changes in colour when a painting has been cleaned or has been subject to other treatment or restoration.'

He is confident of the potential usefulness of his instrument, but expresses doubt of the acceptance by art students of this technological aid: 'Although the spectrophotometer is a large instrument, it is essentially simple in principle, and its method of operation not too difficult to understand. Only experience will show whether it is simple enough to be acceptable to the art student.... Every encouragement is given to the student and restorer to use the instrument. If this is achieved it seems highly likely that spectrophotometry has a very important contribution to make as a tool in art technology.' This comment on the resistance of most art students to using scientific equipment and techniques for studying colour in the arts, goes straight to the point of the lack of communication generally between students of science and of art. Today this is changing. A knowledge of the control of light mixture, both additive and subtractive, is becoming imperative to the student of art.

In commerce and industry, and to some extent in fine art, artists are coming to terms with technological developments in photography, television, and holographic techniques, and they are influenced by developments in the theory of electronics. The projection of colour effects by lighting and kinetic devices sometimes requires the collaboration of artists, scientists and lighting technicians, as an exhibition of optical and kinetic art held at the Tate Gallery in London in 1967 revealed.

No longer is 'intuition' alone a sufficient guide to the use of colour in art, though it may still be true that an acute sensitivity to colour will always be required of artists who work in colour.

The genius for inspired colour relationships of certain painters of any period has no doubt been the result in part of a continuous mental analysis of colour so informing and saturating the subconscious mind that every brush stroke of colour is perfectly related to the whole colour structure of the painting in all the dimensions of colour. But it is no accident that some of the most outstanding colorists of all time have been passionately interested in all the scientific information on colour that was available to them: Leonardo, Turner, Delacroix, van Gogh and Bonnard all saturated themselves in colour theory.

The painter, who, of all artists, is motivated by visual perception, is concerned primarily with the building of colour relationships and their aesthetic attributes. In the ultimate expression of colour, all great colorists must feel with Paul Klee: 'Colour and I are one. I am a painter.' Turner, van Gogh and Matisse must all have experienced what Klee again so clearly articulates: 'Colour has taken hold of me; no longer do I chase after it. I know that it has hold of me for ever. That is the significance of this blessed moment.'

In the prehistoric and ancient past, the colours of paintings reflected the availability of materials—pigments, media and painting surfaces. Variation on a limited

colour theme was forced on the artist not only because of a restricted palette, but because of contemporary conventions and symbolisms. The limitations of hue in plant and animal life in the natural environment probably conditioned his visual response and the aesthetic impulse towards colour.

Apart from actual pigments, media and techniques imposed their own colour restrictions. During the Ice Age, when the earliest paintings so far discovered were made, these were of a very primitive kind. In the paintings found at Les Combarelles in France, or Altamira in Spain, for instance, the living rock provided a porous and absorbent ground of uneven surface for paintings produced with lumps of coloured earths sharpened into primitive crayons, or liquid colour painted directly on to the rocks with the fingers, and probably simple brushes of feathers, fur, or small sticks. Pigments were derived from various coloured ochres, black manganese earths, iron oxides with bone and wood charcoal, bound together perhaps with water, milk, honey or animal fats. Later paintings found in eastern Spain were different in conception and execution—more stylised and mostly in glazed monochromes of red earth. It is interesting to note that conservation of both types of painting derived apparently not from a binding vehicle, but the location in damp caves, where bicarbonate-saturated water, seeping through the pigments, eventually formed a sinter surface—a kind of natural fresco process.

Besides the limitations of technique and pigments, the subject matter of Ice Age and Palaeolithic painters was probably restricted by the constraints of religion and tribal experience beyond the conception of present-day civilisation.

Although a much greater variety of pigments and media was available to painters of the ancient civilisation than to prehistoric painters, a religious or political hierarchy, particularly in ancient Egypt, often dictated the colour, style and subject matter of official paintings, and, because of this, the highly individualised national identity of the paintings was preserved over long periods of time, so that Egyptian, Cretan, Pompeian, and other cultures are still recognisable. Gradually, with the intermingling of civilisations as invaders advanced and withdrew, painting styles were absorbed or exchanged, losing their precise national identity.

A remarkable culture was based on the art of carpet-weaving and dyeing. The comparatively few natural dyes available in the Middle and Far East, before the importation of synthetic dyes at the beginning of the twentieth century, required a disciplined variation on a very few colours in the dyeing of rugs and carpets. Sometimes only two basic dyes, such as indigo and madder, were used with such consummate skill in dyeing and over-dyeing techniques, together with the use of mordants, and the exploitation in the weaving of simultaneous contrast effects, that a rich tapestry of harmonious colours was achieved, echoing the subtle colouring of the indigenous landscape.

In painting, where colour played a predominant role, most of the earliest works of art were also based on a remarkably simple palette of colours, but throughout the history of art, creativity and technical ingenuity have triumphed over such colour restrictions.

Much of the Mediterranean culture was Hellenised, becoming decadent in the late Roman period, and eclipsed in the eventual downfall of the Empire, when

other influences, Celtic, Teutonic and Islamic, flowed over Western Europe. The classical traditions of Greece and Rome were kept alive by the Byzantine Empire and in isolated courts and religious institutions for hundreds of years until, after the consolidation of Christendom and Christian art under Charlemagne in the eleventh century and the flowering of the Gothic period of art, the Renaissance began to emerge as a cultural force and Greek philosophy and art were reborn in medieval Italy, and spread to the rest of Europe.

Until this time, for the last three or four thousand years, the colour palette of the painter had consisted essentially of a few colours: white, black, yellow ochre, chrome yellow, terra-cotta, cadmium red, caerulean blue, ultramarine, and veridian green, with gold and silver enrichment, and all the variations that technical ingenuity—sometimes of a very high order—could achieve. With the advent of Giotto and the Renaissance of painting, the colour palette became more complicated and more sophisticated, and new colour mixtures and techniques were evolved.

Every painter had his individual palette of colours, and a great many handbooks were written on the subject of pigments, grounds, vehicles and techniques; Cennini's, one of the most famous, described the methods of the master painters of his time, and gave practical advice to the student painter. He advocated seven colours: black and white, red, yellow, green, ultramarine and azurite, to be ground by the apprentice artist, and cautioned him about the way suppliers might adulterate their pigments. A more scholarly treatise was written by Leonardo da Vinci, who had studied the precepts of Aristotle, interpreted them, and added his own. Unfortunately for posterity, Leonardo's experiments with incompatible chemical compounds, such as oil paint mixed with fresco, caused his colours to darken and perish.

Pure *buon fresco*—painting into wet lime plaster with pigments dissolved in lime water—demands quick, decisive painting, and no underpainting is possible. The colour is soft, desaturated and silvery.

With tempera techniques it was usual to underpaint, modelling thinly in monochrome, building up numerous thin layers of colour to give depth and brilliance of colour. Examples of Michelangelo's unfinished paintings can be seen in the London National Gallery and elsewhere, clearly showing this technique. Some of the earlier tempera paintings of the Italian Renaissance, on grounds of white gesso plaster mounted on wood, have something of the quality of illuminated manuscripts in the brightness and delicacy of their colours, augmented often by heavy gilding. The painters of the High Renaissance achieved remarkable technical expertise and facility with colour, the Florentines with clear strong colours, the Venetians with a glowing diffusion of golden colours. By the end of the Renaissance, the technique of oil painting, introduced by the van Eyck brothers, was firmly established by the giants of the seventeenth century: Rubens, Rembrandt, and the last Byzantine survival, El Greco.

From the time of Newton in the seventeenth century, the painter was increasingly indebted to the physicist for scientific information on colour and, from the time of Goethe in the early nineteenth century, to the physiologist and psychologist for information on colour perception.

Figure 8.1 Goethe's colour circle (from Goethe's
Theory of Colours **translated by Eastlake, 1840)**

Of all those who have influenced the development of the history of painting in western civilisation, five names are outstanding: Aristotle, Leonardo da Vinci, Newton, Goethe and Turner, all men of extraordinary intellectual and creative genius. Aristotle laid the foundations of colour science, and Leonardo in the Renaissance developed and extended the theme. Deriving from both, and from intermediate scientists, Newton made his monumental contribution on light, Goethe made his on perception and, absorbing and synthesising the discoveries of Newton and Goethe in so far as they related to painting, Turner began a revolution in painting.

The great German dramatist and poet, Goethe, diverted his literary genius for ten years to the production of his monumental *Farbenlehre*, compiled from his own acute observations of colour phenomena. Published in 1810, it was translated into English as *The Theory of Colours* by Charles Eastlake in 1840. Eastlake's accurate and sensitive translation and commentary contributed very greatly to the popularity of the work in English-speaking countries.

In reacting against theories of colour based on Newton's mathematical science of optics, Goethe failed to differentiate between colour as radiant energy, wavelengths and light frequencies, and colour as human experience. But although his arbitrary dismissal of Newton's physics is now discredited, the value of his observations on colour perception are still valid, and, indeed, may be said to be

one of the foundations of the science of colour perception. Indirectly, he has certainly had an enormous effect on modern painting.

In the introduction to the new edition of the *Farbenlehre* (M.I.T., 1970) the eminent American authority on colour physics, Deane Judd, has this to say: 'From what standpoint might an intelligent and well-informed non-specialist approach this 160-year-old book, expounding a largely repudiated theory of colour? . . . He wrote out a clear and systematic description of all his extended observations of colour phenomena interspersed with the arguments supporting his explanations. . . . This book can lead the reader through a demonstration course not only in subjectively produced colours (after-images), light and dark adaptation, irradiation, coloured shadows, and pressure phosphenes, but also in physical phenomena detectable qualitatively by observation of colour (absorption, scattering, refraction, diffraction, polarisation and interference).'

Judd continues: 'As a guide to the study of colour phenomena Goethe had a passion for careful observation and accurate reporting that may come as a surprise from a theatrical director and famous author of fiction, and, Goethe's subjective, rather mystical theory of colours permits him to speak most persuasively regarding colour harmony and aesthetics. . . . Perhaps, after 160 years, Goethe's mystical theory may come to be recognised as foreshadowing, however dimly, the next most important advance in the theory of colour.'

Goethe himself was in no doubt about the value of his contribution to the theory of colour: 'As for what I have done as a poet, I take no pride in it whatever. Excellent poets have lived at the same time with myself, more excellent poets have lived before me, and will come after me. But that in my century I am the only person who knows the truth in the difficult science of colours, of that, I say, I am not a little proud.'

Helmholtz sums up the dual contribution of Goethe as an investigator and as a poet: 'The great sensation produced by Goethe's *Farbenlehre* was partly due to the fact that most people not being accustomed to the accuracy of scientific investigation, are naturally more disposed to follow a clear artistic presentation of the subject than mathematical and physical abstractions.' The following quotation illustrates the point Helmholtz is making, when Goethe, speaking of the phenomenon of successive contrast, gives this example: 'I had entered an inn towards evening, and as a well favoured girl, with a brilliantly fair complexion, black hair, and a scarlet bodice came into the room, I looked attentively at her as she stood before me at some distance in half shadow. As she presently afterwards turned away, I saw on the white wall, which was now before me, a black face surrounded with a bright light, while the dress of a perfectly distinct figure appeared, of a beautiful sea-green.'

Goethe made the general observation: 'All nature manifests itself by means of colours to the sense of sight. . . . From light, shade and colour, we construct the visible world.'

Goethe's *Farbenlehre* has been the source of study and inspiration for countless writers, psychologists and artists. He divided his work into three parts: (1) the outline of a theory of colours; (2) a polemical part attempting to discredit Newton and his followers; (3) an historical account of early inquirers and investigators.

Goethe differentiated three classes of colours: physiological, physical and

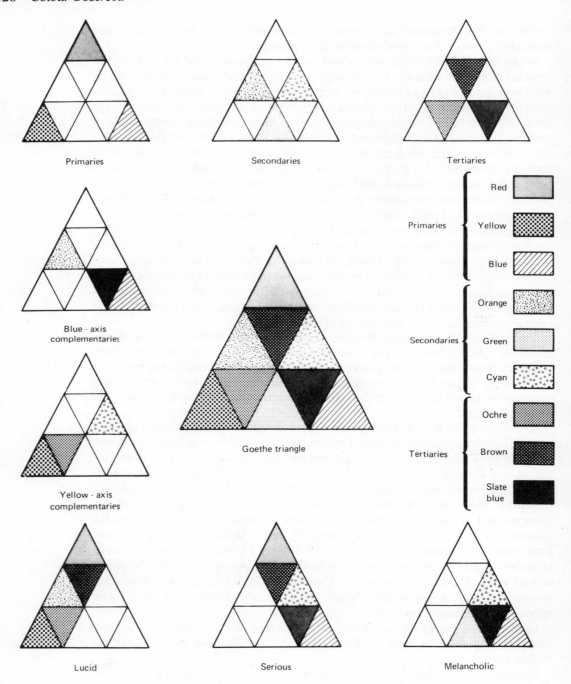

Figure 8.2　Goethe's triangle (centre) and associated harmonies with psychological interpretation

chemical, which he regarded as fleeting, transitory and permanent, respectively. Not all his observations were original, since some derived from Aristotle, Leonardo and post-Renaissance writers on colour, but his obsessional enthusiasm for the subject, combined with his skill as a communicator, are unique in the history of colour science.

Among writers in the historical section of his work, Goethe mentions Simon Portius, who first published Aristotle's treatise at Naples in 1537 and at Florence in 1548. The best authenticated translation is that of Scarmiglione, who published *De Coloribus* in 1591. That such works, gleaned from the classical writers on colour and those of Leonardo, profoundly influenced Goethe's writing is illustrated by comparative quotations from Aristotle, Leonardo and Goethe provided in Eastlake's notes. On local colours and illumination, Aristotle stated: 'We see no colour in its pure state, but every hue is variously intermingled with others even when it is uninfluenced by other colours; the effect of light and shade modifies it in various ways, so that it undergoes alterations and appears unlike itself. Thus bodies seen in shade or in light, in more pronounced or softer sunshine, with their surfaces inclined this way or that, with every change exhibit a different colour.' And Leonardo: 'No substance will ever exhibit its own hue unless the light which illumines it is entirely similar in colour. It very rarely happens that the shadows of opaque bodies are really similar (in colour) to the illumined parts. The surface of every substance partakes of as many hues as are reflected from surrounding objects.'

Goethe's rendering is strikingly similar. On successive contrast Goethe wrote: 'The impression of coloured objects remains in the eye like that of colourless ones, but in this case, the energy of the retina, stimulated as it is to produce the opposite colour, will be more apparent.' He also wrote: 'The colours diametrically opposed [on Goethe's colour circle] are those which reciprocally evoke each other in the eye. Thus yellow demands purple, orange, blue, and red, green, and vice versa.'

Eastlake comments: 'The chromatic diagram does not appear to be older than the last century.... That its true principles were duly felt is abundantly evident from the works of the colorists, as well as from the general observations of early writers.... The more practical directions are occasionally to be met with in the treatises of Alberti, Leonardo da Vinci and others.' He further quotes a passage in Ludovico Dolce's *Dialogue*: 'He who wishes to combine colours that are agreeable to the eye, will put grey next dusky orange, yellow-green next rose colour; blue next orange; dark purple black next dark green; white next black; and white next flesh colour.' That quotation is sometimes attributed to Titian. But again, Goethe has the advantage by making striking literary illustrations. Commenting on after-image effects he wrote: 'The red colour seen by persons dazzled by snow belongs to this class of phenomena.' And he adds: 'Perhaps we might insert under the same category the story that drops of blood appeared on the table at which Henri IV had seated himself with the Duc de Guise to play at dice.'

Goethe wrote unforgettably of a related phenomenon: 'We have hitherto seen the opposite colours producing each other *successively* on the retina; it now remains to show by experiment that the same effects can exist *simultaneously*.... As the compensatory colours early appear where they do not exist in nature, near and after the original opposite ones, so they are rendered more intense where they

happen to mix with a similar real hue.' He illustrated this with: 'In a court which was paved with grey limestone flags, between which grass had grown, the grass appeared of an extremely beautiful green when the evening clouds threw a scarcely perceptible red light on the pavement. In an opposite case we find, in walking through meadows, where we see scarcely anything but green, the stems of trees and the roads often gleam with a reddish hue.'

He illustrated the phenomenon of coloured shadows in an even more dramatic way: 'Two conditions are necessary for the existence of coloured shadows: first that the principal light tinge the white surface with some hue, secondly that a contrary light illumine the cast shadow.' He continued: 'In travelling over the Harz in winter, I happened to descend from the Brocken towards evening; the wide slopes extending above and below me, the heath, every insulated tree and projecting rock, and all masses of both, were covered with hoar frost. The sun was sinking towards the Oder ponds. During the day, owing to the yellowish hue of the snow, shadow tending to violet had already been observable. These might now be pronounced to be decidedly blue, as the illumined parts exhibited a yellow deepening to orange. But as the sun was at last about to set, and its rays, greatly mitigated by the thicker vapours, began to diffuse a most beautiful red colour over the whole scene around me, the shadow colour changed to a green, in lightness to be compared to a sea-green, in beauty to the green of an emerald. The appearance became more and more vivid; one might have imagined oneself in a fairy world, for every object had clothed itself in the two vivid and so harmonious colours, till at last, as the sun went down, the magnificent spectacle was lost in a grey twilight, and by degrees in a clear moon-and-starlight night.' In this description Goethe's trained eye perfectly matched his poet's insight, communicating inimitably with the trained perceptions of the painter.

Aristotle's axiom that colour is 'the primordial phenomenon of light and darkness as acted upon by semi-transparent mediums' was fundamental to Goethe's concept of colour. Both Aristotle and Leonardo applied the principle. Aristotle wrote: 'The air near us appears colourless; but when seen in depth, owing to its thinness it appears blue; in a very accumulated state, however, it appears, as is the case with water, quite white.' And Leonardo: 'The blue of the atmosphere is owing to the mass of illuminated air interposed between the darkness above and the earth. The air itself has no colours but assumes qualities according to the nature of the objects which are beyond it. . . . The blue of the atmosphere will be more intense in proportion to the degree of darkness beyond it.' And demonstrates elsewhere: 'If the air had not darkness beyond it, it would be white.'

Eastlake remarks: 'One effect of Goethe's theory [the doctrine of transparent mediums] has been to invite the attention of scientific men to facts and appearances which had before been unnoticed or unexplained. To the above case may be added the very common but very important fact in painting that a light warm colour passed in a semi-transparent state over a dark one produces a cold, bluish hue, while the operation reversed produces extreme warmth. On the judicious application of both these effects, but especially on the latter, the richness and brilliancy of the best coloured pictures greatly depends.' Eastlake continues: 'The secret of van Eyck and his contemporaries is always assumed to consist of the

vehicle (varnish or oils) he employed, but a far more important condition of the splendour of colour in the work of those masters was the careful preservation of internal light by painting thinly, but ultimately with great force, on white grounds.'

Eastlake very well understood that the doctrine was of ancient origin: 'It is not impossible that the same reason which makes this part of the doctrine generally acceptable to artists now, may have recommended the very similar theory of Aristotle to the painters of the fifteenth and sixteenth centuries. At all events, it appears that the ancient theory was known to those painters. . . . The Italian writers who translated, paraphrased and commented upon Aristotle's *Treatise on Colour* . . . were in several instances the personal friends of distinguished painters.' That Goethe was particularly interested in the problems of painters concerning colour is evident: 'The painter had a light ground for the light portions of his work and a dark ground for the shadowed portions. The artist could work with thin colours in the shadows and had always an internal light to give value to his tints. In our own time, painting in water colours depends on the same principles. Indeed, a light ground is now generally employed in oil painting, because middle tints are thus found to be more transparent and are in some degree enlivened by a bright ground. The shadows, again, do not easily become black.'

It was perhaps ironic that Goethe's efforts to educate artists in this principle which he made so explicit, were so soon to be undermined by the very Newtonian principles that he himself strenuously opposed, and when the technique of glazing thinly over light and dark grounds was to be almost totally replaced by that of opaque painting.

But Goethe's 'clear and systematic descriptions of all his extended observations of colour phenomena' (as Deane Judd wrote), and his carefully listing of the phenomena, not only provided a link with ancient and Renaissance colour philosophy, but became the source of inspiration for painters and Gestalt psychologists throughout his century. His great *Farbenlehre* is now being freshly assessed, through the interest of Deane Judd, Faber Birren and other influential writers.

A bridge between the traditional colour concepts and applications of Renaissance painting, and the revolution in conceptual thinking and techniques of painters during the later nineteenth century, was provided by that great painting personality Turner, who dominated early nineteenth-century painting in England.

Turner studied everything that came to hand on the science of colour. He maintained a close interest in Newton's writings and in physiological optics as they affected painting. He was familiar with Le Blon's *L'Art d'Imprimer les Tableaux* (1756), in which he identified the three subtractive primaries, and with Moses Harris's *Natural System of Colours* (1766), which contained not only the first colour circle produced in full colour, and demonstrated the complementary nature of the three primaries red, yellow and blue, with green, violet and orange, seeking to make them the basis of harmonious colour relationships, but also contained the first system for the organisation, description and standardisation of colours. The physiological researches into coloured after-images by Robert Waring Darwin and into coloured shadows by Benjamin Thomas in the 1780s and 1790s confirmed Harris's theories and pre-dated those of Goethe.

The complementary colour circle of six colours based on these researches had been accepted by many painters around 1800, including Turner in England, Philipp Otto Runge in Germany, and Delacroix in France. The three subtractive primaries, though not usually accurately represented, were also accepted, though it took longer for the three additive light primaries of red, green and violet, discovered by Wunsch in Germany, and for Thomas Young's hypothesis that these were also the primaries of colour perception, to be recognised. That Turner accepted the principle of optical mixture, intuitively or otherwise, is clear from his omitting green from his later paintings, which were at that time executed (particularly his water colours) entirely in reds, yellows and blues, and it was at this later period that he achieved his magical effects of colour, light and aerial perspective.

Turner did not read Eastlake's translation of the *Farbenlehre* until he was nearly 70, when he annotated a copy by no means uncritically. Yet he was intensely interested in Goethe's demonstrations and theory, and, in homage to Goethe, composed two paintings, 'Light and Colour (Goethe's Theory), Morning after the Deluge', and 'Shade and Darkness, the Evening of the Deluge'.

Turner was not prepared to accept Goethe's contention that the distinction between mathematical and optical colours was largely illusory; for Turner they were distinct, and on Goethe's statement that 'optics in general could not dispense with mathematics, but chromatics might', Turner commented: 'There lies the question.' Turner, a supreme professional, also disputed Goethe's assertion that amateur work was valuable in the advancement of science, remarking: 'This generally does very little service to art and frequently retards.'

With brilliant exceptions such as Goya, the eighteenth and nineteenth centuries had been dominated by a heavily academic, classical school of painting, across which the English painter Turner blazed like a comet with his closely observed and imaginative interpretations of landscapes, seascapes and architectural visions executed with incandescent colour and light. Turner used colours of the greatest possible purity combined or glazed over with white, or floated over white paper in watercolour, producing, as he said, 'a pure combination of aerial colours, working on the principle that one colour has a greater power than a combination of two, and a mixture of three impairs that power still more'. From contemporary descriptions it is clear that Turner used only a few powdered pigments, including chrome yellow and bright yellow ochre, gamboge, cobalt, and occasionally ultramarine, ordinary smalt, crimson and scarlet lake, mixed with turpentine, linseed oil, size and water, or sometimes stale beer, on his palette or on the canvas itself, either impasto, or floated over a white ground in scarcely visible colours.

In France at the same time, others, pre-eminently Delacroix, were breaking away from academic sterility. Delacroix exulted in brilliant colour and despised earthy and grey colours. He was the leader of the Romantic Movement and extremely popular. That the work of Turner made an enormous impact both on Delacroix and other French painters, is illustrated by Signac, who wrote in his *De Delacroix au Neo-Impressionism* (1899): 'In 1871, during the course of a long stay in London, Claude Monet and Camille Pissarro discovered Turner. They marvelled at the assured and magic quality of his colours, they studied his work, analysed his technique.' Signac described how he himself discovered Turner: 'National Gallery. A quick glance at the Turners as a whole. From 1834 he frees

himself from black and looks for the most beautiful colorations; colour for colour's sake. You would say he was mad; it seems he wanted to make up for lost time. He was 55 years old when he began to see things clearly; how this gives us hope. March 29th: A serious visit to Turner. . . . In sum, he freed himself from all dark tones after 1830. His colour vibrates, the pictures are composed, the colours organised. It is complete and meditated control. Then 12 years later, he sacrificed everything to colour. What he loses in pre-meditation he gains in pure and harmonious brilliance. His influence on Delacroix is incontestable. In 1834 the French master studied and understood Turner. The tones, the hues, the harmonies I have seen in Delacroix, I find again in Turner.' Of some of Turner's late paintings Signac wrote: 'These are no longer pictures but aggregations of colour, quarries of precious stones, painting in the most beautiful sense of the word.'

Revolutionary though Turner might appear in his treatment of light and colour, he still painted with the traditional techniques of Renaissance painters: a multilayer technique modelling form in white lead solidly in the lightest parts of the picture and more thinly in the mid-tones, allowing a darker undercoat to show through, and exploiting the Tyndall effect of differential light scatter, producing an increase in the colour temperature of the reflected light. Over the white modelling, colours were applied in transparent glazes, causing separation of the luminance and chrominance signals; further white modelling and glazes were superimposed until the final results were achieved. There was little mixing of pigments, and the range of pigments was usually fairly limited, but their interaction produced complex effects. Turner knew exactly how to control this technique to maximum effect. A magnificent draughtsman, Turner astonished his English contemporaries with his virtuosity, but in England his obsession with colour and light was an isolated phenomenon, and it is only recently that his conceptual precocity in light and colour in painting has been internationally acknowledged.

The other contemporary English painter whose work significantly contributed to the revolution of Impressionism, was John Constable whose painting 'The Hay Wain' caused a sensation among painters when it was exhibited in Paris in 1824. Constable, too, was very well versed in colour theory, but his expression of the new concepts was very different from Turner's. He relied on light reflections from the surface of paint applied impasto, or opaque.

Professor Wright, in an essay, 'The Anatomy of Texture', has this to say: 'It was Constable's technical innovations which really stirred the French artists. Constable was obsessed with the importance of luminosity in a painting, for he knew that every part of a scene, however dark, radiates some light. He found that he could best express this luminosity by breaking his colour. Like a musical note of unvarying intensity, a surface which is uniform in colour, appears dull and uninteresting; break it into small areas which differ in colour and lightness and it becomes lively and stimulating; add some surface irregularities, and it may almost vibrate with vitality and sparkle. In "The Hay Wain" these effects were produced not merely by skilful brushwork, but in a very remarkable way, by the extensive use of solid white paint applied with a palette knife. . . . Constable must have evolved his technique through prolonged experiment and research, and for this he is entitled to the greatest respect from all visual scientists.'

Four post-Renaissance concepts influenced the painters of the late nineteenth

century: the spectrum of colour deriving from a beam of white light, the colour circle, the three subtractive primary colours, and the interaction of the chromatic and achromatic complementaries. A further influence was the Japanese print.

Among those most responsible for the scientific ideas infiltrating the consciousness of painters at this time, was the great French scientist, chemist and naturalist Eugène Chevreul, who lived from 1786 to 1889—more than a century. In 1839 Chevreul published his book *The Principles of Colour and Colour Contrast,* which contained the principles relating to optical mixtures, complementary colours, after-images, visual illusions and colour perception generally, with the author's own diagrams in colour that illustrated the optical effects of simultaneous and successive contrast from opposing colour associations and the juxtaposition of variously coloured small surface areas.

The product of vast experience in Chevreul's long working life, particularly of his practical experience in industry, including the Gobelin manufactory of which he was a director, the book became extremely popular, and Chevreul won great acclaim. Through the medium of Delacroix, who greatly admired the book, Chevreul's work became one of the cornerstones of the revolution in art that took place after the middle of the nineteenth century. Delacroix wrote: 'The elements of colour theory have been neither analysed nor taught in our schools of art, because in France it is considered superfluous to study the laws of colour, according to the saying "Draughtsmen may be made, but colorists are born." Secrets of colour theory? Why call those principles secrets which all artists must know and all should have been taught?'

Figure 8.3 The after-image of the white dot on the black disc at the left will appear reversed as a black dot on a white disc when the gaze is shifted to the right-hand dot

By a combination of his powers of observation and his training as a scientist, Chevreul was able to explain and illustrate his theories very lucidly: 'We can establish three conditions in the appearance of the same object relative to the state of the eye. In the first, the organ simply perceives the image of the object without taking into account the distribution of the colours, light and shade; in the second the spectator seeking to properly understand the distribution, observes it attentively, and it is then that the object exhibits to him all the phenomena of simultaneous contrast of tone and colour which it is capable of exciting in us. In the third circumstance, the organ, from the prolonged impression of the colours, possesses in the highest degree a tendency to see the complementaries of these colours, it being understood that these different states of the organ are not

Figure 8.4 Effect of background. The centre circles are the same grey, but they appear to vary from left to right (from *Visual Illusions* by Luckiesh, 1922)

Figure 8.5 Brightness contrast. Both arrows are the same grey, but appear light or dark depending on background (from *Visual Illusions* by Luckiesh, 1922)

Figure 8.6 Black and white discs such as these can be rotated to induce colour sensations

interrupted but continuous, and that if we examined them separately, it was with the view of explaining the diversity of the impression of the same object upon the sight and to make evident to painters all the inconvenience attendant upon a too prolonged view of the model.'

In a good deal of his book, Chevreul is restating and clarifying with his illustrations much of what Goethe had observed and described. Chevreul demonstrated that by means of simultaneous and successive contrast effects, a very restricted palette of colours could be made in weaving to appear richer and more varied—a theory which the weavers of Oriental carpets had for centuries unconsciously applied.

The practical applications of such demonstrations in the manufacture of various artefacts in which Chevreul had a consultant's interest attracted the attention of painters and led to the practice of opposing one complementary against another in hue, value and intensity to achieve a balanced colour composition. This practice had sometimes been implicit in traditional painting; in the new tradition it became explicit. Goethe had tried to encourage traditional techniques in painting in order to exploit the doctrine of transparent mediums. Chevreul tilted the scales towards the counterpoint of complementaries: 'It is by starting both from the physical condition of the coloured elements the Gobelin weaver employs, and from the texture of the tapestry, that I deduce the necessity of representing in this kind of work, only large, well defined objects, and particularly remarkable for the brilliancy of their colour. I prove that patterns for hangings must recommend themselves more by opposite colours than by minute finish in the details.'

Chevreul was also instrumental in popularising Oriental art, and in particular, the Japanese prints with their flat colours, use of black, and use of linear perspective. Chevreul analysed objectively the Oriental style: 'In painting in flat tints the colours are neither shaded nor blended together, nor modified by the coloured rays coming from objects near those imitated by the painter. . . . In this kind of painting, the representation of the model is reduced to the observance of linear perspective (as opposed to aerial perspective), to the employment of vivid colours in the foreground, and to that of pale and grey colours in the more distant planes. . . . If the choice of contiguous colours has been made in conformity with the laws of simultaneous contrast, the effect of the colour will be greater than if it had been painted on the system of chiaroscuro.'

Such observations were not without appeal to French painters and others actively throwing off the restraints of conventional painting. The principle of simultaneous contrast captured the imagination of painter and critic alike and at times it was taken to extremes. Here is John Ruskin, great Victorian art critic and painter: 'Give me some mud off a city crossing, some ochre out of a gravel pit, and a little whitening, and some coal dust, and I will paint you a luminous picture, if you give me time to gradate my mud, and subdue my dust: but though you had the red of the ruby, the blue of the gentian, snow for the light, and amber for the gold, you cannot paint a luminous picture, if you keep the masses of those colours unbroken in purity, and unvarying in depth.'

Ruskin, indeed, was exceptionally sensitive to colour, and comments on white: 'I say, first, the white is precious. I do not mean merely glittering or brilliant: it is easy to scratch white seagulls out of black clouds, and dot clumsy foliage with

Figure 8.7 *The Toilet* by Utamaro. Japanese colour print (British Museum, London)

chalky dew; but when white is well managed, it ought to be strangely delicious—tender as well as bright, like inlaid mother of pearl. . . . The eye ought to seek it for rest, brilliant though it may be; and to feel it as a space of strange, heavenly paleness in the midst of the flushing of colours. This effect you can only reach by general depth of middle tint, by absolutely refusing to allow any white to exist except where you need it, and by keeping the white itself subdued by grey, except at a few points of chief lustre.' This was the critic whose vicious attack ('. . . never expected to hear a coxcomb ask 200 guineas for flinging a pot of paint in the public's face') quoted in a notorious law case, ruined Whistler, one of the most subtle of all painters in his use of white, as his paintings 'The White Girl' and 'Symphony in White' clearly illustrate.

The qualities that Chevreul identified in Oriental art were reflected in the work of painters as various as Gauguin, Manet, Toulouse-Lautrec in France, Whistler in England and throughout the Art Nouveau movement in Europe. A letter from Vincent van Gogh to his brother Theo written in 1889 shows respect for Delacroix, the influence of the Japanese print, and the attraction of prismatic

Figure 8.8 *Miss Cicely Alexander; Harmony in Grey and Green* by J. M. Whistler (Tate Gallery, London)

colour: 'My dear Brother, you know that I came to the South and threw myself into my work for a thousand reasons. Wishing to see a different light, thinking that to look at nature under a brighter sky might give us a better idea of the Japanese way of feeling and drawing. Wishing also to see this stronger sun, because one feels that without it one could not understand the pictures of Delacroix from the point of view of execution and technique, and because one feels that the colours of the prism are veiled in the mists of the North.'

The Impressionists, influenced by the paintings and by the *Journal* of Delacroix, put his ideas on colour in painting to dramatic effect. They transformed the everyday life around them by depicting it in brilliant, impressionistic colour in such a way that people began gradually to look around them with new eyes, and to see colours that previously they had not known existed. The work of the Impressionists, now regarded as attractive and even as rather pretty, in its time was shocking, and outraged critics and public alike.

The Impressionists were motivated by the study of light in the atmospheric world of landscape, the action of light on the appearance of local colour, in flesh, fabrics, flowers, water, sky, foliage and so on, depicted in small brush strokes of prismatic colour. Monet explored the effects of light phenomena on landscape with such fidelity of purpose that he required a fresh canvas every hour of the day to represent his subject as the light changed.

Camille Pissarro, one of the earliest and most influential of the Impressionists, and their acknowledged leader, liked to work as nearly as possible with the three subtractive primaries: yellow, red and blue. He omitted green from his palette and used only white lead, chrome yellow, vermilion, rose madder, ultramarine, cobalt blue and cobalt violet. His use of scintillating, broken colours and optical mixtures had a revolutionary influence not only on the original Impressionist movement, with which he was deeply involved, but also on Neo-Impressionism and Post-Impressionism.

He joined Manet, Monet, and Renoir in 1865, and exhibited regularly with the group. Five years later he visited London with Monet, where both came under the influence of Turner and Constable, and there became interested in luminosity in painting. Another early Impressionist, Manet, was interested not so much in broken colour, but in contrasting bold, flat areas of colour with unrelieved black areas, sometimes suggesting the Japanese print, but totally different from the contemporary conventional painting. Degas was a painter of the impressionism of movement, who shared some of the bold contrast effects of Manet with the lightness of touch and broken colour effects of more typical Impressionists such as Monet, Renoir, Sisley and Pissarro. Although Degas' palette, too, was luminous and prismatic, line was for him as significant as colour. His work also reflected the new influence of emergent photography on painting, not only in his use of tonal contrast, but also in his composition and in the introduction of the arbitrary cut-off of objects and figures by the frame. Degas possessed a big collection of contemporary photographs from which he often worked.

Pissarro's friend and contemporary, Renoir, was essentially an intuitive and sensuous painter, a master of the evocative rendering of sunlit surfaces, filmy fabrics, hair, skin, and the play of light on the ordinary world around him. His palette consisted of black and white, together with eight or nine pure hues. He mixed his colours as little as possible, and used short, broken brushwork, accentuated with black, to obtain his delicate shimmering effects.

Another of the original group, Monet, was far more of a 'scientific' painter than either Pissarro or Renoir. He painted out of doors and assiduously studied the effects of changing light on landscape. Monet liked to paint many variations on a theme; some of the most dramatic are of Rouen Cathedral, Waterloo Bridge in London and, when he was older, of his own garden, to which he was passionately devoted. His studies of atmospheric effects were remarkable, particularly those of London seen under the foggy conditions which delighted him, in contrast to his usual studies of sunlight executed in bold strokes with pure colours.

But 1886 marked the end of Impressionism as a coherent movement, with the introduction to exhibitions of the Neo-Impressionists—notably Seurat, Signac, Vuillard and Bonnard—and the emergence of the Post-Impressionists Lautrec, Gauguin, Cezanne and van Gogh.

Figure 8.9 *The Starry Night* by van Gogh (1889)—graphic rhythms and dynamic colour (collection, The Museum of Modern Art, New York. Lillie P. Bliss bequest)

A typical palette of the two Neo-Impressionists Sisley and Seurat (both young painters who worked in undiluted pure hues arranged on the palette in spectral order) was cadmium yellow, vermilion, rose madder, cobalt violet, ultramarine, cerulean blue, emerald green, pale cadmium, silver white and zinc white. They applied their colours to the canvas in tiny flecks that reflected coloured light, which, mixed optically, built into a shimmering impression of a light-saturated surface that was, at the same time, curiously solid in effect.

The Neo-Impressionists were committed to prismatic colour in their palette. They affirmed that mixing pigments reduced the power of colour, and used tiny dots of pure hues that mixed optically in the eye of the observer. By this technique, drawing directly from Chevreul, Seurat, Signac and Sisley among others, they achieved paintings of a dazzling brilliance of colour.

Three other great painters of the period used colour powerfully but in sharply

contrasted ways. Gauguin, bored by the contemporary bourgeois scene, escaped to Tahiti, where he created his characteristic flat, brilliantly coloured paintings of the primitive island scene in an Oriental style, introducing decorative colour relationships of yellow ochre, strident greens, and blues, with acid yellows and tender pinks, to astonish and disturb his compatriots.

Perhaps the most famous of all the painters of this period, though in his lifetime, the most neglected, van Gogh, driven by an inner compulsion to seek sunlight and colour in the south of France, painted there his legendary series of masterpieces, unsurpassed in sheer sensuous passion for colour and in the calligraphic quality of his brushwork. Van Gogh's palette reflected his obsession with colour in its brilliant reds, oranges, greens and·blues, and in the saturated yellows that dominated so many of the later paintings of his tragic life—pigments he struggled in his poverty to buy, in order to create those paintings which are now beyond evaluation.

Cézanne used colour in a totally different way. He did not confine himself to pure hues, but used the dimensions of colour to define structure, planes and stereoscopic space. In his later years, Cézanne used colour to achieve what amounted to abstract colour relationships in thinly applied squares of colour of a marvellous subtlety, in a series of paintings of the landscapes around his home in Provence. A magnificent painter, both in oils and watercolours, he became the inspiration of generations of painters.

Derain used such brilliant colour in a non-realistic way that he was accused of painting with sticks of dynamite, though his paintings were strictly disciplined by colour theory.

The great American historian of colour, Faber Birren, writes in his *History of Color in Painting* (one of the few books linking colour science with painting): 'Impressionism was greatly influenced by the writings of Chevreul, but Neo-Impressionism was based largely on the technical findings of Ogden N. Rood, Hermann von Helmholtz, David Sutter and Charles Henry. The Neo-Impressionist period was marked by an absorbing interest in the science that pervaded the new art. This science was eagerly accepted by the painters. Art journals published essays on the science of color, and the artist was advised to devote himself to such inquiry. It was generally assumed by men who were to become the greatest painters of their generation that ignorance in matters of colour was unforgivable, and that regardless of individual talent, genius or feeling, a man needed to be versed in the phenomenon of vision and physiological optics.'

Ogden Rood, an American writer ˙on colour who studied both science and painting (an unusual combination, then as now), published in 1879 his book *Modern Chromatics*. As a widely travelled cosmopolitan, educated in physics, chemistry and art, Rood was enthusiastically read both in his own country and in Europe, and for this reason information on light˙and colour was widely circulated. According to Birren: 'Rood undertook discussions of reflected and transmitted light, colour dispersion and the constants of colour, which he looked upon as purity, luminosity and hue. There were notes on the production of colour by interference, fluorescence, absorption, and a list of pigments that would stand long exposure to light. Colour perception, the phenomena of after-images, coloured shadows, colour mixtures, theories of colour vision, were all taken up.

He explained how tinted light affected the appearance of surface colours, talked of complements, simultaneous contrast, colour harmony, and the duration of colour impressions on the retina.'

Rood made explicit to painters what Chevreul had pointed out with reference to the applied arts. 'We refer', he wrote, 'to the custom of placing a quantity of small dots of two colours very near each other, and allowing them to be blended by the eye at the proper distance. . . . The results obtained in this way are true mixtures of coloured light. . . . This method is almost the only practical one at the disposal of the artist whereby he can actually mix, not pigments, but masses of coloured light.'

Both Rood and Chevreul contributed dynamically to the divisionist technique of dividing colour areas into point elements, which Post-Impressionists practised. The move towards abstraction was certainly accentuated by the break-up of colour influenced by their writings, but Chevreul was involved in abstractionism in a different way, and the following passage by him indicates the beginning of a rejection of faithful representation: 'The essential qualities of painting in flat tints necessarily consist in the perfections of the outlines and colours. These outlines contribute to render the impressions of colours stronger and more agreeable, when, circumscribing forms clothed in colours, they concur with them in suggesting a graceful object to the mind, although in fact the imitation of it does not give a faithful representation. . . . The objects preferable as models are those whose beauty of form are so remarkable as to attract the eye by outlines easily traced and by their vivid colours, as birds, insects, flowers, etc.'

**Figure 8.10 *Bedroom at Arles* by van Gogh
(The Art Institute of Chicago)**

French painters were in fact moving towards abstraction in colour. Signac's 'no longer pictures but aggregations of colours', which he applied to Turner's late paintings, began to apply to French painting of the late nineteenth century. In a letter to Theo written at Arles in 1888, van Gogh describes a painting he has yet to make, but the colour images are already so clear in his mind that his verbal description evokes an image hardly less clear in the mind of the reader, who could at once identify the painting that was produced the next day:

Another canvas of size 30. This time its just simply my bedroom, only here colour is to do everything, and giving by its simplification a grander style to things, is to be suggestive here of *rest* or of sleep in general. In a word, to look at the picture ought to rest the brain or rather the imagination.
The walls are pale violet. The floor is of red tiles.
The wood of the bed and chairs is the yellow of fresh butter, the sheet and pillows very light lemon-green.
The coverlet scarlet. The window green.
The toilet table orange, the basin blue.
The door lilac.
And that is all. There is nothing in this room with closed shutters.
The broad lines of the furniture must again express inviolable rest.
Portraits on the walls, and a mirror and a towel and some clothes.
The frame—as there is no white in the picture—will be white. . . . I shall work at it again all day to-morrow, but you see how simple the conception is. The shadows and the thrown shadows are suppressed, it is coloured in free flat tones like Japanese prints.

The painting is mentally organised purely as colour relationships; the visual interactions of the vibrating colours are already felt, and there is a faint echo of Chevreul. Van Gogh was one of the greatest colorists of all time, and few painters have been so articulate in words. He was obsessed by colour, lived and died for it.

Cézanne, after his early experiments in Impressionism, ignored pointillism and began to paint in broad masses, accentuating structure, form and dimension. More than any other painter of his time he used colour objectively to build form and solidity on the flat canvas, and his paintings inspired the later cubists. Itten wrote of Cézanne: 'To him modulating colour meant varying it between cold and warm, light and dark, or dull and intense. . . . Cézanne was now integrating the whole picture formally, rhythmically and chromatically.'

The paintings of the Post-Impressionist Paul Gauguin are not remarkable for form and spatial relationships, but for the design and pattern of the flatly painted areas of sumptuous colours. The decorative treatment of his subject matter related only marginally to the actual colour of his subject matter, and reflected the current interest in Oriental and exotic art. He observed, 'Painting is an abstraction', and his paintings certainly contained elements of abstraction which the later non-representational painters did not fail to remark. Matisse, the leader of the short-lived Fauvist movement, was also influential in the Cubist movement, which included Picasso, Braque, Léger and Juan Gris. Later, Matisse developed the highly individualistic style in which he used colour and line with supreme mastery

to construct spatial relationships of lyrical simplicity. Picasso early attracted attention with his *Période blue* and *Période rose* series of paintings, and established a reputation for the immaculate draughtsmanship and mastery of classical construction and techniques which always underlined the bewildering versatility of his work and with which he achieved enormous contemporary prestige and a vast fortune. Picasso's colours varied from the tenderness of his early works to those bold, passionate hues associated with his politically motivated paintings, and the rich, sombre colours of the series of paintings he based on the works of his compatriot, Velasquez.

With the advent of twentieth-century art, abstract painting came into its own. The first totally abstract paintings were contained in a book called *Thought Forms* (1902) by C. W. Leadbeater and Mrs Besant. Kandinsky's first abstract water-colour was painted in 1910. The so-called liberation of colour from its traditional role for its new abstract role in painting was first announced in the work of Delaunay and Kupka in 1912, and was then promoted by the paintings of Léger, Kandinsky, Klee and Delaunay, followed by several others. Bright saturated colour was used with almost frenetic abandon. The intellectual discipline of the Impressionists had disappeared and was replaced by emphasis on psychological content.

Kandinsky wrote and painted in passionate terms on the spiritual content of colour and its musical connotations. Describing a sunset, Kandinsky wrote: 'It melts down the whole of Moscow into a single puddle, which like a mad bass tuba, sets all one's inwardness, one's soul, vibrating. . . . This is merely the final chord of the symphony, which brings each colour into supreme life, which makes all Moscow vibrate, like the fortissimo of a giant orchestra. Pink, lavender, yellow, white, blue, pistachio-green, the flaming red houses, the churches—each an independent song—the frantically green lawns, the deeper tones of the trees.'

This passage is symptomatic of pseudo-scientific interest by the Fauve and Art Deco movements of the early twentieth century in the identification of colour with the aesthetics of music. In 1882 Renoir spoke to Wagner of 'the impressionism in music' while Debussy's 'Printemps' was reviewed as 'vague impressionism'. Painters called their paintings 'symphonies' (Whistler), or 'harmonies' (Monet). Kandinsky, in 1908, claimed to have experienced sensations of abstract colour and form at a performance of *Lohengrin*. Others found specific ratios between colours and musical notes. *The Art of Mobile Colour* (1912) by A. Wallace Rimington contained a table of such ratios, and 'colour organs' were in vogue. It was a period of esoteric and mystic exploration and of mild intellectual hysteria, in which Helena Blavatsky and Rudolf Steiner gained popularity.

The turn of the century produced painters of great power and confidence in the use of colour. The colour relationships of Munch, Nolde and Marc were marvell-ously composed to enhance the emotional impact of their Expressionist paintings. The colours of Léger were almost violent; those of Vlaminck highly dramatic, and those of Kandinsky charged with emotion. Matisse, Bonnard and Derain composed with acute sensitivity in brilliant counterpoint of complementaries from fully saturated to palest hues, in a superb balance of colour that delighted the sophisticated eye. These painters had absorbed intuitively from the paintings of

Visual Vibrations	395	433	466	500	533	566	600	633	666	700	733	757	Invisible
Colour	Deep Red	Crimson	Orange Red	Orange	Yellow	Yellow Green	Green	Bluish Green	Blue Green	Indigo	Deep Blue	Violet	
Musical Note	C	C#	D	D#	E	F	F#	G	G#	A	A#	B	C
Sound Vibrations	256	277	298	319	341	362	383	405	426	447	469	490	512

Figure 8.11 Colour music table from *The Art of Mobile Colour* by A. Wallace Rimington (London, 1912)

the Impressionists and their followers the colour values those painters had achieved intellectually from their study of the various scientific writers and from each other. They arrived at a new, lyrical synthesis of colour. On the whole, with the acceptance of abstract painting, interest in colour science declined. The intellectual discipline and passion for colour was replaced by emphasis on Significant Form and on psychological and political content.

In Germany, for a brief ten years, a new dynamic in the teaching of colour was launched by a group of painters at the Bauhaus (1919–1933) under the direction of the architect, Walter Gropius. After the destruction of the Bauhaus by Hitler, these painters scattered to spread their ideas abroad. Kandinsky, Albers, Klee, Itten and Moholy-Nagy, all were intensely articulate in their use of words as well as paint, and all became famous. The repercussions of their work rippled out like waves from a stone flung into a pool, to bring new life and a new aesthetic vitality to the visual culture first of Europe, then of North America.

Klee painted his symbolic imagery in witty and subtle associations of colour and wrote his aesthetic creed in *The Thinking Eye* (1961). Itten wrote and illustrated a major book *The Art of Colour*, published in Germany in 1961, in which he systematically explored optical aspects of colour. He wrote: 'Close study of the great master colorists has convinced me that all of them possessed a science of colour.' Writing in twentieth-century terms he declared: 'Colours are forces, radiant energies that affect us positively or negatively, whether we are aware of it or not.' He also declared: 'The effects of colour should be experienced not only visually but also psychologically and symbolically.... The artist finally is interested in colour effects from their aesthetic aspect and needs both physiological and psychological information. Discovery of relationships mediated by the eye and brain between colour agents and colour effects in man is a major concern of the artist.'

Albers, with the co-operation of his students, made a comprehensive study of perceptual illusions and visual effects, illustrated and discussed in his monumental *Inter-action of Colour* published in America in 1963, in which he acknowledged his debt to Goethe. He himself made a series of paintings called 'Homage to the

Figure 8.12 The von Bezold effect. The grey pattern is the same throughout; the black and white grounds seem to 'spread' over the pattern to make it appear darker or lighter (from *The Theory of Colour* by Wilhelm von Bezold, 1876)

Square', in which he explored in unchanging geometric compositions, the optical effects of colours one upon another; in this he was influenced by the Bezold Effect—an optical effect named after Wilhelm von Bezold, who found he could change colour combinations entirely by adding or changing one colour only. In criticising Chevreul's method of constructing a graduated scale of greys, Albers wrote: 'What is necessary to produce a visually even progression in mixture? The answer is the Weber–Fechner law: "The visual perception of an arithmetic progression depends upon a physical geometric progression".' The law demonstrates the surprising discrepancy between physical fact and psychic effect.

In the twentieth-century the change from traditional to synthetic colours, already evident in the paintings of the Impressionists, removed the discipline of the limited palette, and conceptual disciplines were substituted. In America, the Action group of painters, headed by Jackson Pollock, painted with totally non-representational swirls of colour in a richly coloured and textured surface.

After the domination of completely abstract concepts in painting, a new vision of colour, rooted in colour theory, emerged with the Op painters, such as Vasarely, Bridget Riley and Morris Louis, who owed much to the teaching of the Bauhaus in their approach to optical mixtures of pure colours applied in geometric patterns.

The work of twentieth-century painters is no longer dominated by the use of conventional painting materials—pigments, media, grounds, etc.—and there is no longer a definitive line to be drawn between the work of painters and sculptors (and, increasingly, of architects) and between commercial, industrial and fine art. Every form of vehicle for colour is exploited in collages, three-dimensional structures and kinetic abstractions. In 'paintings', colour is used descriptively, evocatively, or thematically.

During the twentieth century the last conventional barriers of painting have been overthrown, and Optical Art, visual games and technological apparatus appeared in the picture galleries. The constructivists produced kinetic structures, sometimes combining them with optical devices with spectral colour effects. The picture frame disappears: the work of art expands into architectural space.

Coloured glass, mirrors, transparent membranes, and steel combine with motion and illumination to create a world of illusion, which involves the participation of the observer. A new world of colour is unfolding in the art of today—a world informed by the discoveries of the physicist, the chemist, the engineer, the physiologist, the psychologist and the photographer.

The painter may be conscious or unconscious of these sources. Bridget Riley states: 'I have never studied "optics" and my use of mathematics is rudimentary and confined to such things as equalising, halving and quartering and simple progressions. My work has developed on the basis of empirical analyses and syntheses, and I have always believed that perception is the medium through which states of being are indirectly experienced. Everyone knows by now that neuro-physiological and psychological responses are inseparable.'

But how do we know this? Riley herself had studied van Gogh's colour and calligraphy, Chevreul, Klee's *The Thinking Eye*, Cézanne and the Cubists, and a synthesis of these sources of inspiration is implicit in her work. The response to the paintings of Riley and Vasarely, to the kinetic structures of Gabo or the shifting metamorphoses of illuminated surfaces of other kinetic artists, is a response to natural law gradually revealed through individual scientists and philosophers and interpreted by the artist.

In this context, colour provides a bridge between art and science in the world of visual perception. A most vital link in the structure of the bridge, photography, is itself both an art and a science. Photography as a science owes much to the development of the science of colorimetry. Both sciences are involved in the analysis of colour in art.

In his book *Colour Photography* (1968), Eric de Maré writes:

The true start of colour photography occurred in May 1861 when the great Scottish physicist, Sir James Clerk Maxwell . . . demonstrated dramatically at the Royal Institution in London that any colour can be obtained by mixing light of the three primary colours of red, green and blue in varying proportions. . . . For his demonstration Clerk Maxwell made three photographic exposures of a tartan ribbon on black and white photographic plates, one through red glass, one through green, and the third through blue. Positive lantern slides were printed from the negatives and each was projected by a lantern through its appropriate colour filter to coincide in superimposed register on the screen to form a fairly effective colour photograph of the tartan. That was the first additive system of colour photography.

The first subtractive system was announced independently during the 1860s by two Frenchmen who were quite unknown to each other but had both been experimenting along similar lines. Their names were Charles Cros and Louis Ducos du Hauron. Later the two worked together and evolved several methods of three-colour photography. In 1869 du Hauron published a remarkable small book, *Les Couleurs en photographie, solution du problème*, in which all the main principles of modern colour photography were laid down.

Du Hauron's subtractive method was as follows. He took three separation negatives behind green, orange and violet filters, and from these he made positives on sheets of bi-chromated gelatine containing coloured pigments of red, blue and yellow—that is the respective complementary of the negative

colours. The carbon prints were then superimposed in transfer on a mount either on paper to make a print or on glass to make a transparency. They were called Heliochromes.

Maré goes on to describe the introduction in 1873 by Vogel of Germany of aniline dyes (made available through Perkin's initial discovery of synthetic dyes) leading to the orthochromatic plate and the appearance in 1906 of the panchromatic plate.

Zenken had pointed out in 1868 the possibilities of interference heliochromy, and in 1891 Gabriel Lippmann at the Sorbonne obtained remarkable colour photographs by exploiting interference phenomena using a plate coated with silver bromide in contact with a bath of mercury. When the plate was developed and fixed and placed above a light-reflecting mercury bath, very true colours were produced. But this ingenious process was not found to have commercial applications and was abandoned.

Another additive system was used by John Joly of Dublin, who in 1893 invented the screen plate, resulting in the first colour photograph to be seen as a single entity. Other additive colour photographic processes resulted from Joly's discovery including the Dufay process invented by Louis Dufay in 1908. The screen of Dufay's plate was composed of a transparent grid of red lines interspersed with alternate blue and green squares, and the Johnson process, in which the screen was composed of a mosaic of red, blue and green squares, foreshadowed future television processes.

All additive processes, however, were eventually replaced by subtractive processes, both in films and printing papers, in the form of the integral tri-pack. The first subtractive film appeared on the market in 1935 as the 35 mm Kodachrome, which is still popular. The first subtractive negative colour film was produced by Agfa in 1939, together with a new tri-pack printing paper, so creating the first commercial negative–positive subtractive system of colour photography.

At about the same time as the Bauhaus teachers were making their contribution to the understanding of colour science, the American physicist, Edward Land, was experimenting with visual adaptation phenomena and the generation of colour sensations from kinetic black-and-white associations, first demonstrated by Benham with his rotating black-and-white discs in 1894. Land's photographic development of this theme with photographic separations has been a major contribution to colour science in this century.

The revolution in graphic reproduction and photographic reproduction that the invention of photography has introduced, with photo-mechanical reproduction techniques, the half-tone process for black-and-white pictures and the three-, four- and multicolour process, is still in progress. Its effect on the arts and sciences has been incalculable.

Professor Bronowski in *The Ascent of Man* points to one further explanation of the revolution in twentieth-century art: 'Since the time of Newton's *Opticks* painters had been entranced by the coloured surfaces of things. The twentieth century changed all that. The notion that there is an underlying structure, a world within the world of the atom, captivated the imagination of artists at once. From the year 1900 on, art is different from the art before it.'

9

Colour and Environment

No one knows how far back in time the human passion for colour evolved, but fashion in colour and its transmigration from one culture to another, can be traced from archaeological fragments as old as recorded history.

The buildings of the ancient world—of the Mediterranean Basin, the Far East and South America—were rich in highly chromatic symbolism. In medieval Europe, the Gothic period flowered briefly in the gorgeous decoration of stone, timber and plaster, and the incomparable stained glass of its religious buildings. The Renaissance revived a form of classical architecture but omitted the characteristic brilliant polychromy of ancient Greece and Rome. The Protestant Reformation destroyed confidence in people's natural delight in colour; literacy removed their need for colour symbolism, and puritanism discouraged its use.

Since the Renaissance, architecture—the Queen of the Arts—has neglected colour in building. Line, form and spatial relationships have dominated the architectural imagination. The puritanical horror of colour as an integral part of buildings evident in so much post-medieval architecture in Western civilisations, reached its climax in the twentieth century with the spread of buildings in unfaced, re-inforced concrete, and the suppression of decoration culminating in 'brutalist' architecture. Architects, obsessed with building technologies, ignored human interest in colour, and architectural involvement with colour science was confined to the technical aspects of colour in building materials.

But reaction has now set in sharply to the concept of buildings as drab-coloured 'machines for living in' (introduced by the influential French architect and writer, Le Corbusier) and public disillusion with so-called architectural Functionalism is widespread. The enormous potential for dynamic colour in architecture is gradually being realised. A new enthusiasm for rich colour in public buildings reverses yet again the puritanical trend evident at the beginning of this century. Sources for inspiration for brilliant colours are both historical and ethnical; a new colour culture is emerging with the sophistication of late twentieth-century technology behind it.

In the confusions of the modern world, Jean-Philippe Lenclos of France has bravely built up a logical and, at the same time, poetical use of colour in architecture. He identifies two contrasting uses: (1) colour that is sympathetic to

RED

PINK

YELLOW

GREEN

BICE GREEN

BLUE

PALE BLUE

BROWN

BLACK

WHITE

A

B

C

EGYPT

**Figure 9.1 Supergraphics: colour coding. Narrow boats
identified by their decoration (see colour key)**

the natural and traditional environment; and (2) colour that imposes an artificial
aesthetic for new urban and industrial projects.

Lenclos was invited to apply his ideas in Tokyo. He divided the city into four
areas: (1) traditional buildings of the old city; (2) modern buildings in new
districts; (3) mixed transitional areas; and (4) industrial zones, and he planned his
colour schemes accordingly.

Lenclos's approach epitomises the new outlook on environmental colour in

**Figure 9.2 Supergraphics in nature and art.
Colour as pattern, unrelated to structure and form**

which he is so influential. First an analysis is made of the basic colours of the natural environment of the architectural complex—soil, mineral and vegetable components— and then the colours of the traditional buildings—mortar, daub, plaster and colour washes, which derive from these natural components, and establish a close link between the landscape and building. Regarding the rich variety of natural building materials in France, Lenclos comments: 'It is interesting to note that in general the total palette of a French town never exceeds more than two or three basic hues.' It is the variation in value and intensity of these few hues— the colour dimensions— that give subtlety to his schemes.

'Beyond the objective study of minerals, soil, building materials and paint,' observes Lenclos, 'we turn to the more subjective aspect of our study: the random factors and elements which are subject to changing colour—light, sky, water and vegetation. Although a building may reflect the same range of colour as its mineral environment, its colour is not static. It evolves, shifts and changes seasonally as a result of changes in light, air, humidity, rain and drought. In addition, natural parasites, such as mosses and lichens, add to the charm of the materials in the passage of time.'

Where the natural environment has become completely urbanised, new townscapes are created, predominantly of synthetic materials. Two types of urban landscape can be identified: civic areas (housing, shops, schools, theatres, etc.) and industrial zones. Where no natural element exists, colour can bring a rhythmic, poetic quality to what may otherwise be a drab, inhuman environment, and the imagination is stimulated. Jean-Philippe Lenclos foresees in the use of colour a new dynamic element in the built environment of the future, in which colour plays the creative role in the transformation of totally artificial environment. In *Color for Architecture* (1976), he writes: 'One can see some experiments which take us towards the idea of a coloured city. Here colour in material, structure, rhythm, contrast, can be a new plastic language whose riches are offered to the city of tomorrow.'

Lenclos sees in Supergraphics a significant manifestation of this new approach to colour in architecture. A recent concept as an art form, Supergraphics are revealed in nature, piebald, skewbald, dapple and stripes, in the colour camouflage of mammals, birds, fishes and insects, and in land and seascape where bright sunlit areas contrast with deep shadows in chance effects cast by clouds. Until Supergraphics became accepted as a form of colour expression, it was used only in a negative way for military camouflage, but now its architectural potential is beginning to be realised.

'Supergraphics', says Lenclos, 'is a graphic art applied to a volumetric surface without submitting to its contours. It covers planes, edges and corners, enhancing the initial scale of the mass. By the power of its pattern, to which is added the expressive strength of contrast and colour, it plays a real part in creating considerable visual transformation of architectural space.'

Other architects have used modern architectural colour boldly and successfully—Piano and Rogers of Milan, Foster Associates in England, Gaudi in housing at Tarragona, and Ricardo Bofil at 'La Muralla Roja' at Sitges. Schweitzer has used new colour ideas in the medieval façades of Hoechst in

Germany, and the same sort of approach is evident in the colours applied to the Victorian houses of San Francisco.

Anna and Ricardo Bofil write of the organic approach to architectural colour: 'There is no architecture without colour, even when it is omitted it is still there. . . . Through colour, architecture can be brought to life, a living breath to animate the coldness of the building.' Perhaps the buildings of the future will vibrate with colour as once did those of the ancient and medieval worlds.

It seems likely that the success of these experiments with colour will prompt imitations, and further experiment. If the quality of polychromatic architecture, pioneered by skilful colorists, is to remain high when commercial enterprise exploits the fashions, many more colour planners of imagination and sensitivity, with a basic knowledge of colour science will be needed. A new approach to colour education will be required.

A marvellous faculty of colour vision combined with innate human curiosity have contributed through art, science and technology to colour in the man-made world as we know it today. A new culture, more leisured and more creative—the product of the technological revolution through which we are struggling—may bring a new aesthetic harmony to tired cities and protect and extend those natural beauties that remain. In such a culture, colour will be a vital element.

References and Bibliography

Chapter 1 Understanding Colour

References

Bronowski, J., *The Ascent of Man*, BBC Publications, London, 1973

Goethe, Johann Wolfgang von, *Theory of Colours* (English translation by Charles Lock Eastlake, introduction by Deane B. Judd), MIT Press, 1970

Humphrey, Nicholas, 'The Colour Currency of Nature', in Tom Porter and Byron Mikellides, *Color for Architecture*, Van Nostrand Reinhold, New York, 1976

Bibliography

Birren, Faber, *Color, Form and Space*, Reinhold Publishing Corporation, New York, 1961

Birren, Faber, *Color Psychology and Color Therapy*, University Books, New York, 1961

Birren, Faber, *New Horizons in Color*, Reinhold Publishing Corporation, New York, 1961

Clark, Kenneth, *Civilisation*, BBC Publications and J. Murray, London, 1971

Judd, Deane B. and Wyszecki, Gunther W., *Color in Business, Science and Industry*, John Wiley and Sons, New York, 1963

Chapter 2 Classifying Colour

References

'Analysis of the Ostwald Color System', *J. Opt. Soc. Am.*, 1944

Aristotle, *De Coloribus* (English translation in The Works), Oxford University Press

Baumann, P., *Neue Farbentonkarte* (system), Germany

Birren, Faber, *History of Color in Painting*, Van Nostrand Reinhold, New York, 1965

Boyle, Robert, *Experiments and Considerations Touching Colour*, Johnson Reprint, 1964

British Colour Council, *Dictionary of Colour Standards*, London, 1934

Chevreul, M. E., *De la Loi du Contraste Simultané des Couleurs*, Imprimerie Nationale, 1889

Chevreul, M. E., *The Principles of Harmony and Contrasts of Color*, Van Nostrand Reinhold, 1967

CIE (Commission Internationale d'Éclairage), 1931

Colorizer (system), Colorizer Associates, USA

Granville, W. C. and Jacobson, E., *J. Opt. Soc. Am.*, 1944

Härd, A., *The NCS Colour Order and Scaling System*, Swedish Colour Centre, Stockholm, 1969

Harris, Moses, *The Natural System of Colours*, Whitney Library of Design, New York, 1963

Hays, D. R., *Nomenclature of Colours*, William Blackwood and Sons, 1846

Hering Ewald, *Outlines of a Theory of the Light Sense*, Harvard University Press, 1964

Hesselgren, S., *Colour Manual*, Sweden, 1953

Hickethier, Alfred, *Ein-mal-eins der Farbe zur Farbenordnung* (system), Otto Maier Verlag, Ravensburg, 1963; English translation *Colour Matching and Mixing*, B. T. Batsford, London, 1970; published in USA as *Color Mixing by Numbers*, Van Nostrand Reinhold, 1970

ICA (International Colour Authority) London, New York, Amsterdam (seasonal)

ICI Colour Atlas (colour system, Keith Maclaren), 1973

ISCC-NBS: US Department of Commerce, *Nat. Bureau of Standards Circ. 553*, 1955 (Method of Designating Color, and Dictionary of Color Names)

Itten, Johannes, *The Art of Color*, Reinhold Publishing Corporation, New York, 1961

Jacobsen, Egbert, *Basic Color*, Paul Theobald and Co, Chicago, 1948

Johansson, Trygve, *Färg*, Stockholm, 1937

Kornerup, A. and Wanscher, J. H., *Handbook of Colour*, Methuen, 1967

Küppers, Harald, *Colour: Origin, Systems, Uses*, Van Nostrand Reinhold, New York, 1974

Le Blon, *First Colour Prints Based on Newton*, Frankfurt, 1730

Leonardo da Vinci, *A Treatise on Painting*, English translation by J. F. Rigaud, George Bell and Sons, London, 1877

Maerz and Paul, *Dictionary of Color*, McGraw-Hill, New York, 1950

Munsell, A. H., *A Color Notation*, Munsell Color Co, Baltimore, 1926

Newton, Sir Isaac, *Opticks*, 1665 (first published London, 1706), Dover Publications

Nu-Hue Systems, Martin Senour Co, USA

Ostwald, Wilhelm, *Color Harmony Manual*, The Container Corporation, USA, 1942

Ostwald, Wilhelm, *Colour Science* (English translation by J. Scott Taylor), Winsor and Newton, London, 1931

Plochère Colour System, USA

Pope, Arthur, *An Introduction to the Art of Drawing and Painting*, Harvard University Press, Cambridge, Mass., 1929

Pope, Arthur, *Color in Art. A Tribute to Arthur Pope*, Fogg Art Museum, Harvard University, 1974

Ridgeway, R, *Color Standards and Nomenclature*, published by the author in 1912, Washington, DC

Rood, Ogden N., *Modern Chromatics*, Van Nostrand Reinhold, 1974

Runge, Philip Otto, *Die Farbenkugel*, Verlag Freies Geistesleben, Stuttgart, 1959

Séguy, E., *Code Universel des Couleurs*, Paul Lechevalier, France, 1936

Société Française des Chrysanthémistes, France, 1936

Villalobos, *Colour Atlas*, Argentina

Wilson, Robert, *Horticultural Charts*, London, 1938–41

Bibliography

British Standards Institution, BS 1611, *Glossary of Colour Terms Used in Science and Industry*, London, 1953, superseded by BS 4727, Part 4, terms particular to lighting and colour

Physical Society, Colour Group: Report on Colour Terminology, London, 1948

Thomas Parsons and Sons, Historical Colours

Chapter 3 Colorants

References

Aristotle, *De Coloribus*, see Chapter 2

Badianus, Juan, *Badianus Manuscript*, Spain, 1552 (English translation by Martin de la Cruz), Vicenza, 1968

Boschini, *Le Ricche Minere della Pittura Veneziano*, Italy, 1674

Brunelli, Franco, *The Art of Dyeing*, Nero Rozzi, Neri Press, Cleveland, Ohio, 1973

Cellini, Benvenuto, *Autobiography*, Florence, 1558 (English translation by A. Macdonell), Everyman's Library, Dent

Cennini, Cennio D'Andrea, *The Craftsman's Handbook*, Dover Publications

Dioscorides, *De Materia Medica*, Ad 50 (German translation), Stuttgart, 1902

Hernandez, Francisco, *Thesaurus*, 1570, Pub. Accademia dei Lincei, 1615

Herodotus, *The Histories*, Greece, 450 BC (English translation by A. de Selincourt), Penguin

Pliny the Elder, *Naturalis Historia* (English translation by Henry Bohn), Heineman

Vasari, Giorgio, *Lives of Painters, Sculptors and Architects* (English translation by Hinds, Ed. W. Gaunt), Everyman's Library, Dent

Bibliography

British Standards Institution, BS 1006: *Methods for the Determination of the Colour Fastness of Textiles to Light and Weathering*, London, 1971

Church, A. H., *The Chemistry of Paints and Painting*, Seeley and Co, London, 1892

Colour in Surface Coatings, Paint Research Station, England, 1956

Constable, William G., *The Painter's Workshop*, Beacon Press, 1963

Dalton, John, *A New System of Chemical Philosophy* (facsimile of 1808 edition), Dawsons, Pall Mall, 1953

Dye Plants and Dyeing—A Handbook, Brooklyn Botanic Garden Record, Plants and Gardens

Eastlake, Charles, *Methods and Materials of Painting of the Great Schools and Masters*, Dover Publications

Field, George, *Chromatography or a Treatise on Colours and Pigments and of their Powers in Paints*, Charles Tilt, London, 1835

Goodwin, Michael, *Artist and Colourman*, Enfield, 1966

Harley, R. D. *Artist's Pigments c. 1600–1835*, Butterworth, 1970

Herberts, Kurt, *The Complete Book of Artist's Techniques*, Praeger, 1969

Hiler, Hilaire, *Color Harmony and Pigments*, Favor Ruhl and Co, Chicago, 1942

Maroger, Jaques, *The Secret Formulas and Techniques of the Masters*, Studio Publications, New York and London, 1948

Matiello, J., *Protective and Decorative Coatings*, John Wiley, New York, 1941

Mayer, Ralph, *The Artists' Handbook of Materials and Techniques*, Faber, 1972

Paint Journal, food and drink industries issue, **2**, No. 81

Pigment Particles, Paint Research Station, England, 1956

Remington, J. S. and Francis, W., *Pigments: Their Manufacture, Properties and Uses*, Leonard Hill, 1954

Ross, Denman Waldo, *The Painter's Palette*, Houghton Mifflin and Co, Boston, 1919

Thompson, Daniel V., *The Materials of Medieval Painting* (Ed. Bernard Berenson), Dover Publications, 1971

Chapter 4 Colour and Light

References

Aristotle, *De Coloribus*, see Chapter 2

Boyle, Robert, *Experiments and Considerations Touching Colour*, see Chapter 2

Descartes, Renati, *Principia Philosophiae*, Danielem Elsevirium, Amsterdam, 1677

Evans, Ralph M., *Introduction to Color*, John Wiley and Sons Inc, 1948

Fechner, G., *Elements of Psychophysics*, Holt, Rinehart and Winston, 1966

Halstead, M. B., *Colour Rendering—Past, Present and Future*; Lecture at Color Troy 1977
 Conference, Adam Hilger, 1977

Helmholtz, H. L. F., *Treatise on Physiological Optics* (Ed. Southall), Dover, Constable

Hering, Ewald, *Outlines of a Theory of the Light Sense*, see Chapter 2

Leonardo da Vinci, *A Treatise on Painting*, see Chapter 2

Newton, Sir Isaac, *Opticks*, see Chapter 2

Wright, William D., *The Measurement of Colour*, Hilger, 1969

Young, Sir Thomas, *Trichromatic Theory of Colour Vision*, London, 1801

Bibliography

British Standards Institution, BS 3020, *Improved Inks for Letterpress Four-Colour Printing*,
 London, 1959

Hunt, R. W. G., *The Reproduction of Colour*, Fountain Press, 1975

International Printing Ink Corporation, Three Monographs on Color—*Color Chemistry*;
 Color as Light; *Color in Use*, USA, 1935

Letouzey, V., *Colour and Colour Measurement in the Graphic Industries*, English transla-
 tion by V. G. W. Harrison, Pitman, London, 1958

Murray, H. D., *Colour in Theory and Practice*, Chapman and Hall, London

Chapter 5 Biological Colour

Bibliography

Bronowski, J., *The Ascent of Man*, see Chapter 1

Calder, Nigel, *The Key to the Universe*, BBC Publications, 1977

Cott, H. B., *Adaptive Coloration in Animals*, Methuen, 1940

Darwin, Charles, *The Origin of the Species*, Dent, 1972

Fox, Harold Munro and Vevers, H. Gwynne, *The Nature of Animal Colours*, Sidgwick and
 Jackson, London, 1960

Hinton, H. H. E., 'Natural Deception', in *Illusion in Nature and Art* (Eds. R. L. Gregory
 and E. H. Gombrich), Duckworth, London, 1973

Hinton, H. H. E., 'Some Little Known Surface Structures', *Symp. R. Ent. Soc.*, London, 5

Jaeger, P., *La Vie Étrange des Fleurs*, Horizons de France, Paris

Lutz, F. E., 'Invisible Colours of Flowers and Butterflies', *J. Am. Mus. Nat. Hist.*, 33

Maxwell, Sir James Clerk, *Treatise on Electricity and Magnetism*, Dover Publications

Tswett, M., *Chromophylls in the Plant and Animal World*, Warsaw, 1910

Wallace, Alfred, *On the Law which has Regulated the Introduction of New Species*, London,
 1855

Wickler, Wolfgang, *Mimicry in Plants and Animals* (English translation by R. D. Martin), Weidenfeld and Nicolson, London, 1968

Zechmeister, L. and Cholnoky, Z., *Principles and Practice of Chromatography* (English translation by A. L. Bacharach and F. A. Robinson), Chapman and Hall, London, 1943

Chapter 6 Colour and the Eye

References

Chevreul, M. E., *De la Loi du Contraste Simultané des Couleurs*, see Chapter 2

Dalton, J., 'Extraordinary Facts Relating to the Vision of Colours', *Mem. Liter. and Philos. Soc. Manchester*, 1798

Deutsch, Felix, Psycho-physical Reactions of the Vascular System to Influence of Light and Impressions Gained through Light, *Folio. Clin. Orientalia*, 1937

De Valois, R. L., Abramov, I. and Jacobs, G. H., *J. Opt. Soc. Am.*, 1966

Droscher, V. B., *The Magic of the Senses* (English translation by U. Lehrburger and O. Coburn), W. H. Allen, 1969

Fechner, Gustav, *Elements of Psychophysics*, see Chapter 4

Helmholtz, H. L. F., *Treatise on Physiological Optics*, see Chapter 4

Hering, Ewald, *Outlines of a Theory of the Light Sense*, see Chapter 2

Itten, Johannes, *The Elements of Colour*, Van Nostrand Reinhold, 1971

Land, Edwin, 'The Retinex Theory of Colour Vision,' *Scientific American*, December, 1977

Wright, W. D., *The Rays Are Not Coloured*, Hilger, London, 1967

Bibliography

Brindley, G. S., *Physiology of the Retina and the Visual Pathway*, Edward Arnold, 1970

Eldridge Green, F. W., *The Physiology of Vision*, George Bell, London

Wright, W. D., *Researches on Normal and Defective Colour Vision*, Kimpton, London, 1946

Chapter 7 Colour and the Mind

References

Alschuler, R. H., and Hattwick, L. W., *Painting and Personality: A Study of Young Children*, University of Chicago Press, 1969

Berenson, Bernard, *Aesthetics and History* (Reproduction), Somerset Pub, 1955

Bergson, Henri, *Matter and Memory*, Allen and Unwin, London, 1911

Birren, Faber, *History of Colour in Painting*, see Chapter 2

Birren, Faber, *Light, Color and Environment*, Van Nostrand Reinhold, New York, 1969

de Maré, Eric, *Colour Photography*, Penguin Books, London, 1968

Gattegno, Caleb, *Towards a Visual Culture*, Avon, 1971

Gattegno, Caleb, *Towards a Visual Culture*, Avon, 1971

Gattegno, Caleb, *Towards a Visual Culture: Educating Through Television*, Outerbridge, 1969

Gattegno, Caleb, *Words in Colour*, Educational Explorers

Gregory, R. L. and Gombrich, E. H. (eds.), *Illusion in Nature and Art*, see Chapter 5—Hinton

Huxley, Aldous, *The Doors of Perception and Heaven and Hell*, Chatto, 1968

Huxley, Aldous, *The Mind at Large*, Chatto

Katz, David, *Gestalt Psychology*, Ronald Press Co, New York, 1950

Katz, David, *The World of Colour*, Kegan Paul, Trench, Trubner and Co, London, 1935

Koestler, Arthur, *The Ghost in the Machine*, Hutchinson, 1976

Lewin, Roger, 'The Brain's Other Half', *New Scientist*, June 6th, 1974

Lowenfeld, Margaret, *The Non-verbal Thinking of Children*, The Institute of Child Psychology, London, 1965

Luckiesh, M., *Light, Vision and Seeing*, Van Nostrand Reinhold/Macmillan, 1947

Luckiesh, M., *Visual Illusions: Their Causes, Characteristics and Applications*, Dover Publications, 1965

Lydiatt, E. M., *Spontaneous Painting and Modelling*, Constable, 1971

Morris, Desmond, *The Biology of Art*, Methuen, London, 1966

Morris, Desmond, 'Primates' Aesthetics', *Nat. Hist.*, **70**, 1961

Newton, Sir Isaac, *Opticks*, see Chapter 2

Ostwald, Wilhelm, *Colour Science*, see Chapter 2

Reitman, F., *Psychotic Art*, Routledge, 1950

Sault, J., 'The Human Brain', *Doctor*, November, 1972

Smith, Peter, 'The Dialectics of Colour', in Tom Porter and Byron Mikellides, *Color for Architecture*, see Chapter 1—Humphrey

Southall, James P., *Introduction to Physiological Optics*, Dover Publications, 1937 (quoted by Birren)

Stokes, Adrian, *Colour and Form*, Faber, London, 1937

Vernon, Magdalen D., *The Psychology of Perception*, Penguin Books, 1970

Wright, W. D., *The Rays Are Not Coloured*, see Chapter 6

Bibliography

Eng, Helga, *The Psychology of Children's Drawings*, Routledge and Kegan Paul, London, 1954

Grozinger, W., *Scribbling, Drawing, Painting*, Faber and Faber, London, 1955

Kellogg, Rhoda, *What Children Scribble and Why*, author's edition, San Francisco, 1955

Klopfer, B. and Kelly, M., *The Rorschach Technique*, Harrap, 1946

Kluver, Heinrich, *Mescal and Mechanisms of Hallucinations*, University of Chicago Press, 1966

'Psychedelic Art', *Life Magazine*, September, 1966

Chapter 8 Colour-Science and Art

References

Albers, Josef, *The Interaction of Color*, Yale University Press, 1975

Aristotle, *De Coloribus*, see Chapter 2

Besant, Annie and Leadbeater, C. W., *Thought Forms*, Theosophical Pub. House, 1970

Birren, Faber, *History of Color in Painting*, see Chapter 2

Bronowski, J., *The Ascent of Man*, see Chapter 1

Cellini, Benvenuto, *Autobiography*, see Chapter 3

Cennini, Cennio D'Andrea, *The Craftsman's Handbook*, see Chapter 3

Chevreul, M. E., *De la Loi du Constraste Simultané des Couleurs*, see Chapter 2

Chevreul, M. E., *The Principles of Harmony and Contrasts of Color*, see Chapter 2

Delacroix, Eugène, *The Journal of Eugène Delacroix* (English translation by Walter Pach), Covici Friede Inc, 1937

de Maré, Eric, *Colour Photography*, see Chapter 7

Dickson, John, *Instant Pictures: The Complete Polaroid Camera Guide*, Pelham Books

Doerner, M., *The Materials of the Artist* (English translation by E. Neuhaus), Hart-Davis, 1969

Eastlake, Charles Lock, introduction and notes to his English translation of Goethe's *Theory of Colours*, see Chapter 1—Goethe

Harris, Moses, *The Natural System of Colours*, see Chapter 2

Helmholtz, H. L. F., *Treatise on Physiological Optics*, see Chapter 4

Henry, Charles, *The Scientific Aesthetic*

Itten, Johannes, *The Elements of Colour*, see Chapter 6

Judd, Deane B., Introduction to Goethe's *Theory of Colours*, see Chapter 1

Kandinsky, Wassily, *The Art of Spiritual Harmony* (English translation by M. T. H. Sadler), Houghton Mifflin and Co, Boston, 1914

Kandinsky, Wassily, *Concerning the Spiritual in Art* (English translation by M. T. H. Sadler), Dover Publications, 1977

Klee, Paul, *Notebooks Vol. 1—The Thinking Eye* (English translation by R. Manheim, Ed. J. Spiller), Lund Humphries, 1961

Le Blon, J. C., *L'Art d'Imprimer les Tableaux*, P. G. le Mercier, Paris, 1756

Leonardo da Vinci, *A Treatise on Painting*, see Chapter 2

Newton, Sir Isaac, *Opticks*, see Chapter 2

Piper, John, *Stained Glass: Art or Anti-art*, Studio Vista/Reinhold, 1968

Riley, Bridget, Comments in Catalogue, The Arts Council of Great Britain, London, 1973

Rimington, A. W., *The Art of Mobile Colour*, England, 1912

Rood, Ogden N., *Modern Chromatics*, see Chapter 2

Ruskin, John, *Modern Painters*, Dent

Signac, Paul, *De Delacroix au Neo-Impressionisme*, Paris, 1899

Sutter, David, *The Phenomenon of Vision*, L'Art, 1880

Van Gogh, Vincent, *Letters* (Ed. Mark W. Roskill), Fontana, 1963

Wright, W. D., 'The Anatomy of Texture' in *The Rays Are Not Coloured*, see Chapter 6

Bibliography

Archer, W. G., and Melville, Robert, *40,000 Years of Modern Art*, Institute of Contemporary Arts, London, 1949

Arnheim, Rudolph, *Art and Visual Perception: A Psychology of the Creative Eye*, University of California Press, 1954

De Voltaire, Francois M., *Elements of Sir Isaac Newton's Philosophy* (English translation by John Hanna), Frank Cass/Int. School Book Service, 1967

Gage, John, *Colour in Turner—Poetry and Truth*, Studio Vista, London, 1969

Morris, Desmond, *The Biology of Art*, see Chapter 7

Morris, Desmond, *Primates' Aesthetics*, see Chapter 7

Pasmore, Victor, *The Developing Process*, University of Durham, 1959

Priestley, Joseph, *History and Present State of Knowledge Relating to Vision, Light and Colours*, London, 1772

Chapter 9 Colour and Environment

Bibliography

Bayes, K. *The Therapeutic Effect of Environment on Emotionally Disturbed and Sub-normal Children*, Unwin, London, 1967

Bofill, Anna and Ricardo, Contribution in Tom Porter and Byron Mikellides, *Color for Architecture*, see Chapter 1—Humphrey

Bossert, H. T., *An Encyclopaedia of Colour Decoration*, Victor Gollancz, London, 1928

Bossert, H. T., *An Encyclopaedia of Ornament*, Simkin and Marshall, London, 1937

Eysenck, H. J., *A Critical and Experimental Study of Colour Preferences*, Am. J. of Psychol., **54**, 1941

Fowler, John and Cornforth, John, *English Decoration in the 18th Century*, Barrie and Jenkins, London, 1974

Gombrich, Ernst H., *The Story of Art*, Phaidon Press, 1978

Hauser, Joachim, *Talk at Color Troy '77 Conference*, Adam Hilger, London, 1977

Ketcham, Howard, *Color Planning for Business and Industry*, Harper and Row, 1958

Kobayashi, Masao and Yoshinori, Mori, *Talk at Color Troy '77 Conference*, see above—Hauser

Kuller, R., *A Semantic Model for Describing Perceived Environment*, National Swedish Institute for Building Research, Stockholm, 1973

Lenclos, Jean Philippe, 'Living in Colour' in Tom Porter and Byron Mikellides, *Color for Architecture*, see Chapter 1—Humphrey

Pugin, A. W., *Floriated Ornament*, Henry G. Bohn, London, 1849

Richardson, Marion, *Art and the Child*, University of London Press, 1948

Savage, G., *A Concise History of Interior Decoration*, Thames and Hudson, London, 1966

Tilke, M., *Costume Patterns and Designs*, Zwemmer, 1956

Name Index*

* Italicised entries refer to figures

Subject Index*

* Italicised entries refer to figures